1979

TREASURES
OF
IRELAND

TREASURES OF IRELAND

IRISH PAGAN
&
EARLY CHRISTIAN ART

A. T. LUCAS

A Studio Book

THE VIKING PRESS · NEW YORK

Published in 1974 by The Viking Press, Inc.
625 Madison Avenue, New York, N.Y. 10022

SBN 670-72652-4

Library of Congress catalog card number: 73-6063

Printed and bound in England

Published in agreement with UNESCO

Filmset and Printed by
Jolly & Barber Ltd, Rugby

TO MY WIFE, CASSIE

Contents

Foreword

The writer gladly acknowledges his indebtedness to his colleagues, Dr Joseph Raftery, Keeper of Irish Antiquities, National Museum of Ireland, and Mr Etienne Rynne, formerly Assistant Keeper of Irish Antiquities and now of the Department of Archaeology, University College, Galway. Drafts embodying technical and archaeological data, drawn up by the former in respect of the Early Christian period and by the latter in respect of the prehistoric period, have been freely utilised and both provided helpful comment and criticism on the text. For all matters involving interpretation, the writer accepts sole responsibility.

A. T. LUCAS
NATIONAL MUSEUM OF IRELAND

9

List of Colour Plates

List of Monochrome Illustrations

Sources of Illustrations

All the colour photographs were taken by Signor Mario Carrieri on behalf of UNESCO, with the exception of the following which are by the National Museum of Ireland: Plates 4, 13 and 26.

All the black and white photographs are by the National Museum of Ireland, with the exception of the following which were kindly supplied by the Commissioners of Public Works: Figs 1–4, 104–108, and 110–133 and the view on page 23. Thanks are expressed to the authorities of Trinity College, Dublin, for permission to photograph subjects from the Books of Kells, Durrow and Armagh, and to the Royal Irish Academy, Dublin, for permission to photograph subjects from St Maelruain's Gospel ('Stowe Missal').

Except where otherwise stated, all the portable artifacts mentioned in the text are in the National Museum of Ireland, Dublin. Casts of the high crosses at the following sites are also exhibited in the Museum. Ahenny, Co. Tipperary (North and South Crosses): Drumcliff, Co. Sligo: Dysert O'Dea, Co. Clare: Kells, Co. Meath (Cross of Patrick and Columba, Market Cross, West Cross): Killamery, Co. Kilkenny: Monasterboice, Co. Louth (Muiredach's Cross, West Cross) and Tuam, Co. Galway, together with casts of the iron age carved stones from Turoe, Co. Galway, and Castlestrange, Co. Roscommon.

Note on Illustrations

As an indication of size, one dimension of each object is given in the captions and the following abbreviations are used: L = length; w = width; H = height; D = diameter. In manuscript illuminations, fo = folio. In the present state of knowledge only very approximate dates can be assigned to many items.

Map showing sites and find-places.

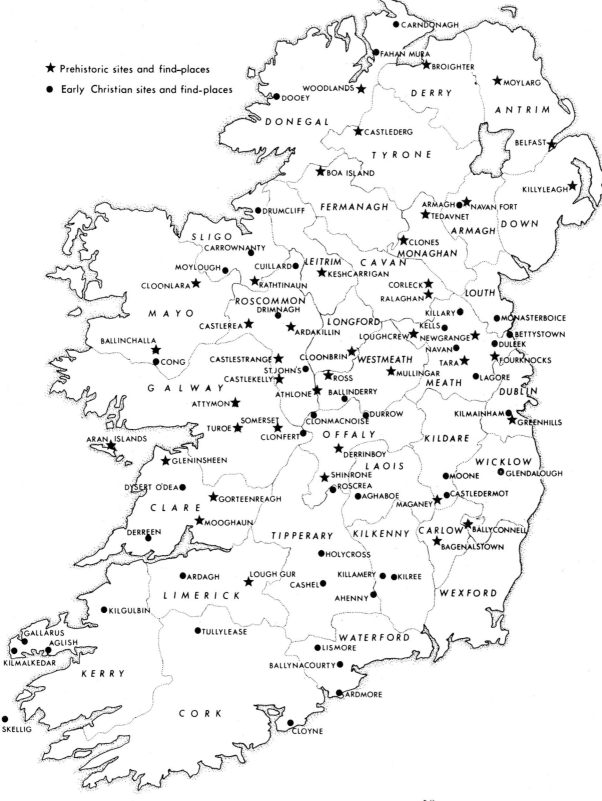

★ Prehistoric sites and find-places

● Early Christian sites and find-places

CARNDONAGH
FAHAN MURA
★ BROIGHTER
★ MOYLARG
DERRY
ANTRIM
WOODLANDS ★
● DOOEY
DONEGAL
★ CASTLEDERG
BELFAST ★
TYRONE
KILLYLEAGH ★
★ BOA ISLAND
FERMANAGH
ARMAGH ● NAVAN FORT
★ TEDAVNET
DOWN
● DRUMCLIFF
ARMAGH
SLIGO
CARROWNANTY ★
★ CLONES
MONAGHAN
MOYLOUGH ●
CUILLARD ●
LEITRIM
CAVAN
CORLECK ★
LOUTH
CLOONLARA ★
★ RATHTINAUN
★ KESHCARRIGAN
RALAGHAN ●
KILLARY ●
● MONASTERBOICE
MAYO
ROSCOMMON
DRIMNAGH ★
KELLS ●
● BETTYSTOWN
CASTLEREA ★
★ ARDAKILLIN
LOUGHCREW ★
NEWGRANGE ★
● DULEEK
BALLINCHALLA ★
NAVAN ●
● CONG
CASTLESTRANGE ★
★ CLOONBRIN
WESTMEATH
TARA ★
★ FOURKNOCKS
ST. JOHN'S ●
CASTLEKELLY ★
★ ROSS
★ MULLINGAR
● LAGORE
GALWAY
ATHLONE ●
★ BALLINDERRY
MEATH
DUBLIN
ATTYMON ●
SOMERSET ★
● DURROW
KILMAINHAM ●
TUROE ★
● CLONMACNOISE
★ GREENHILLS
ARAN ISLANDS
CLONFERT ●
OFFALY
KILDARE
★ GLENINSHEEN
DERRINBOY ●
WICKLOW
DYSERT O'DEA ●
★ GORTEENREAGH
★ SHINRONE
LAOIS
● MOONE
● GLENDALOUGH
CLARE
★ MOOGHAUN
● ROSCREA
● CASTLEDERMOT
● DERREEN
AGHABOE ●
MAGANEY ★
TIPPERARY
KILKENNY
CARLOW ★ BALLYCONNELL
● HOLYCROSS
BAGENALSTOWN
● ARDAGH
LOUGH GUR ★
KILLAMERY ●
● KILREE
CASHEL ●
LIMERICK
AHENNY ●
WEXFORD
● KILGULBIN
● TULLYLEASE
WATERFORD
● LISMORE
GALLARUS
BALLYNACOURTY ●
AGLISH
KERRY
KILMALKEDAR
● ARDMORE
CORK
★ SKELLIG
● CLOYNE

19

Introduction

The record of human habitation begins in Ireland in the Mesolithic period but the first evidence for anything of a consciously artistic nature dates from Neolithic and Bronze Age times. The field monuments and the surviving artifacts of those phases of prehistory show that during them the country was subject to a succession of influences from different parts of Europe, all of which have left their traces on Irish prehistoric art and craftsmanship. In the last centuries before Christ the culture of the La Tène Iron Age reached the island, so profoundly affecting its artistic tradition that some of the motifs then introduced were to be found in use nearly a thousand years later.

The country escaped the Roman conquest which extended to so much of neighbouring Britain but Roman influence from there and from continental Europe made itself felt in various minor ways. The advent of Christianity in the fifth century brought the country into more intimate contact with Latin speech and learning and was followed by the rapid spread of monasticism, leading to considerable missionary activity in the sixth and seventh centuries by Irish monks in Britain and Europe. The favourable conditions created at home by the growth of the monasteries and the fertile contacts made abroad combined to produce a great outburst of artistic production in the service of the church which manifested itself in manuscript illumination, metalwork and sculpture and reached its highest development in the eighth century.

It has been customary to ascribe the supposed decline in standards during the ensuing centuries to the havoc wrought on church and society by the Viking invaders, the earliest recorded appearance of whom off the Irish coast dates to 796. It may be, however, that the extent of the decline has been exaggerated by the acceptance of such outstanding objects as the Tara Brooch and Ardagh Chalice as the norm of eighth-century achievement when, in fact, they are so wholly exceptional that they occupy a position all to themselves. The opinion is also gaining ground that the effects of the Viking raids were not as catastrophic for Irish society or Irish art as the formerly prevailing interpretation of the ancient evidence implied. It has been overlooked

that in early (as in medieval) times the more valuable personal possessions of the inhabitants of the surrounding district were placed for safekeeping in the local church where they enjoyed the privilege of sanctuary under the protection of God and the patron saint and that it was this cache of lay property and not the church treasures which was the real quarry of the Viking raiders. It has also been overlooked that the early chroniclers were almost exclusively churchmen who were, understandably, assiduous in reporting Viking depredations involving church property and that later historians were all too prone to invoke the Vikings as a *diabolus ex machina* to whose intervention might be attributed anything in Irish society which seemed less than ideal. The instances of intermarriage between Norse and Irish at the highest social level, the frequent alliances between them in raiding and war and the many words borrowed from Old Norse into the Irish language all suggest the existence of a closer relationship between the two peoples than has hitherto been supposed. Indeed, recent excavations on the site of the old city of Dublin seem to indicate that the Viking settlement there and, by inference, those at Wexford, Waterford, Cork and Limerick, which evolved into the first real urban communities the country had ever known, may well have made an important contribution to the art of the Early Christian period in its latest phase. Certainly many of the surviving examples of Irish decorative art of the eleventh and twelfth centuries show Irish adaptations of Scandinavian style. We may take the Anglo-Norman invasion from Britain towards the end of the twelfth century as marking the close of the long independent Irish artistic tradition.

Even from this very summary outline of the prehistory and history of Irish art, it will be evident that, although Ireland is an island lying off the extreme west of Europe, the art at no time exhibits the narrow insularity which might be expected to result from such geographical isolation. While developing, in both prehistoric and historic times, its own interior lines of evolution, it remained an integral part of the European tradition in existence at any particular epoch, although the individual sources from which it drew inspiration varied from one period to another. Inspiration from abroad, however, rarely entailed merely the adoption and perpetuation of an alien idiom. The native tradition generally proved vigorous enough to shape the development of the new styles and new ideas into something with a character peculiarly and unmistakably Irish.

The text which follows is a sketch of Irish art from its first known remains in prehistoric times to the final extinction of the purely native tradition in the twelfth century. With so much material to be covered in a comparatively brief survey, a great deal has necessarily been omitted and comment has, in general, been confined to the objects illustrated. Considerations of space have precluded all but the briefest

reference to problems of origin and international connections, which are, in any event, still far from solution in regard to many aspects of the subject. For the prehistoric period, the material has been dealt with approximately in order of date, but to have treated the very disparate material of the Early Christian period chronologically would have been very confusing for the general reader; the items belonging to that period have, therefore, as far as is practicable, been grouped according to type, a chronological order being, where applicable, observed within each group.

Cashel, Co. Tipperary: showing the towers of Cormac's Chapel in left background and cathedral to right with round tower in front of it.

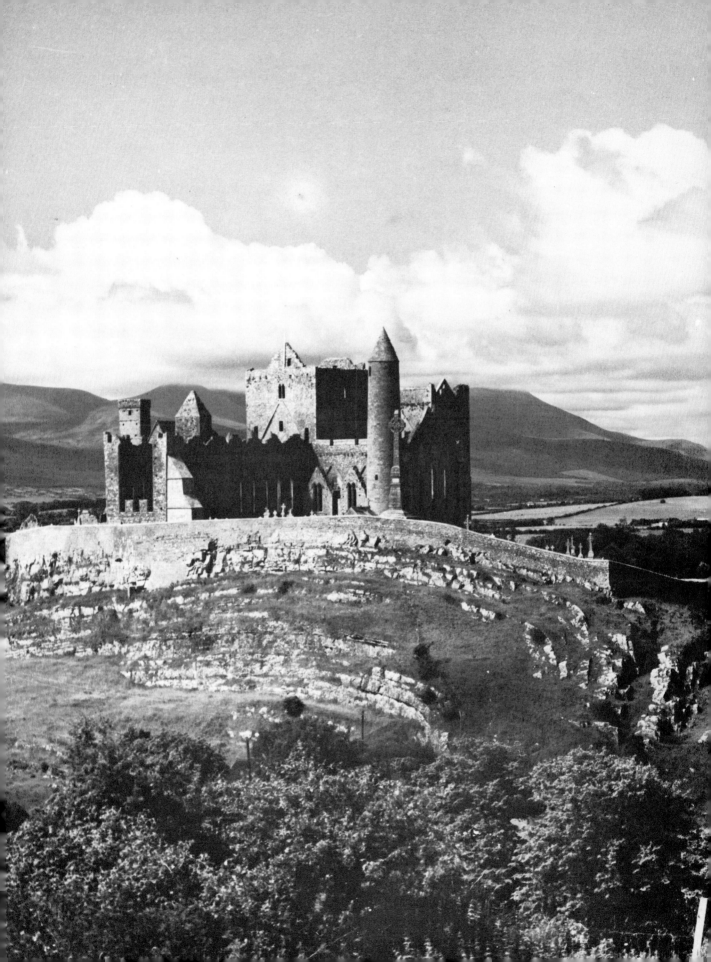

Plate 1. Above opposite: Gold disc, Tedavnet, Co. Monaghan. D. 11·6 cm. 1800–1500 B.C.

Plate 2. Below opposite: Right: Gold spiral ornament, Donnybrook, Co. Dublin. L. 6·5 cm. *c.* 1000 B.C. Left: Gold-plated lead ring, Killyleagh, Co. Down. D. 3·4 cm. *c.* 1000 B.C. Centre: Gold-plated lead pendant, Bog of Allen. H. 6·5 cm. *c.* 800 B.C.

Plate 3. Overleaf above: Outer: Gold torc, Tara, Co. Meath. D. 36 cm. *c.* 1000 B.C. Inner: Gold torc, find-place unknown. D. 21·7 cm. *c.* 1000 B.C.

Plate 4. Overleaf below: Gold hair rings, Gorteenreagh, Co. Clare. D. 10 cm. *c.* 700 B.C.

24

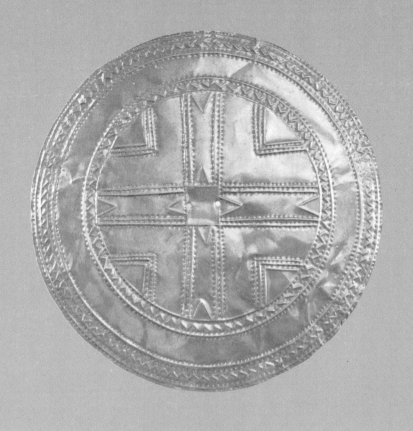

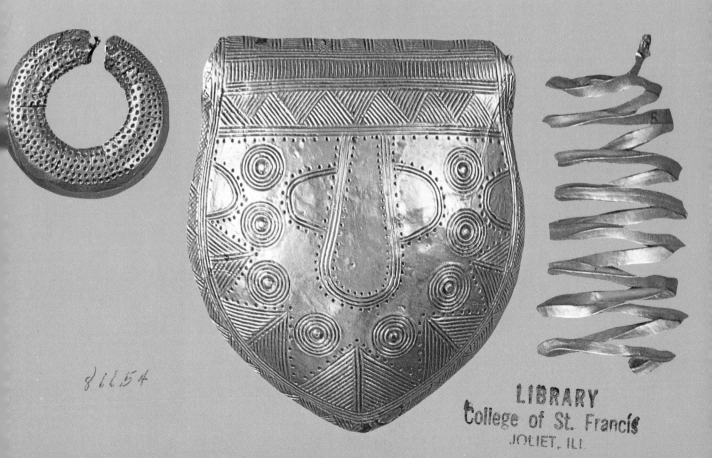

81154

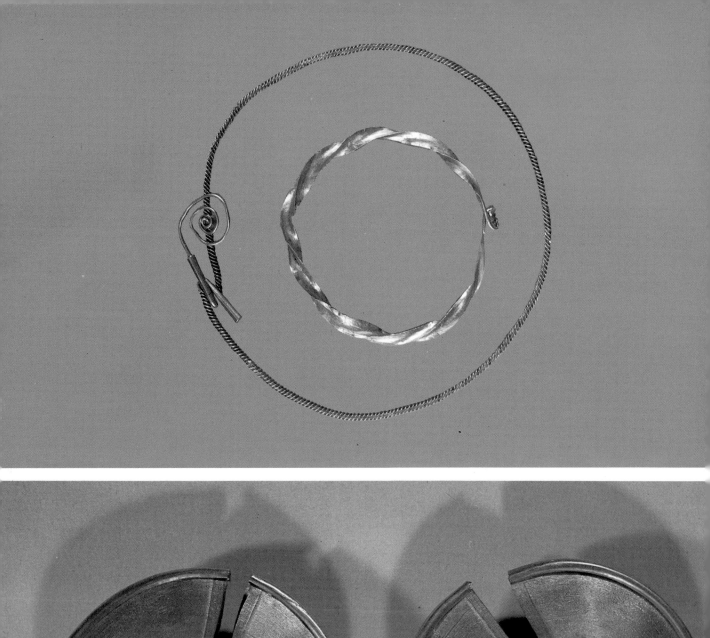
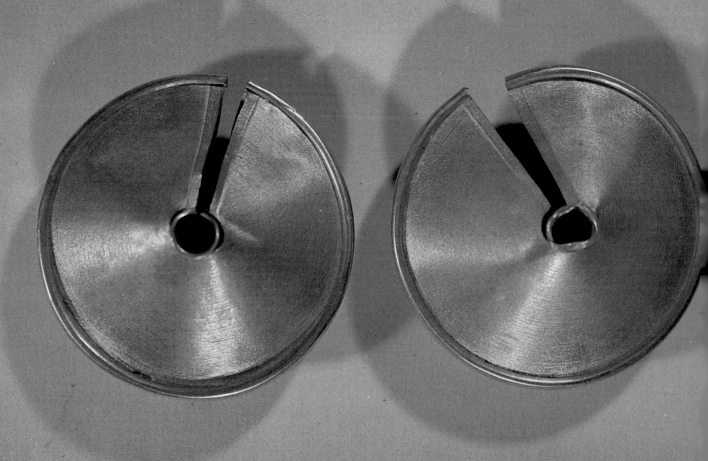

PREHISTORIC PERIOD

Neolithic and Bronze Ages

s far as is known, Ireland remained uninhabited through-out the long Palaeolithic epoch, the first human occupa-tion dating from Mesolithic times. Mesolithic remains are confined to purely utilitarian artifacts and if objects of an artistic nature existed among the hunters and food collectors of the period, none has yet been discovered. Sometime before 3000 B.C. the first elements of Neolithic civilisation were introduced, making poss-ible a more settled way of life and the growth of a larger population. There followed the arrival of the custom of erecting great megalithic tombs, large numbers of which still remain throughout the country. One type of these, consisting of circular mounds of earth or stones, which contain passage graves (stone chambers approached by lintelled stone-built passages), provides the earliest examples of Irish decorative art. A number of the tombs, particularly those situated on the Lough-crew Hills in Co. Meath and others beside the River Boyne in the same county, contain stones bearing patterns consisting of chevrons, lozen-ges, circles, spirals and a variety of other curvilinear devices (Figs 2, 4). In most instances, these patterns do not appear to have been conceived primarily as decoration, for they bear no apparent aesthetic relation to the stones on which they are carved or to each other and many of them are in situations where they must always have been wholly or partly hidden from view. They seem to be in the nature of magico-religious symbols and scarcely one of them is immediately recognisable as the representation of anything. It is probable, however, that some of them are, in fact, extremely conventionalised human figures since it is possible to detect some elements which have a similarity to rather more identifiable human representations in the grave furniture of some Iberian megalithic tombs which are thought to be ancestral to the Irish passage graves. A stone in a passage grave at Fourknocks, Co. Meath, for example bears what may be intended as a schematic rendering of a human face, possibly symbolising a god or goddess of the dead (Fig. 3).

27

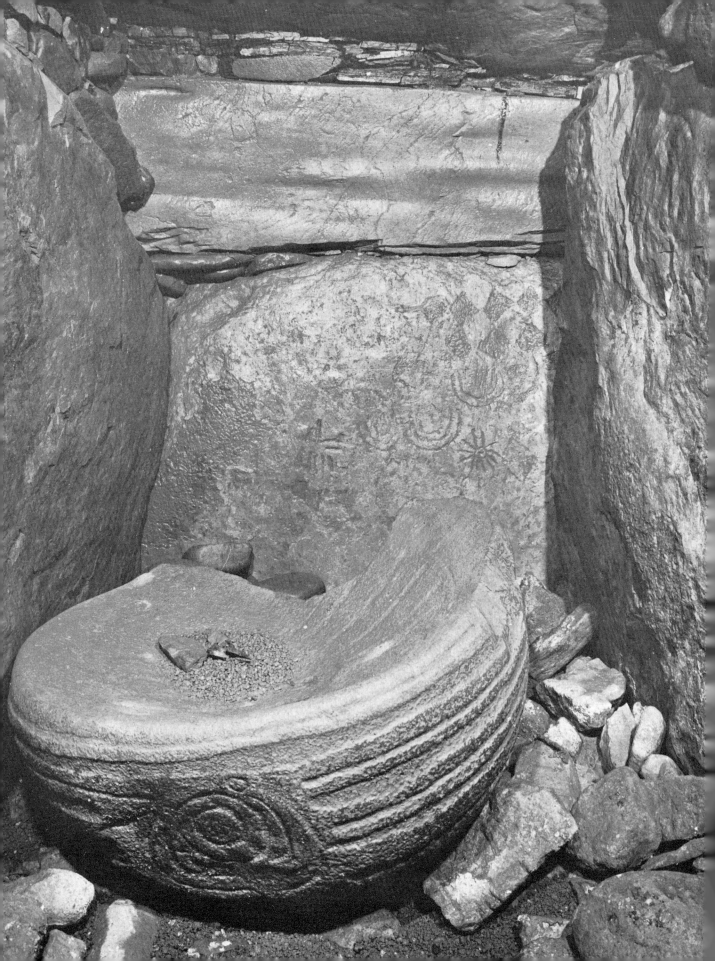

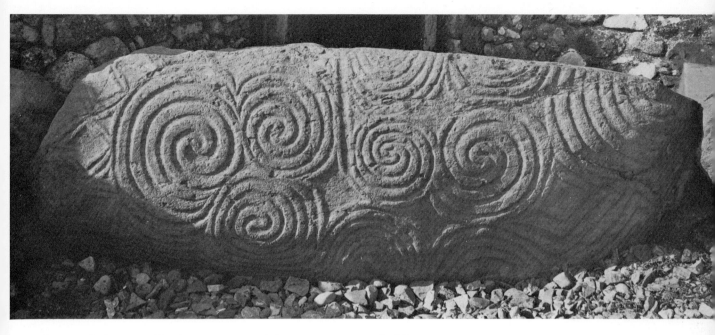

A stone lying outside the entrance of the passage grave in Newgrange, beside the Boyne, falls into a different category. It is one of a kerb of great stones set on edge girdling the base of the mound, which is one of the largest in Europe. A number of the kerb stones bear patterns but this one, possibly on account of its position, seems to have been selected for special treatment. In contradistinction to the other carved stones in the tomb, the design seems intended to be primarily decorative. Its chief elements are conjoined spirals and concentric semicircles which cover the whole outer surface, so that the pattern seems to flow on to the stone at one edge and off it at the other, to produce a remarkable effect (Fig. 2). The design was executed by first polishing the surface of the stone and then lowering the grooves by hammering to leave the pattern standing out in relief. The neighbouring passage grave of Knowth also contains striking examples of this art (Fig. 4).

As the Neolithic gave way to the Bronze Age, a quick development of metallurgy took place in Ireland. Weapons and tools of cast bronze were produced and objects of gold were fashioned either for personal ornament or for ritual use. The bronze work includes daggers, halberds and flat axeheads, many of the last being of remarkably sophisticated form, splaying out to wide convex cutting edges. Some have their long edges faceted by hammering and their faces decorated with punched and hammered geometric patterns (Fig. 6). The gold objects embrace small discs, which have generally been found in pairs, each having two perforations in the centre, presumably for attaching it to some backing material (Plate 1). They carry a cruciform *repoussé* design encircled by one or more concentric bands filled with chevrons, transverse ridging

Fig. 1. Opposite: Massive decorated stone basin in chamber of passage grave, Knowth, Co. Meath. *c.* 2500 B.C.

Fig. 2. Above: Stone at entrance to passage grave, Newgrange, Co. Meath, decorated with a pecked pattern of lozenges and spirals. *c.* 2500 B.C.

29

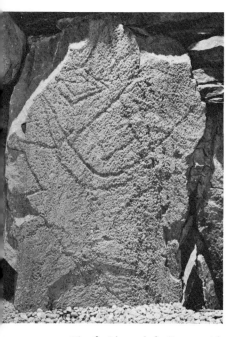

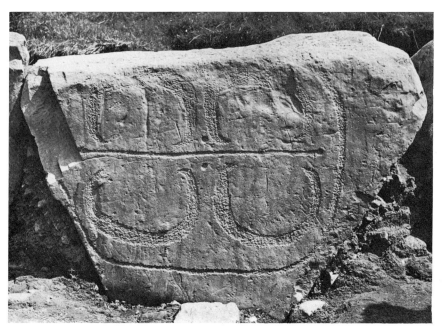

Fig. 3. Above left: Stone with design, possibly representing a human face, in passage grave, Fourknocks, Co. Meath. *c.* 2500 B.C.

Fig. 4. Above right: Decorated stone in kerb of passage grave, Knowth, Co. Meath. *c.* 2500 B.C.

or dots. Even more typical are the crescentic gold objects called lunulae. Since over forty have been found in Ireland and only a few widely scattered specimens in Britain and continental Europe, it has been concluded that they are all Irish in origin. Each consists of a thin flat sheet of metal, the horns of the crescent ending in oval expansions which are twisted out of the plane of the sheet (Fig. 5). The decoration is always incised, strictly rectilinear and confined to the horns and the margins of the wider part of the crescent. The repertoire of motifs is very limited and consists chiefly of triangles and chevrons.

The common grave type of the Early Bronze Age was no longer a great megalithic tomb but a small stone-lined cist in which the cremated remains of the dead were placed, usually accompanied by a small hand-shaped pot of thick coarse ware called a food vessel. Two types of this vessel are known from Irish tombs. One is a low wide bowl, of satisfying proportions and with its rich decoration usually arranged in horizontal zones pleasantly adapted to the contours (Fig. 9). The other is a tall straight-sided vase with a wide shoulder (Fig. 10). On both kinds the decoration generally covers the entire outer surface of the vessel and is both incised and impressed. It is exclusively non-representational in character and very similar to that found on the flat bronze axeheads (Fig. 6) and the lunulae (Fig. 5), while a cruciform pattern, resembling that on the gold discs (Plate 1), appears on the bases of many examples of the bowl type.

In Middle Bronze Age times (*c.* 1500–1000 B.C.) new pottery types occasionally occur in graves. Among them are diminutive pots, often biconical in form, which are of ultimate Mediterranean derivation and

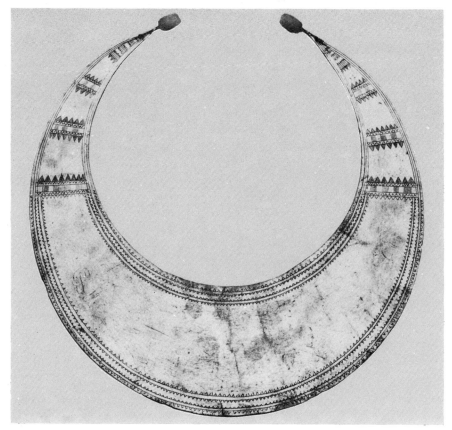

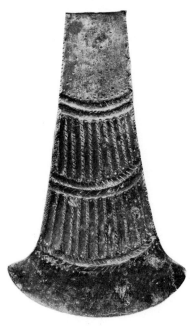

known as 'pygmy cups'. Their decoration is in the familiar geometric style and adds nothing to the existing repertoire, but some specimens of another kind of small funerary vessel exhibit a new concept in the integration of form and applied decoration. These are illustrated by an excellent example from near Bagenalstown, Co. Carlow (Fig. 8). It is the only Irish specimen with a handle, and a particular *tour de force* of its meticulously executed ornament is the chevron produced by the false relief technique on the outer edge of its rim. An exceptional object, like a miniature food vessel of the vase type, comes from Greenhills, Co. Dublin (Fig. 7). It has an assured firm outline and is exuberantly decorated with geometric devices, incised and in false relief. Much commoner than any of the foregoing tiny vessels are the large urns which are generally placed mouth downwards over the cremated bones. Names like 'urn' and 'vessel' probably do violence to the real nature of the object which, to judge from the position in which it is usually found and from its shape, was not conceived as a container but as a cover, sheltering the remains of the person in death as his house had sheltered him in life. The majority bear rather perfunctory decoration of incised patterns, but those which fall into the class known as encrusted urns exhibit a new technique, the most prominent elements

Fig. 5. Above left: Gold lunula, Ross, Co. Westmeath. w. 20 cm. 1800–1500 B.C.

Fig. 6. Above right: Decorated flat bronze axehead, Co. Monaghan. L. 22 cm. *c.* 1600 B.C.

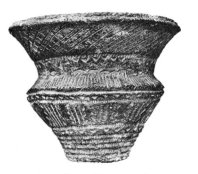

Fig. 7. Above: Pottery 'pygmy cup' from Bronze Age grave, Greenhills, Co. Dublin. H. 8 cm. *c.* 1400 B.C.

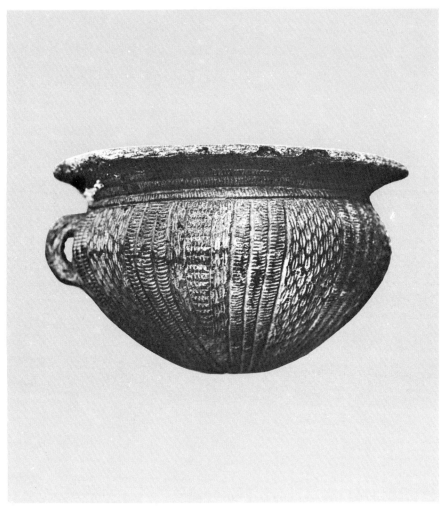

Fig. 8. Right: Pottery 'pygmy cup' from Bronze Age grave, Bagenalstown, Co. Carlow. H. 5.3 cm. *c.* 1500 B.C.

of the ornament consisting of pellets, chevrons, festoons and encircling ridges in true relief (Figs 12, 13).

Personal ornaments of gold increase in number and variety during this phase of the Bronze Age. Earrings were made of gold rods of square section twisted to provide a richer surface, the twists being few or many as fashion or personal choice dictated (Plate 8, bottom). More sumptuous effects were produced by drawing out the edges of the rod into flanges before twisting (Plate 8, top). One of the finest and most interesting earrings to be found in the country may be an imitation in solid metal of a bead-strung type current in the Near East at the time. It has in the centre a large milled disc with biconical expansions on each side of it (Plate 8, centre). There are also in existence a large number of gold torcs of widely varying sizes, some intended to be worn as necklets, others as anklets or bracelets, while a few are large enough to have functioned as girdles (Plate 3). Like the earrings, they are made of bars

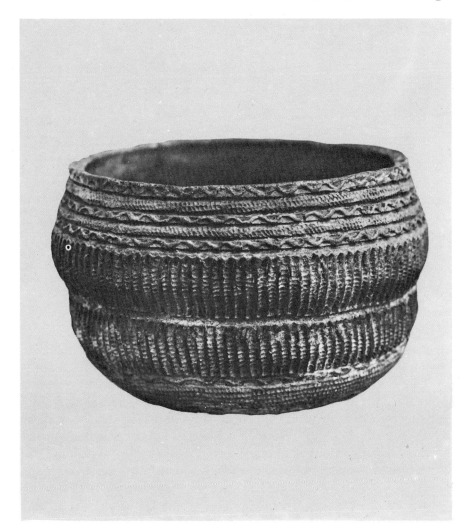

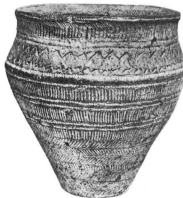

Fig. 10. Above: Vase-type pottery 'food vessel' from Bronze Age grave, Ballin-challa, Co. Mayo. H. 15·3 cm. 2000–1000 B.C.

of square section, with or without flanges, but a number are twisted from flat ribbons of gold (Plate 5).

From the Late Bronze Age (*c.* 1000–200 B.C.) the types of gold objects are yet more diversified. They include a large number of small but thick penannular rings, formerly believed to be a form of currency and hence named 'ring money'. On account of their resemblance to the wig rings worn in ancient Egypt, they have also been interpreted as hair ornaments. Unlike earlier objects, which are all of solid gold, many of these have cores of bronze, lead or clay. One from Killyleagh, Co. Down, has a lead core and is decorated with punched dots (Plate 2). Lead also forms the core of a highly decorated object from the Bog of Allen which has a cylindrical perforation running across the broader end and was, probably, a pendant (Plate 2). Triangles filled with sloping lines and small bosses ringed by concentric circles are the main elements in the decorative scheme. The latter motif appears on many Irish

Fig. 9. Left: Bowl-type pottery 'food vessel' from Bronze Age grave, Killinagh, Co. Cavan. H. 9·8 cm. 2000–1000 B.C.

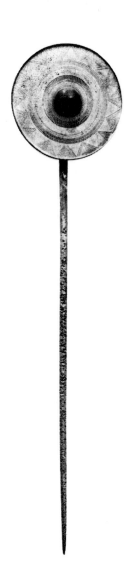

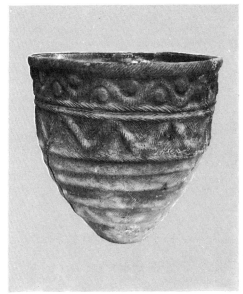

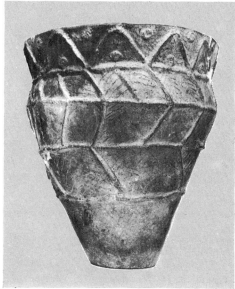

objects of the time and has an extremely wide distribution in Europe. It forms the chief decorative feature of the bronze pins with large circular heads, known as sunflower pins, and on the one illustrated it is combined with the hatched triangles already noticed on the pendant above (Fig. 11). Among the most numerous kinds of Late Bronze Age gold objects are the so-called fibulae or 'dress fasteners'. They consist of two large hollow conical terminals connected by a bow and are probably derived from a rather similar North European type which has flat disc terminals joined by a bow and provided with a pin, which is present in no Irish example. They vary very considerably in size, the two largest known being from Castlekelly, Co. Galway (Plate 9), and from near Clones, Co. Monaghan (Plate 10); the latter has its terminals decorated with a pattern of concentric circles surrounding small central depressions. There is another type of the object with plain flat terminals, inclined to each other and connected by a short ribbed bow. Two circular gold boxes, found near Mullingar, Co. Westmeath, bear exactly similar decoration based on the favourite motif of boss and concentric circles (Plate 7).

Inspiration from southern Scandinavia is to be seen in a pair of gold armlets decorated with *repoussé* lines and rope mouldings and dating to about the end of the second millennium B.C., which were found in a bog in Derrinboy, Co. Offaly (Fig. 15). To influences from the same source at about the same time must be attributed the largest individual gold articles ever found in Ireland, a series of collars or gorgets, of which all but one have been discovered in the region of the Shannon estuary. Each is made from a crescentic sheet hammered up into three or more swelling ribs separated by rope mouldings or lines of punched

Fig. 11. Above: Bronze sunflower pin, Rathtinaun, Co. Sligo. The central conical boss is surrounded by a pattern of concentric circles and hatched triangles. L. 42 cm. *c.* 800 B.C.

Fig. 12. Opposite, top left: Encrusted pottery urn from Bronze Age grave, Maganey Lower, Co. Kildare. H. 38·5 cm. 1500–1000 B.C.

Fig. 13. Opposite, top right: Encrusted pottery urn from Bronze Age grave, Ballyconnell, Co. Wicklow. H. 33 cm. 1500–1000 B.C.

34

Plate 5. Opposite: Gold torc, near Belfast, Co. Antrim. D. 15 cm. Date uncertain, possibly *c.* 700 B.C.

Plate 6. Overleaf: Gold collar, Broighter, Co. Derry. D. 18·2 cm. 1st–5th cent. A.D.

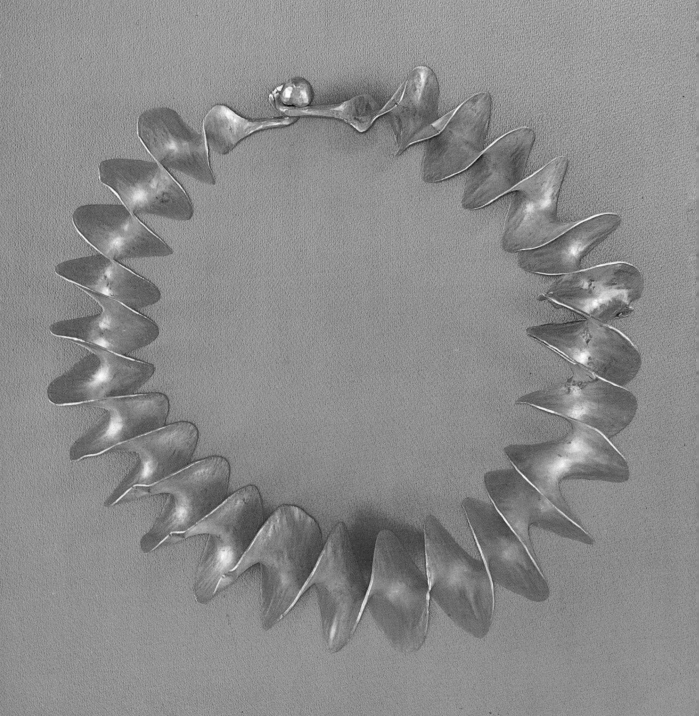

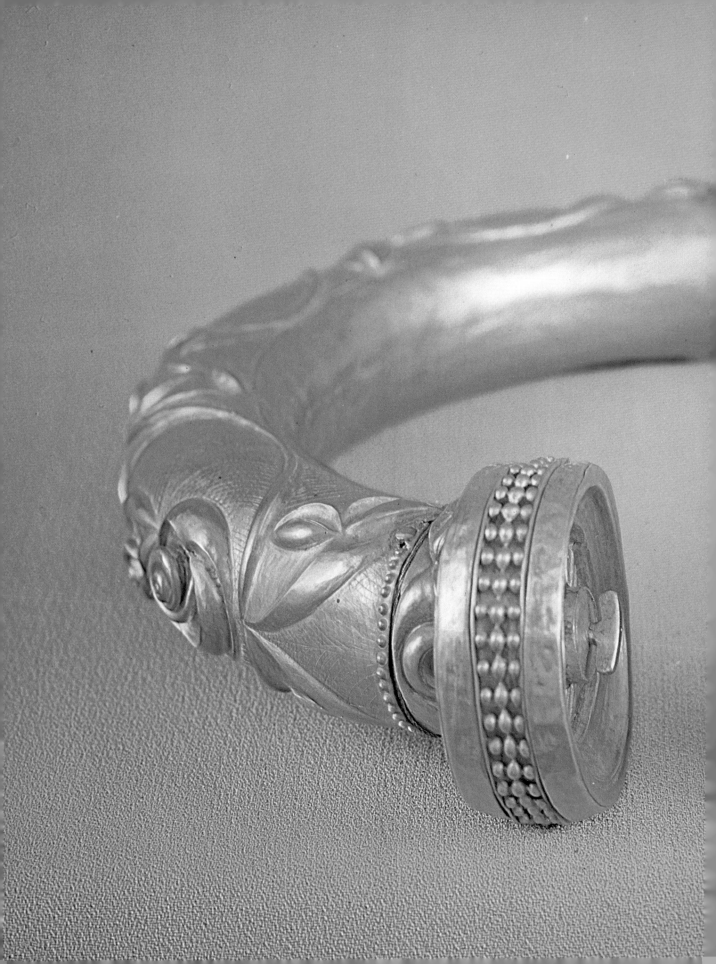

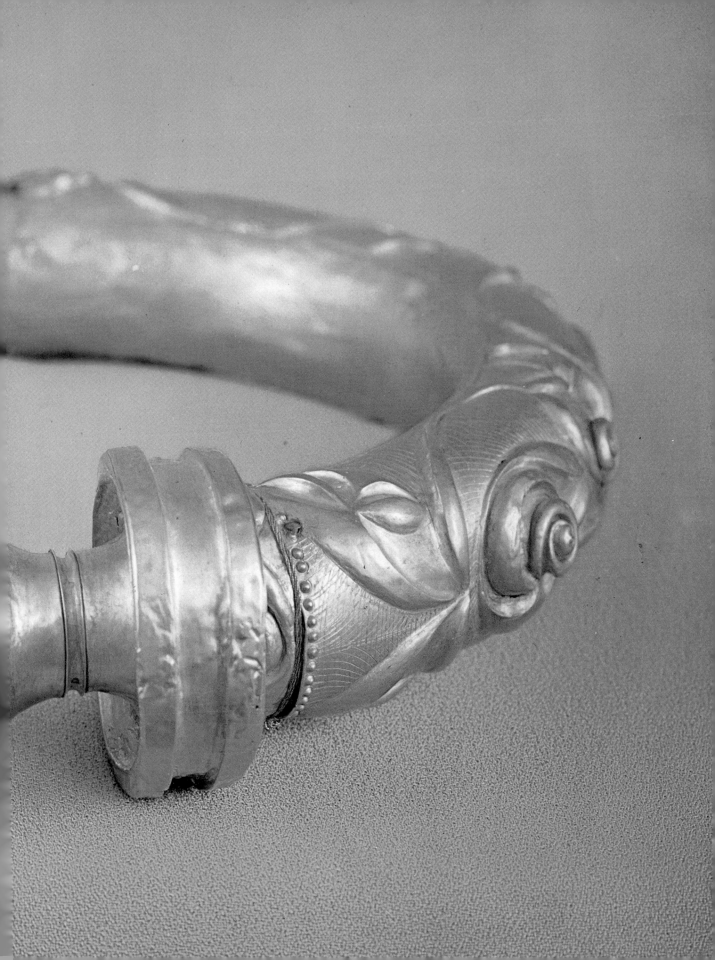

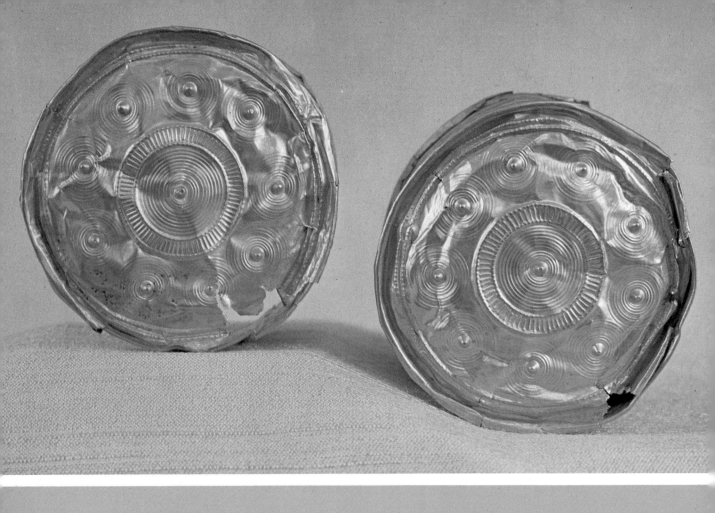

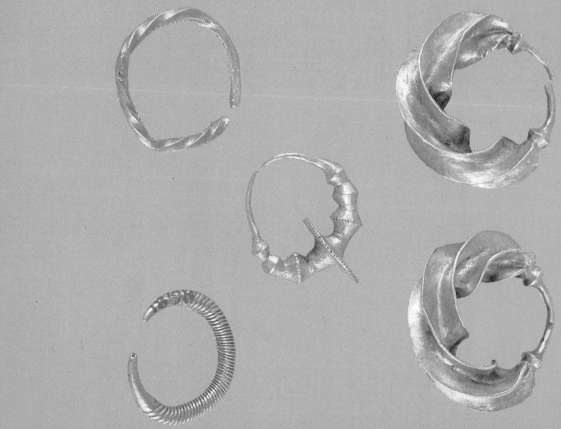

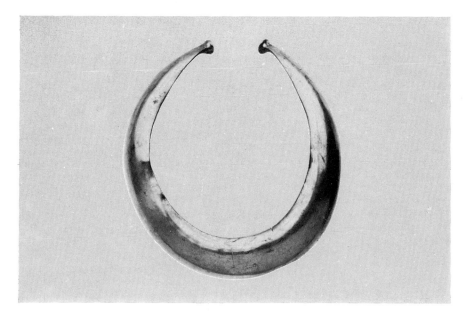

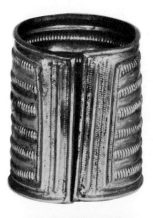

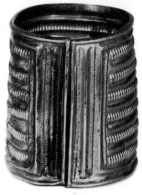

dots. The ends of the crescent are decorated with discs attached to them with gold wire which, concealed in a moulding, is also used to reinforce the edges of the collar. The terminal discs are made of two plates fitted back to back and a number of them are ornamented on front with a central conical boss ringed by concentric circles, this being, in turn, surrounded by a circle or circles of smaller bosses similarly ringed, each of which repeats in miniature the design on the disc as a whole. The backs of the discs are also ornamented but in a simpler and different style. The finest and best preserved specimen was found in a rock crevice at Gleninsheen, Co. Clare, in 1934, and the sheer perfection of its workmanship and the refinement of its design entitle it to rank as one of the finest products of Irish Bronze Age art (Plate 11). A simpler form of gorget is exemplified by one from a huge hoard of gold objects found at Mooghaun North, Co. Clare, in 1854, the greater part of which was, unfortunately, melted down (Fig. 14). These are convex in front and concave on the back and have conical terminals, such limited decoration as they bear being incised.

In design and technique Irish Late Bronze Age goldwork reaches the summit of its not very lofty achievement in those rather enigmatic objects which have been termed hair rings, because it has been suggested they hung on a lock of the wearer's hair. Although some have been found in Britain and although similar and, apparently, related specimens have been found in France, they appear to be commoner in Ireland than elsewhere. They are biconical in shape, the opposed cones being thin sheets of metal held together by a rounded binding strip which covers the meeting edges (Plate 4). Cones and strip are interrupted by a slit, the edges of which are also finished off with binding

Fig. 14. Above left: Gold collar, Mooghaun North, Co. Clare. W. 18 cm. *c.* 700 B.C.

Fig. 15. Above right: Pair of gold armlets, Derrinboy, Co. Offaly. H. *c.* 7 cm. *c.* 700 B.C.

Plate 7. Opposite, above: Two gold boxes, near Mullingar, Co. Westmeath. D. 6 cm. *c.* 700 B.C.

Plate 8. Opposite below: Right: Pair of gold earrings, near Castlerea, Co. Roscommon. W. 3·6 cm. Middle: Gold earring, find-place unknown. W. 2·5 cm. Top left: Gold earring, find-place unknown. W. 3·3 cm. Bottom left: Gold earring, find-place unknown. W. 3·3 cm. All *c.* 1200 B.C.

39

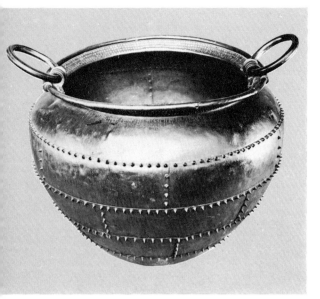

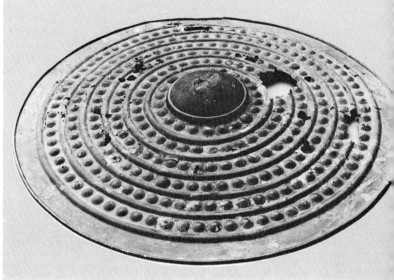

Fig. 16. This page, left: Bronze cauldron, Castlederg, Co. Tyrone. D. 53 cm. *c.* 700 B.C.

Fig. 17. This page, right: Bronze shield, Lough Gur, Co. Limerick. D. 72 cm. *c.* 700 B.C.

Fig. 18. Opposite, left: Wooden shield, Cloonlara, Co. Mayo. D. 48 cm. *c.* 700 B.C.

Fig. 19. Opposite, right: Leather shield, Cloonbrin, Co. Longford. D. 58 cm. *c.* 700 B.C.

Fig. 20. Opposite, left: Bronze spearhead, River Shannon, Athlone, Co. Westmeath. L. 29·2 cm. *c.* 700 B.C.

Fig. 21. Opposite, right: Bronze sword, Shinrone, Co. Offaly. L. 48·4 cm. *c.* 800 B.C.

strips. Through the centre of the object runs a tube with an opening down the side which coincides in width and position with the slit in the cones. The surface of the cones is covered with a continuous series of minute parallel grooves, sometimes as many as five to a millimetre, which impart a matt satin sheen to the metal. These were apparently drawn with a compass as concentric circles while the sheet was still in the flat and before the slit had been cut. If this operation demanded great skill and sureness of touch, the grooves were, in some cases, produced by one calling for even greater skill, for the sheet was built up of fine wires laid side by side and soldered together to form one continuous surface.

Many of the more utilitarian articles of Late Bronze Age craftsmanship are of a high standard, the wedding of graceful blade and tapering socket making some of the spearheads, in particular, things of real beauty (Figs 20, 21). To this time also date the first shields known in the country: circular ones of bronze, wood and leather, all alike in having a hemispherical boss ringed by the same concentric mouldings which appear so frequently in the decoration of the gold ornaments (Figs 17, 18, 19). The metal in the bronze specimen from Lough Gur, Co. Limerick, is too thin to have afforded adequate protection against enemy weapons and it was, in all likelihood, intended for ritual or ceremonial use only. The V-shaped indentations in the mouldings of the leather one and the U-shaped indentations in the wooden one appear in the contemporary shields from many parts of Europe and have their origin in the notched shields of the Aegean-Near East region. An outstanding blend of design and function is found in a number of large cauldrons which have been discovered in bogs in various localities. They are built up of

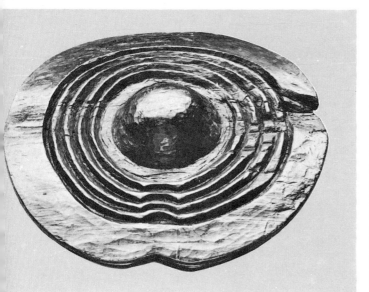

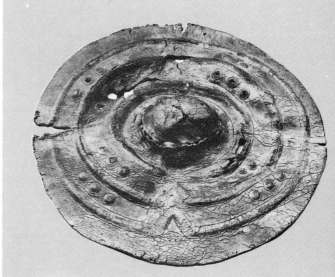

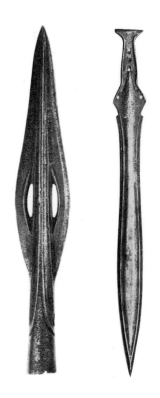

comparatively small sheets of bronze, fastened together by rivets, the outer ends of which are frequently provided with decorative conical heads. A wide everted rim, stiffened by mouldings, sits firmly on the swelling body and carries stout attachments to hold the two freely moving suspension rings (Fig. 16).

From this very brief review of some of the typical relics of Neolithic and Bronze Age Ireland, the virtually total absence of any representational art is strikingly evident. Were it not for the remotely representational elements detectable in the megalithic patterns and the possible inclusion of a rude clay figurine from Ballintoy, Co. Antrim, to which a Neolithic date has sometimes been attributed, the absence would be complete. Nothing which could be immediately recognised as a human, animal or vegetable figure has ever been found reproduced by any technique in any medium. The surviving artifacts also show that, while there was great sensitivity to beauty of shape and contour and continuous and successful experiment with new forms, the repertoire of the applied decoration remained astonishingly poverty-stricken. To judge from what has survived on the pottery and metalwork of the earlier phase of the period, it was largely restricted to the multiplication and combination of a few angular geometric devices which, in the later phase, were supplemented by a monotonous profusion of bosses ringed by concentric circles. On stone, the only other medium on which it has come down to us, the decoration has a more curvilinear complexion but its most fluid and developed motif, the megalithic spiral, disappeared at an early stage and the majority of the non-megalithic rock scribings consist of cup-like depressions surrounded by concentric circular grooves.

41

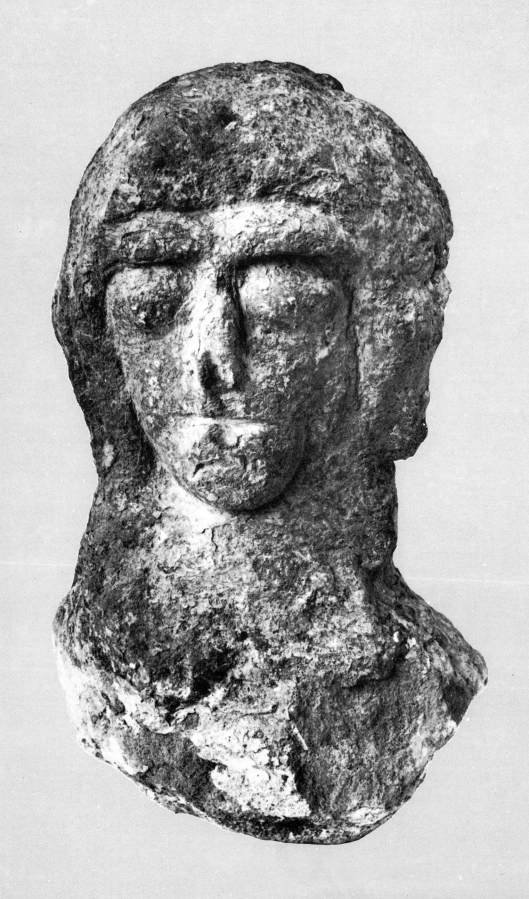

Iron Age

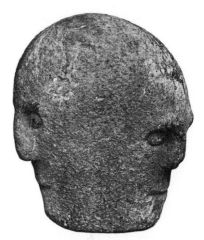

This torpid decorative art was completely reshaped by the impact of continental Iron Age art and, more particularly, by the La Tène facies of it which was the result of the fusion, during the last five centuries before Christ in the region of the upper reaches of the Rhine and Danube, of three traditions: an old native geometric art, the animal art of the steppes, and motifs from classical art. The result was not an amalgam but a digest, and there emerged a fresh vocabulary of motifs, calculated neither to enhance meaning nor to stir emotions but to express a sense of rhythm new to the western world. This art reached Ireland in the last centuries before Christ. The transformation it effected made it seem that, whereas in Bronze Age times pattern had been imposed on surface to fill a void, under the new order pattern and surface became integrated into the overriding rhythm of the design.

As if to proclaim that it had come to stay, the new art made one of its earliest appearances on a massive monument at Turoe, Co. Galway (Fig. 26). It is a large stone, like a squat pillar with a rounded top, the whole upper surface of which is covered with an overall curvilinear pattern in relief of swirling scrolls, swelling curves and triskeles, flawlessly contoured to the curvature of the surface. At the bottom a horizontal band of step-pattern girdles the stone. A monument, alike in style but smaller and having the pattern executed in lines pecked into the stone, stands at Castlestrange, Co. Roscommon (Fig. 25). A third decorated stone of this family, now much damaged, is at Killycluggin, Co. Cavan. While standing stones, solitary, in alignments and in circles, are known from Bronze Age times, these La Tène monuments are the earliest recorded instances of Irish stone sculpture in the round.

To the Iron Age, too, belongs the first figure sculpture known from the country. Among the concentrations of Celtic figure sculptures found in southern France and the Rhineland there occur representations of two-faced and three-faced divinities, parallels to which are found in Ireland. One of the most striking is a small two-headed stone figure on Boa Island, Co. Fermanagh (Plate 12). The heads are back to back and the features highly conventionalised but set with complete assurance within the triangle of the face. The eyes, with their moulded sockets, are enormous in relation to the mouth, but both they and the mouth are perfectly adjusted in size to the width of the face at the points where they lie. The lower part of the statue is damaged and, in its present

Fig. 23. Above: Three-faced stone head, Corleck, Co. Cavan. H. 30 cm. 1st to 5th cent. A.D.

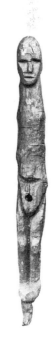

Fig. 24. Above: Wooden figure, Ralaghan, Co. Cavan. H. 114 cm. 1st cent. B.C.

Fig. 22. Opposite: Three-faced stone head, Woodlands, Co. Donegal. H. 52 cm. 1st to 5th cent. A.D.

43

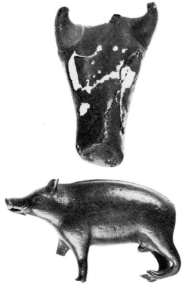

Fig. 27. Above: Bronze ox-head, find-place unknown, L. 9·5 cm. 1st cent. B.C.–1st cent. A.D. Bronze pig, find-place unknown. L. 8 cm. 1st cent. B.C.–1st cent. A.D.

state, the crossed limbs can be interpreted as arms visible from the elbows up with the hands resting on the shoulders or as arms with the hands crossing below at the wrists or (more probably) as the shins and crossed feet of a squatting figure. If the sculptor's intention in regard to the limbs is in doubt, there is none about the impressiveness which he imparted to his two impassive yet curiously alert faces. Of the two three-faced stone carvings extant, one is a bust and the other a head. The former is from Woodlands, Co. Donegal, an area in which there are a number of other stone heads. It consists of two faces back to back with a smaller one on one side between them. The two large faces differ considerably since one is carved in high relief, with bulging eyes and simian brow ridges (Fig. 22), and the other is flat, with its features crowded together. It is evident that the sculptor carried out little preliminary shaping on the rough block he selected for carving but adapted his treatment of the faces to the natural contours of the stone with considerable skill. The swift economy of line and the magisterial aloofness of the Boa Island figure are even more evident in the second three-faced head, which comes from Corleck, Co. Cavan (Fig. 23). Its three very similar faces share a single massive skull to create the impression of one all-seeing being. In connection with this sculpture in stone, it may be appropriate to mention here a wooden figure from a bog at Ralaghan, Co. Cavan (Fig. 24). It was carved without arms and its legs are disproportionately short, but to realise that the sculptor was concerned with animating a post and not with disengaging a shape from a mass is to appreciate how well he has succeeded within his narrow limits. Interest is concentrated on the face and on the genital

Fig. 25. Centre, below: Iron Age carved stone, Castlestrange, Co. Roscommon. H. *c.* 90 cm. 1st cent. B.C.

Fig. 26. Right, below: Iron Age carved stone, Turoe, Co. Galway. H. *c.* 119 cm. 1st cent. B.C.

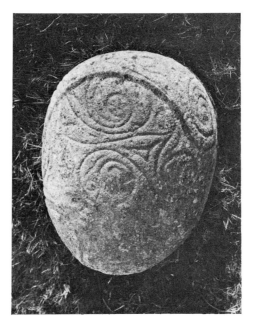

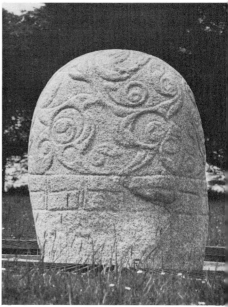

region, suggesting that the figure was connected with a fertility cult. Its date is uncertain and it may belong to a somewhat earlier time than the stone figures just described. Recalling the frequent occurrences of boars in various Celtic contexts are two small bronze figurines of pigs. Their surprising naturalism is contrasted with the summary outline and suppression of detail which characterise a hollow bronze head of an ox of about the same date (Fig. 27).

Apart from the fact that it is one of the few naturalistic delineations from the Irish Iron Age, a stag scratched on a slip of bone has no significance, but its childish freehand is wholly out of context amid the sophisticated compass-work where it occurs, for it is drawn on one of some hundreds of slips of polished bone found in the last century in one of the passage graves at Loughcrew, Co. Meath. These are decorated with compass-drawn curvilinear designs, some of which are extremely beautiful (Figs 28, 29). The ambivalence of these patterns, in which the voids are frequently as structural in the design as the overt motifs, is seen to the full in a bronze box from Cornalaragh, Co. Monaghan, where the gradated voids in the openwork lattice group and regroup themselves anew under the eye and where those in the central roundel, once seen, fasten themselves with such emphasis on the vision that they abstract all the reality from the metalwork which bounds them (Fig. 33). A similar visual effect is produced by another bronze box from Somerset, Co. Galway (Fig. 32).

An analogous effect, using colour instead of empty space, was achieved in metalwork by filling the voids in the patterns with red enamel. The metal in the voids was removed to leave hollows into which the fused enamel was poured; this technique, known as *champlevé*, was used in Ireland during the Iron Age and the greater part of the Early Christian period. (The sister technique, known as *cloisonné*, by which cells for the reception of the enamel were made by soldering strips of metal to the surface, was not employed in Ireland until the twelfth century.) A stud of red enamel still remains in position in the centre of an openwork bronze mount from Somerset, Co. Galway, but the enamel has disappeared from many of the objects it once adorned, leaving the pattern standing out from the empty roughened spaces around them which it formerly occupied. This can be seen, for example, in one of a family of strangely shaped objects called 'latchets', which were, presumably, brooches and which consist of a bronze disc with a sinuous strip of metal extending from it in the same plane (Fig. 31). The decorative effect of the enamel was frequently enriched further by the insertion into it of small tablets of millefiori glass. These were made by placing together small rods of glass of different colours so that their ends formed the pattern required. They were then fused and drawn out into a single rod, from which thin transverse slices were cut, each reproducing the pattern in which the

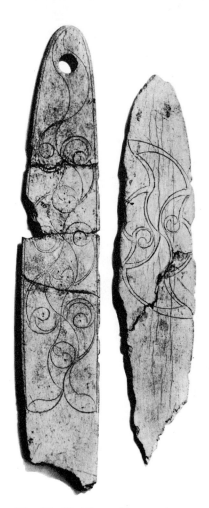

Fig. **28, 29.** Three decorated bone slips, one (below) with figure of a stag, Loughcrew, Co. Meath. L. *c.* 13·5 cm. Early 1st century A.D.

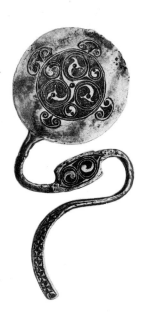

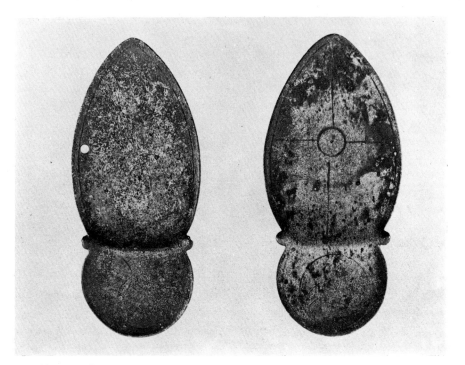

Fig. 30. Pair of bronze 'castanets', find-place unknown. L. 12·5 cm. 1st cent. A.D.

Fig. 31. Above: Bronze 'latchet' brooch, find-place unknown. The hollows in the design of spirals and bird-heads were originally filled with red enamel. L. 13·5 cm. Date uncertain, possibly 1st cent. A.D.

Plate 9. Opposite above: Gold 'dress fastener', Castlekelly, Co. Galway. W. 28 cm. *c.* 700 B.C.

Plate 10. Opposite below: Gold 'dress fastener', near Clones, Co. Monaghan. W. 21 cm. *c.* 700 B.C.

Plate 11. Overleaf: Gold gorget, Gleninsheen, Co. Clare. W. 31 cm. *c.* 700 B.C.

component rods had been originally arranged (Fig. 66). The technique is derived from the Roman world, where it dates chiefly from the second and third centuries A.D., and continued in use throughout the Early Christian period in Ireland into the twelfth century, when it is found in the Lismore Crozier (Fig. 74). White and blue are the commonest colours but red and green also occur and the designs on the tablets comprise step- and chequer-patterns and other geometrical formations. Another method used on the metalwork to allocate the requisite visual emphasis to the voids in the pattern was to hatch them or otherwise differentiate their surface from that of the pattern itself. An example of this is provided by a pair of spoon-shaped bronze objects, the purpose of which is unknown but which are sometimes referred to as 'castanets' (Fig. 30). They are not, as a type, uniquely Irish, other specimens having been discovered in Britain and France. Each consists of a small, oval, concave bronze plate, pointed at one end and with what may be described as a handle at the other, the decoration being mainly restricted to this last part. The design was outlined with a compass, the lines being subsequently deepened by some kind of tracer or graving tool, in the operation of which the craftsman sometimes failed to keep to the compass lines (Fig. 36). In one of the castanets (above) the voids are hatched; in the other stippled.

46

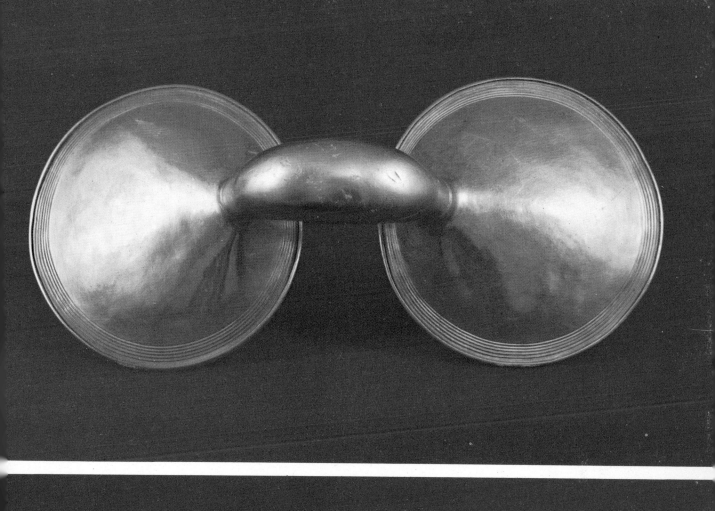
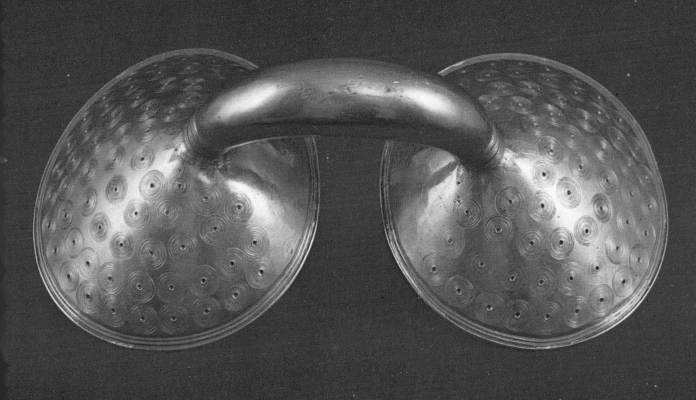

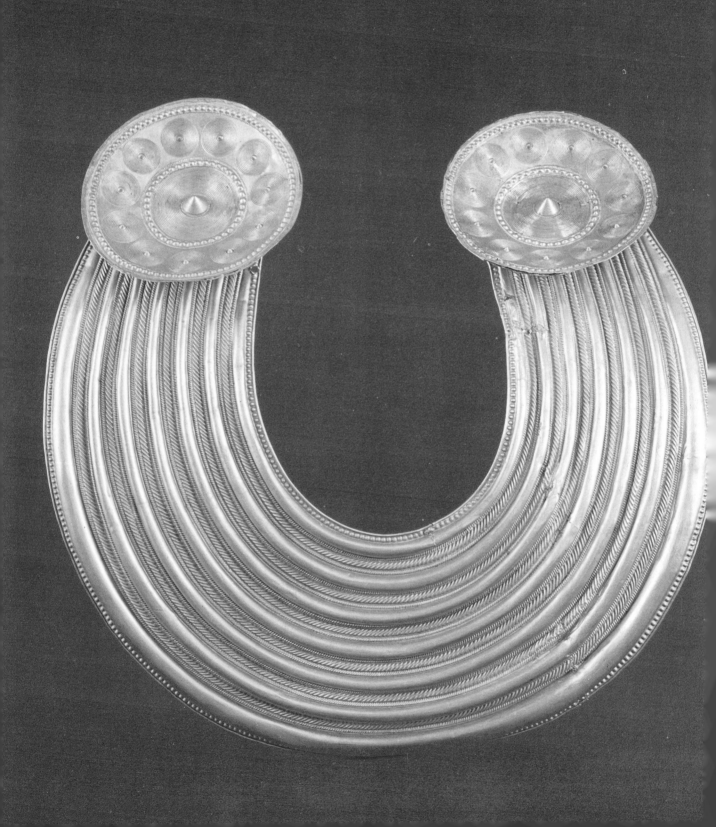

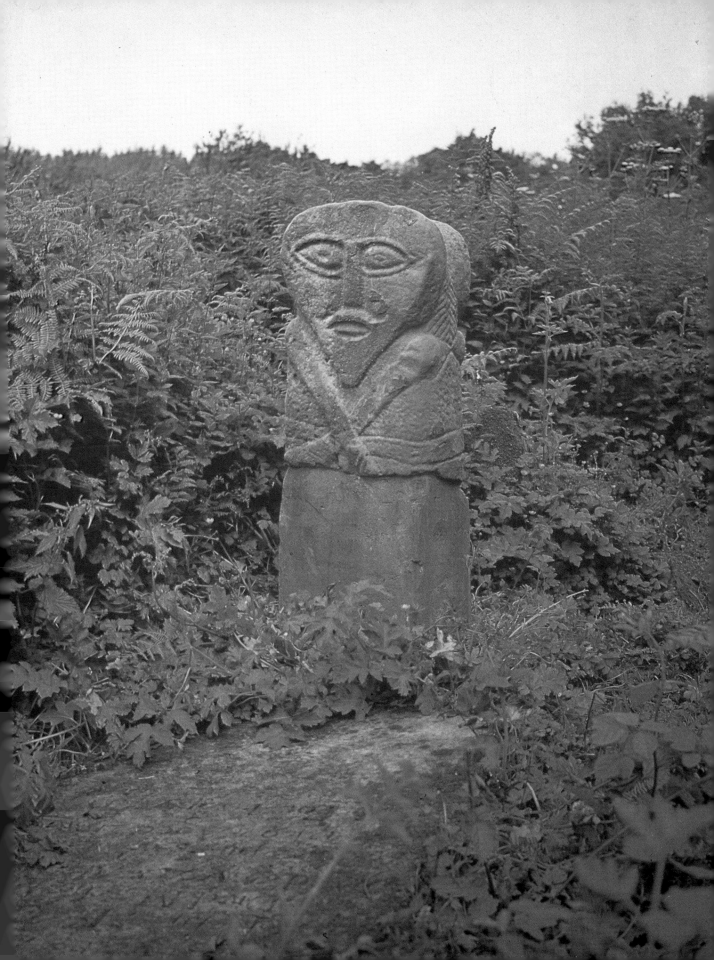

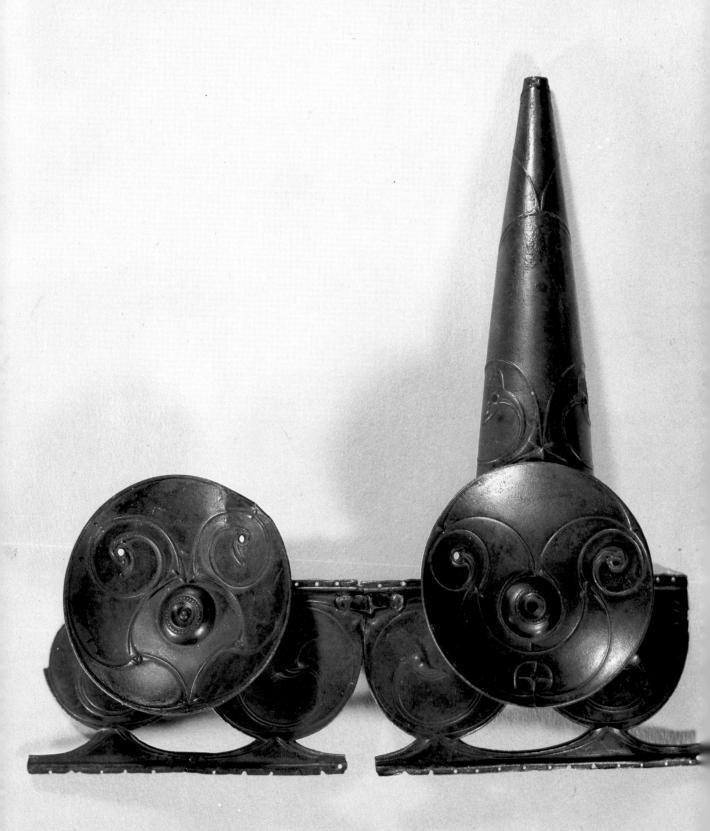

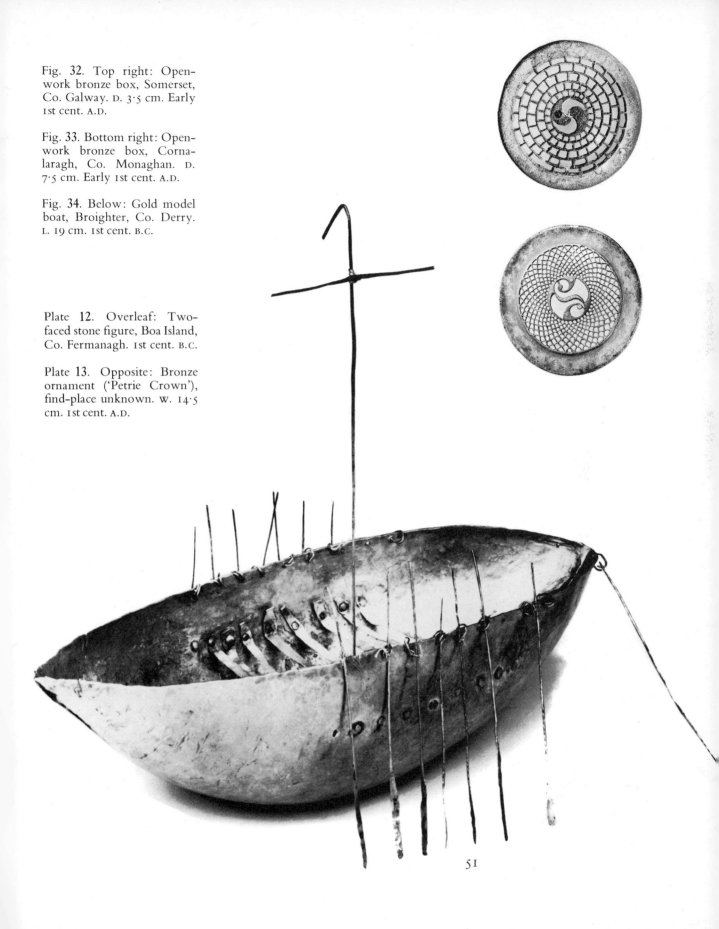

Fig. 32. Top right: Open-work bronze box, Somerset, Co. Galway. D. 3·5 cm. Early 1st cent. A.D.

Fig. 33. Bottom right: Open-work bronze box, Cornalaragh, Co. Monaghan. D. 7·5 cm. Early 1st cent. A.D.

Fig. 34. Below: Gold model boat, Broighter, Co. Derry. L. 19 cm. 1st cent. B.C.

Plate 12. Overleaf: Two-faced stone figure, Boa Island, Co. Fermanagh. 1st cent. B.C.

Plate 13. Opposite: Bronze ornament ('Petrie Crown'), find-place unknown. W. 14·5 cm. 1st cent. A.D.

51

Fig. 36. Above, opposite: Top of bronze 'castanet' decorated with incised curvilinear patterns, find-place unknown. L. 3 cm. 1st cent. A.D.

Fig. 37. Opposite, below: Flange of mouth of bronze horn (this page), Loughnashade, Co. Armagh. D. 19·3 cm. 1st cent. B.C.

La Tène patterns are at their most beautiful where they exist in three-dimensional form, achieved most frequently by use of the *repoussé* technique. One of the most splendid objects decorated in this manner is a gold collar found at Broighter, Co. Derry (Plate 6). It is related to types known from Britain and continental Europe and dates, in all probability, to between the first and fifth centuries A.D. It is, unfortunately, broken in the centre and, in its present state, consists of two tubes of thin sheet gold to the ends of which are attached two cylindrical terminals. One terminal is provided with a T-shaped projection, the other with a matching slot; these engage to close the collar. The collar bears a very beautiful curvilinear design in high relief, executed by the *repoussé* technique, of a standard never excelled and seldom equalled in Irish art. The motifs employed are trumpet-patterns, lentoid bosses and spirals, which are arranged in a design so flowing and open that all sense of its essential regularity is dissipated in sinuous movement across and out from the surface. The emancipation of the decoration from its background is increased by filling the voids with a mesh of fine compass-drawn curved lines, which mute the sheen of the surface to leave the pattern one degree more brilliant. The perfection of the design is all the more remarkable since it was almost certainly executed while the gold sheet was still in the flat, so that the craftsman had to produce on a flat surface a pattern destined for a curved one. The collar formed part of a hoard which included a small model boat with mast and oars (Fig. 34), a small hemispherical bowl and four necklets, all of gold. Two of the necklets are of woven wire with elaborate fastening devices which are closed by the insertion of a double sliding pin. Another object decorated with a *repoussé* pattern is a magnificent bronze horn discovered at Loughnashade, Co. Armagh (Fig. 35). Its long slender curved tube, made of sheet metal, is a marvel of technical virtuosity in riveting, the seam being shut by a bronze strip fastened by more than six hundred of them. The wide flange around the mouth bears an unusually symmetrical design which illustrates the equilibrium between the motifs and the surrounding space which is such an important feature of the style (Fig. 37).

This is apparent to an even greater degree in a fragmentary bronze object, known, after the nineteenth-century Irish scholar who once

Fig. 35. Bronze horn, Loughnashade, Co. Armagh. L. along chord of curve 127 cm. 1st cent. B.C.

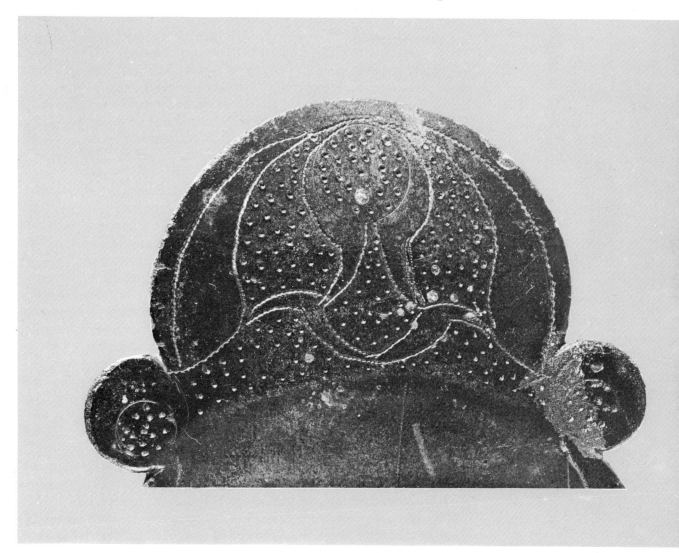

owned it, as the 'Petrie Crown' (Plate 13). It now consists of four shield-shaped segments which form a sort of frieze, to the outer face of which two larger concave discs are attached, a tall cone rising behind one of them. Whatever its purpose, it was, obviously, intended to be fastened to something through the row of small holes along the upper and lower borders of the frieze. The ornament which it bears was executed neither by the *repoussé* technique nor by casting but by the laborious process of tooling away the surface of the bronze to leave the pattern standing in relief. All the components are decorated, the principal motif being a very elongated trumpet-pattern with lentoid bosses at the junction of the units and with expansions at the free ends in the centre of the spiral turns. Terms like decoration and ornament, as ordinarily used, are largely meaningless when applied to the spare patterns in which these

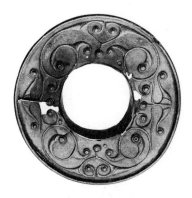

53

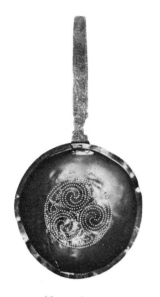

Fig. 38. Above: Bronze strainer with iron handle, Moylarg, Co. Antrim. L. 21·2 cm. 7th–8th cent. A.D.

motifs are here arranged. To compare with them the Bronze Age art which preceded them or the Early Christian art which followed them is to make both of these appear barbarous: the former because it seems merely to add one thing to another in a childlike series; the latter because it seems, in general, to lack self-control. In fact, however, the comparison with either is impossible, since the pattern on the Petrie Crown is not decoration as the Bronze Age or Early Christian artists understood it but by a study in rhythm. It is this disengagement from all appeal to the sensuous eye which gives the object so much of its cold esoteric beauty.

Closely akin to the Petrie Crown are three hollow bronze cones in the Cork Public Museum which were found deep in river mud in that city in 1909. The decoration of spirals and slender trumpet-patterns is confined to the bases of the cones and, like that on the Crown, it was produced by tooling away the surface of the surrounding metal. A small bronze disc, in the Ulster Museum, Belfast, which was found in the River Bann near Coleraine, Co. Derry, bears a design in relief executed by the same technique. It is a triskele with sweeping spiral arms, having at its centre a smaller triskele with tightly wound limbs, all the lines being composed of elongated trumpet-patterns. Designs very reminiscent of those on the discs of the Petrie Crown appear on a number of large bronze discs of unknown function, six of which were found at Monasterevin, Co. Kildare. They are balanced about large saucer-shaped hollows located eccentrically on the discs but the conspicuous relief of the trumpet-patterns and spirals of which they are composed is repoussé.

The scope of the La Tène artist's work was not confined to monuments, items of personal ornament or objects of parade, for we find such things as bridle bits also decorated with his motifs (Figs 39, 42). Nor was the expression of his talent restricted to surface ornament, for he was equally sensitive to controlled elegance of shape. His accomplishments in the treatment of form are particularly obvious when, as in the case of bridle bits, he is dealing with articles of slender propor-

Fig. 39. Below: Three-link bronze bridle bit, Attymon, Co. Galway. L. 31·2 cm. 3rd–4th cent. A.D.

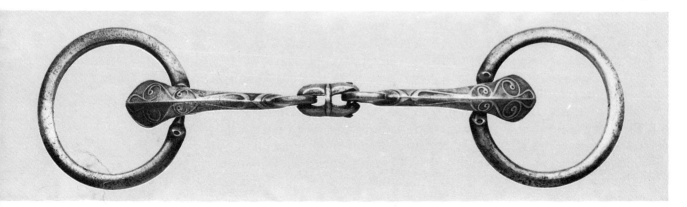

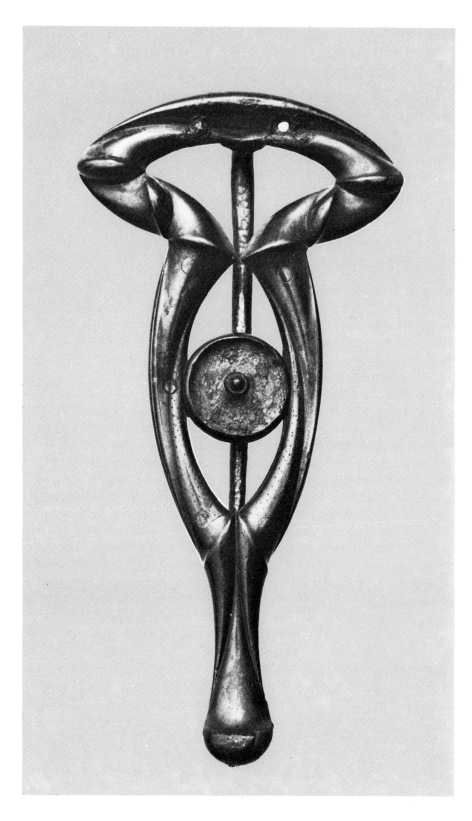

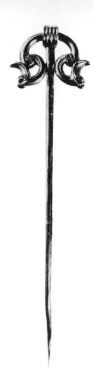

Fig. **40**. Left: Bronze brooch, Navan Fort, Co. Armagh. The central disc was originally filled with red enamel. L. 10 cm. 1st cent. B.C.

Fig. **41**. Above: Silver 'omega' pin, so named from shape of head, Aran Islands, Co. Galway. L. 9.6 cm. 1st cent. A.D.

Fig. **42**. Below: Human face on end of link of bronze bridle bit, find-place unknown. *c.* 300 B.C.

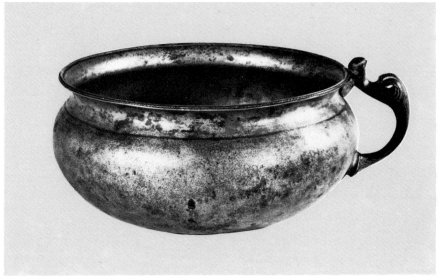

Fig. 43. Above right: Bronze cup, Keshcarrigan, Co. Leitrim. D. 14·5 cm. 1st cent. A.D.

Fig. 44. Above: Bronze brooch with central panel of broad ribbon interlace, Ardakillin, Co. Roscommon. L. 7·6 cm. 6th–7th cent. A.D.

tions, the limited surfaces of which force him to concentrate for his effects on modulations of outline and the interplay of small planes. This is well illustrated by small bronze brooches of the safety-pin type, known as fibulae, like the specimen from Navan Fort, Co. Armagh, to the assured graceful outline of which the sculpture of the surface adds a strength and richness unexpected in an object of such delicate structure (Fig. 40). Another kind of pin which, from the resemblance of its head to the Greek letter of that name, has been called the 'omega' type, exhibits, perhaps, an even greater sophistication in the manner in which the minute variations of its surface are integrated into its crisply scalloped outline (Fig. 41). The same instinct for grace informed by strength is even more perceptible in a bronze cup from Keshcarrigan, Co. Leitrim (Fig. 43). The summary contour of the body, spreading volume over width rather than allowing it to sag in depth, complemented by the unhesitating incurve of the neck and the sharp eversion of the rim, give its shape an air of predestined rightness. Decoration is pared down to a single zig-zag line on the rim, a groove encircling the neck, and the delicately contoured bird-headed handle. No better example of the almost obsessive preoccupation of the craftsmen of the time with their curvilinear motifs can be found than a bronze strainer with an iron handle from Moylarg, Co. Antrim, where the holes in the bottom have been punched to form a design of spirals and trumpet-patterns (Fig. 38). A very beautiful bronze brooch from Ardakillin, Co. Roscommon, which probably dates to the sixth or seventh century, with spiralling Iron Age *repoussé* curves at its ends and a band of broad ribbon interlace on its bowed centre panel, may serve to lead into the Early Christian period in which interlace became more and more the vocabulary of artistic expression (Fig. 44).

EARLY CHRISTIAN PERIOD

General Introduction

reland was converted to Christianity in the fifth century, the most notable of the missionaries being the Romanised Briton, St Patrick. The Irish society to which he preached the new faith consisted of a warrior aristocracy and their free followers, together with an unfree population, possibly large. While agriculture played its part, the economy seems to have been predominantly pastoral and cattle the chief form of wealth. Although there were a number of over-kings, the essential major unit of society was a comparatively small group headed by a king elected from among the members of the ruling family. This social system was unfavourable to the organisation of the Church on a strictly territorial basis and this factor and the spirit of the age encouraged the growth of monastic settlements in the succeeding centuries.

To these monastic communities, flourishing under the patronage of local dynastic families, the development of Early Christian art is, in large measure, due. They had to meet out of their own resources the demand for books for study and recitation of the monastic office and divine service; this ultimately entailed the establishment in, at least, the larger monasteries of scriptoria, where trained scribes devoted themselves to the multiplication of the required texts. It is probable, too, that the monasteries had to make provision for supplying the vessels and other articles necessary for church and altar use and that some members of the community specialised in metalwork, although they may also have employed lay craftsmen for this purpose. As a result of the closer contacts with Europe made through the agency of the Irish missionary monks of the sixth and seventh centuries, scribe and craftsman became acquainted with new artistic styles and motifs, which they adopted, developed and made their own, blending them with the surviving Iron Age artistic tradition to produce an art which, in all its essential features, continued to be characteristic of the country till the twelfth century. It remains to us in a few manuscripts and a very considerable amount of stone sculpture and metalwork but there is evidence to show that it also found expression in such more perishable media as wood, leather and textiles.

One of the most fundamental characteristics of this art is that it is

largely non-representational in the letter and almost wholly so in the spirit. Where representations of human beings occur, as in the comparatively rare examples in the manuscripts and the relatively abundant ones on the high crosses, their presence is due mainly to foreign tradition and hardly at all to any spontaneous sympathy on the part of the artist. The manuscript figures have no bodies under their clothes and the anatomy of their hands and feet and even of their faces is quite capricious. Although exceptions do occur on some of the high crosses, e.g. that of Muiredach at Monasterboice (Fig. 117), the attitude to and treatment of the human form remain essentially the same from the beginning to the end of the period. This will be evident from a glance at a series of figures spanning the Early Christian centuries, e.g. the Matthew symbol in the Book of Durrow, 7th century (Fig. 49), the St John's crucifixion plaque, late 7th or early 8th century (Plate 32), the Aghaboe gilt bronze figure, 9th century (Fig. 45), the Cloyne mount, 11th/12th century (Plate 34), the figure on the Dysert O'Dea cross, 12th century (Fig. 120), and a gilt bronze shrine-figure, 12th century (Fig. 46). This traditional attitude persisted to even later times, in spite of the strong outside influences at work in the country.

While the art abounds with animal forms, portrayals of real animals are comparatively rare. Apart from birds, which generally maintain a tolerable resemblance to reality, the majority of the animal forms consist of imaginary creatures, executed with a freedom and verve, contrasting so markedly with the lifelessness of the real animals depicted that there can be no doubt which kind afforded the better scope for the artist's creative faculties. Representations from the vegetable world hardly occur at all, the most coherently naturalistic ones being, perhaps, some renderings of the vine in the Book of Kells. In sculpture, both the vine and the Tree of Knowledge are sometimes so closely adapted to patterns of spiral decoration that only a gesture remains to indicate their real nature. At best, the Tree appears as a drastically conventionalised symbol (Plate 38, Fig. 117). The real preoccupation of the artists of the Early Christian period is the vast repertoire of abstract patterns which, in unlimited variation and combination, they exploited to the uttermost.

These patterns may be divided into two main groups, one derived from Iron Age motifs, the other of mixed Mediterranean and North European ancestry. The first group was ultimately La Tène in inspiration, its chief motifs being the trumpet-pattern, with its accompanying pointed oval or lentoid boss, the spiral, the triskele and the stylised palmette. In their Irish environment these motifs underwent developments and modifications. The trumpet-pattern became elongated and slender and the spiral was conjoined with others in symmetrical groups or running scrolls (Figs 57, 99). Its coils were doubled or trebled and their ends provided with thick lobes which interlocked in the centre of

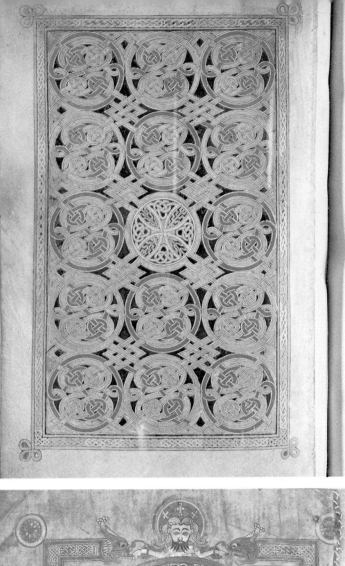

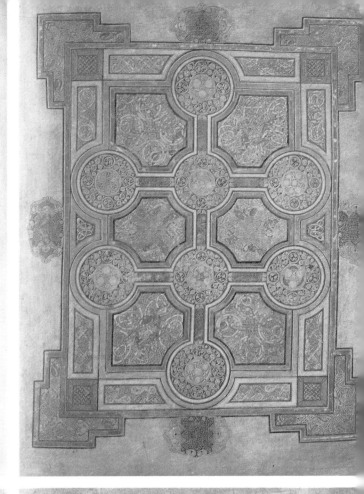

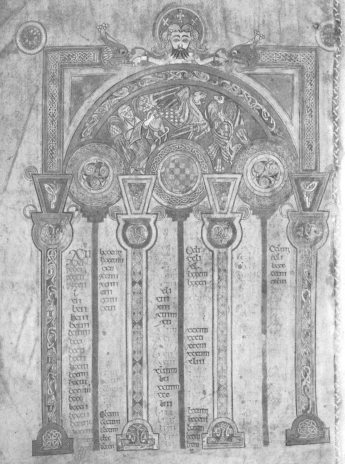

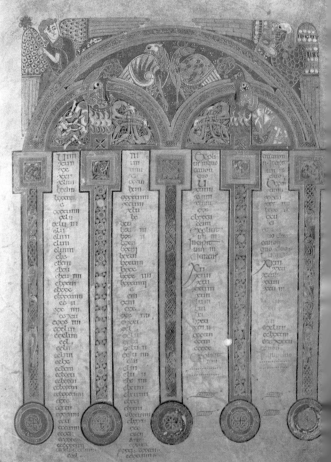

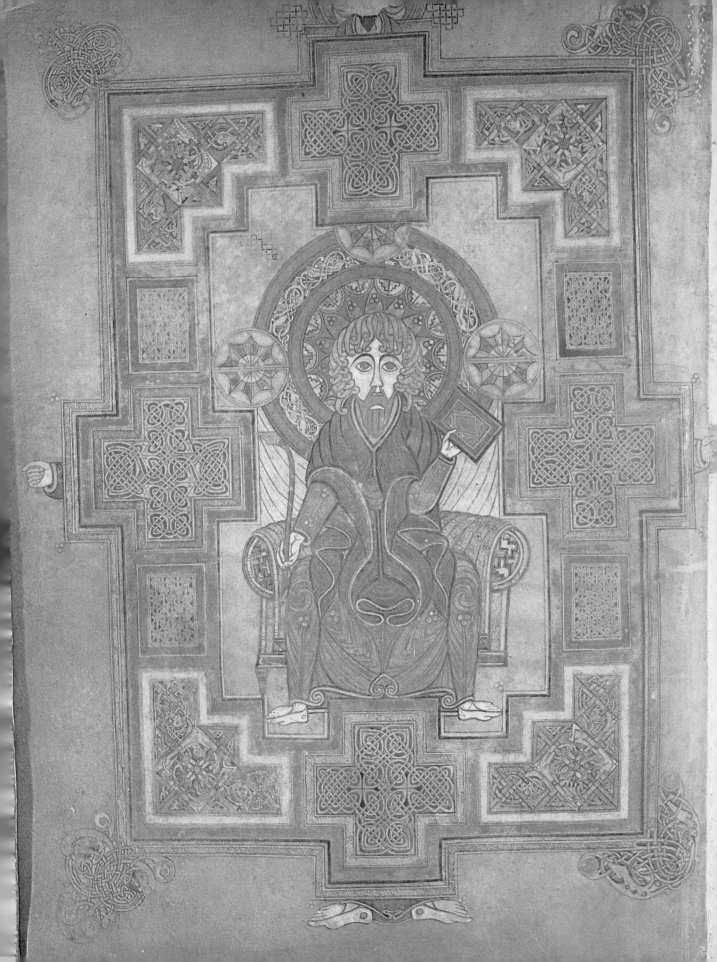

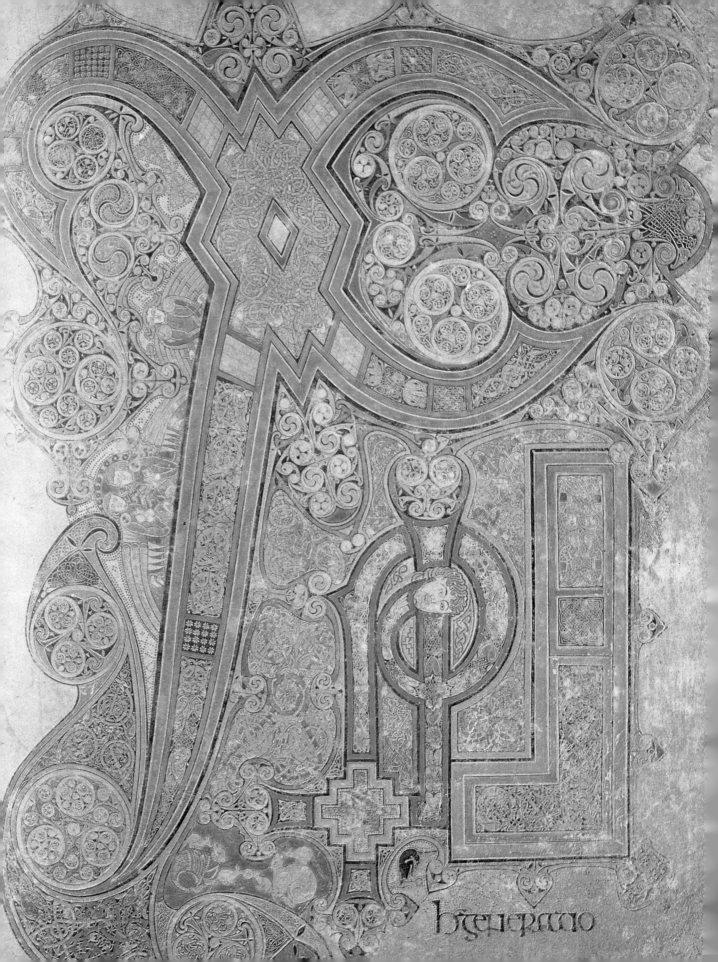

higenatio

the design to give a livelier focus of attention to the eye. The triskele, lithe and sprightly compared with the sluggish coils of the spiral, was a favourite motif, especially on metalwork, lending itself to infinite play of fancy in the sinuous or angular contortion of its limbs (Plate 14, Figs 59, 67, 101). By itself or in combination with one or more of the others, any of these motifs may be multiplied as the components of a larger composition, the total impression of which is utterly different from that of its unit parts.

The second main group of patterns consists of interlacements of different types. The most straightforward of these is the ribbon inter-lace derived from the Mediterranean world, in which single or double strands of uniform width are woven into a bewildering variety of designs, open or close, simple or complicated, adapted with the utmost ingenuity to fill any space of any shape at the disposal of the artist with a uniform overall texture or one divided up into subsidiary patterns to enrich the visual effect. On the metalwork this interlace is sometimes carried out in the 'Kerbschnitt' technique, originally derived from wood-carving, whereby the strands were left in relief by removing the surface of the material between them with sloping chisel-cuts. In metal this is achieved by casting (not cutting) and the result is a honeycombed surface in which, in some cases, the pattern of the shadow-filled hollows dominates that of the interlace itself, a striking instance being on the stem of the Ardagh Chalice (Plate 29). The second type of interlace is of North European affinities and consists of animals with relatively broad ribbon bodies, convoluted spirally or drawn out into undulating curves and furnished with long slender limbs which inter-weave with the turns and twists of the writhing body. Narrower filaments, sprouting from the animal's head, are twined and threaded in a freer and looser mesh through the maze formed by the limbs and body. However inadequate words may be to convey a true impression of a single individual of the species, they fail utterly to describe the creatures as we find them in their normal environment, for only exceptionally are they found solitary. Long closed processions of them progress around the borders of pages and panels (Fig. 47), a line of them moves across a frieze, clusters of them, inextricably interlocked, inhabit nooks between other elements of the decorative scheme or assume strictly symmetrical positions to fill panels, square, rectangular, triangular or round (Plate 18). In most of these contexts the creatures do not subsist as separate individuals, since their bodies and limbs have no function except to interlink with those of their fellows to form a pattern which exists at two levels of vision: what appears to the lazy eye as a repetitive mosaic of broken segments becomes to the alert one a perpetual motion running in endless circuits. But beasts with serpentine bodies are not the only genus of creatures to be found in these designs, for they may yield place to birds, sometimes with all their natural

Plate 19. Overleaf: Book of Kells: St John, fo. 291 v.

Plate 20. Opposite: Book of Kells: Chi-Rho monogram, fo. 34 r.

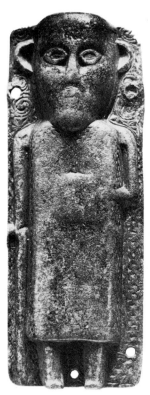

Fig. 45. Gilt bronze figure of ecclesiastic with book and crozier, Aghaboe, Co. Laois. Much worn but traces of decoration on garment can be seen under the chin. The head is flanked by spiral patterns and the body is framed by ribbon interlacements. H. 13 cm. 9th cent. A.D.

characters preserved but warped into strange postures, sometimes almost gruesomely dissected to nothing but heads, claws and a few feathers. In the manuscripts, particularly in the Book of Kells, even the human body is, occasionally, treated as some infinitely ductile substance, to be drawn out and wound upon itself as space demands or caprice suggests (Plates 18, 23) while in the manuscripts, on the metalwork and in the sculpture, as on crosses at Ahenny, Clonmacnoise, Monasterboice and elsewhere, we find panels of ornament formed by interweaving the enormously elongated legs and arms of human figures (Figs 77, 119).

The bare statement of some of the foundation elements of Irish design conveys no real idea of the illimitable field of opportunity so eagerly exploited by scribe, metalworker and sculptor in the combination of these and other motifs in patterns disciplined by the confines of set compartments or streaming over the surface in a riot of invention. To marry with these rhythmic motifs they could, when fitness demanded it, call upon a formidable reserve of static ones: frets, diapers and mosaics. In the first half of the Early Christian period, the archaic Iron Age motifs of spiral and triskele were freely incorporated with the new inspirations from abroad but they disappear from the art of objects attributable to the last phase of the period, while the interlaced ornament of that time betrays by various nuances an echoing of style back and forth across the seas via the Viking settlements in Ireland and much of the interlace shows strong influence from the Scandinavian Urnes type.

This art found, naturally, its freest outlet for expression in manuscript illumination, achieving its most ecstatic proliferation in the Book of Kells, and in the illuminations there is added the interplay of the colours which load every detail to lend another dimension to the spectator's wonder. While the exuberance of the manuscripts is circumscribed in the contemporary metalwork by the limitations imposed by the nature of the medium, the craftsman brought all his resources of knowledge and skill to bear on the task of transcending those limitations. By schooling his hand to working to a scale almost incredibly minute and by utilising granulation, filigree and other techniques to magnetise light and shade on to his surfaces in microscopic distribution he did, in cases like the Ardagh Chalice and Tara Brooch, triumphantly succeed. Over a thousand years of exposure to the weather has taken its toll of the surface detail of the stone sculpture but those portions which have fared best in sheltered positions retain, even yet, enough of their original character to show that, in many instances, a courageous attempt was made to transfer to stone the intricate patterns of the manuscripts and the metalwork (Figs 110, 117).

Impersonal though this art may be, the appreciation of much of it in the original manuscripts and metalwork is a highly personal experience

in one respect at least, for it is so incredibly small and intricate that two persons cannot see it simultaneously in all its finesse (Plates 20, 27, Figs 63, 64). Indeed, the best of it had to await the invention of enlarged photographs before it could be seen adequately, steadily and in entirety. In this respect, the enjoyment of the originals of many of the masterpieces in these two media remains eternally private, collective appraisal of the art being possible only when its translation to stone makes the reproduction of its patterns on a larger scale inevitable. If ever, too, 'art for art's sake' was true of anything, it is true of much of this art, which calls for something of the same patience and concentration on the part of the viewer as the execution of it did on the part of the artist and the scrupulous perfection of the smaller details of which is lost to the average eyesight. The workmanship lavished on the back of the Tara Brooch, which was invisible when the brooch was in wear, and on the underside of the foot of the Ardagh Chalice, which must have met the eye on few occasions, is another aspect of the same attitude of mind (Plates 27, 30). It is as if there was no concept of objects having a 'back' or an 'underside' in the pejorative sense of these words in Early Christian Ireland and that things were made, not to stand on or against a surface but to occupy a point in free space where they could be viewed from every angle.

Indeed, the very existence of the art raises sociological and psychological problems as yet unsolved for if, on grounds of sophistication and detachment, any art deserves to be called aristocratic, this one surely does, but nothing which can be gleaned from literary texts or which has been disclosed by archaeological excavation could be further removed from any idea of palace and courtier than the picture of essential rusticity in habitation, precinct, food and day-to-day preoccupations of the Ireland of the time which emerges from these two sources. On the ecclesiastical side, the same mysterious contrast presents itself between the monumental accomplishment of the high crosses and the wattle-and-daub monastic cells which, as far as we can gather from existing information, formed their immediate environment, and between the spacious extravagance of the illuminated manuscripts and the diminutive churches of wood or stone which housed them. One obvious escape from the dilemma is an admission that preconceptions about the social conditions prescriptive for the emergence and flowering of an art like this, which are founded on what we know about ancient Sumeria and Egypt, Greece, Rome, Constantinople or Florence, are not necessarily valid for ancient Ireland.

Paradoxical as it may seem, this art is very much a reflex, if not of life, then of thought and mode of thought in ancient Ireland. The people to whom its patterns were a daily visual experience were experiencing verbal and mental patterns of very much the same kind in the prose and verse of the contemporary storytellers and poets, for the ancient litera-

Fig. 46. Gilt bronze figure of ecclesiastic with mitre and crozier, probably from a shrine. Find-place unknown. H. 18·7 cm. 12th cent. A.D.

ture, in all its forms, is in many respects of one piece with the art. The following is a description of a house in the royal fort of Cruachan from the tale called *Táin Bó Fraích* or the 'Cattle Raid of Fraech': 'The manner of that house was this: There were seven companies in it; seven compartments from the fire to the wall, all round the house. Every compartment had a front of bronze. The whole was composed of beautifully carved red yew. Three strips of bronze were in front of each compartment. Seven strips of bronze from the foundation of the house to the ridge. The house from this out was built of pine. A covering of oak shingles was what was upon it on the outside. Sixteen windows was the number that were in it, for the purpose of looking out of it and for admitting light into it. A shutter of bronze to each window. A bar of bronze across each shutter; four times seven *ungas* was what each bar contained.' The cloud of details which never crystallises into a picture, the symmetry in whole and in part, the balanced numbers and the curious selection of certain details for particular emphasis make this description the verbal counterpart of a panel of abstract ornament. Landscape and living things, too, exist as manipulations which bear only incidental relation to reality, as, for example, in the following passage from the story of a voyage performed by two of St Columba's monks: 'And after weariness of voyaging they sighted an isle. Thus was the isle: with a single great and stately tree therein, having a frame of silver and golden leaves upon it, and its summit spread over the whole isle. And thus was that tree, with every branch and every bough that it put forth quite full of birds with wings of silver. In the top of the tree was a throne with a great bird thereon, and on that bird a head of gold and wings of silver.' In so far as natural things are represented in the manuscript illumination and the metalwork, this description, with all its disregard of natural colours and proportions, might well refer to something executed in either medium. Far from being exceptional, these two quotations are typical of the manner in which everything is treated in the great bulk of Irish literature. It would not be an exaggeration to say that in many respects Irish art and literature are two aspects of the same thing: a fundamental compulsion to pattern in the Irish mind. They are not the only aspects of it. The fantastic elaboration of the early syllabic metres and the complex assonantal schemes of the later poetry, both of which made the thing said of far less moment than the manner of saying it, are one in character with the art. Perhaps the most striking example is Irish dancing, which is not a native institution at all but evolved from imported models in recent centuries into highly complicated patterns of steps, the mathematical sophistication of which is utterly unlike the loose patterns and freer rhythms of European folk dancing in general.

The perfectionism and technical adroitness which are so apparent in Irish art in all its manifestations may have their roots in yet another

national characteristic. Everywhere in the country and in all ages there has been a common tendency to defer to the specialist. In the ancient schools of poetry, we are told, there was a long progression from neophyte to master through a series of grades, for each of which there was an exact specification of the numbers and types of tales to be studied and memorised. Society itself, if we are to believe some of the ancient legal tracts, resembled a textbook diagram of an ideal geological stratification, being divided precisely into a hierarchy of ascending orders of nobility, in respect of each of which there is given an exhaustive valuation of one of its members: his honour-price, the size of his house, his dress, the capacities and types of his domestic vessels, the numbers and kinds of his tools, agricultural implements and livestock. Even if we choose to regard these highly regulated systems of poetic apprenticeship and social organisation as mere legal fictions, the very fact that there were people with a passion for classification engaged in thinking them out and that there must have been others ready and willing to discuss their theorising with them is indicative of the existence of a mental climate in which specialisation breeds. But its existence is not just a matter of inference, for specialisation is self-evident in the great corpus of law tracts which has come down to us, in the variety and complexity of the verse metres, in the many styles of literary composition, in the long genealogical lists, in the topographical treatises, in the different kinds of craftsmen who are mentioned and in the particulars which are given of their separate skills, in the grades of musicians, and in the countless references to individuals who are described as masters of some particular acrobatic feat, sleight-of-hand or other physical or mental proficiency. Indeed, throughout the whole range of Irish literature we find, in general, that a person is described and distinguished from his fellows, not in terms of his personality or character or even of his bodily appearance but, primarily, in terms of some individual mental or physical accomplishment. He is, in fact, presented to the audience as a specialist. There was no room for the amateur in Irish society, for the Irish view admitted only different degrees of specialisation. In this atmosphere the specialist, caught between the pressures of public opinion and of his own self-esteem, had no course open to him but to specialise the more. This is reflected in the art of Early Christian Ireland at all levels and in all media. The assurance of the specialist master pervades it and traces of the apprentice hand are very rare.

Illuminated Manuscripts

anuscripts were written on vellum prepared from calf-skin, those intended for everyday use being of comparatively small format. The earliest extant is a copy of the psalter, measuring about 18 cm. by 12 cm. It probably dates to the second half of the sixth century and is mentioned on several occasions in the Irish annals since it was the custom among the O'Donnells of Co. Donegal to have it carried round their army on proceeding into battle as an insurance of victory. From this circumstance it was called in Irish the *Cathach*, a name which can be roughly translated as 'The Battler'. It contains fifty-eight folios written in the Irish semi-uncial script and decoration is restricted to some sixty-four initial letters. The colours employed are red and brown, dots of the former colour being freely used to outline the letters. Spirals and trumpet-patterns appear among the motifs but the illumination is rudimentary and its interest is historical and technical rather than artistic.

Stimulated by foreign exemplars, or derivatives of them, reaching the country through the medium of contacts established in Britain and continental Europe by the Irish missionary monks in the sixth and seventh centuries, the monastic scriptoria began to produce large and sumptuously decorated texts. The very existence of the few surviving specimens and the elaborate nature of these presuppose that there must have been many more which have been lost. The earliest in existence in Ireland is the copy of the gospels known as the Book of Durrow, which is dated to the second half of the seventh century and takes its name from Durrow, Co. Offaly, where the site of the ancient monastery with which it is associated is still marked by the presence of a high cross and a number of decorated grave slabs. It contains 248 folios and the Irish majuscule script in which it is written shows the high development which Irish penmanship had already attained. Each gospel is prefaced by the symbol of its author and a full page of ornament, and the opening words of the text itself are enlarged and decorated. There are four other illuminated pages, making a total of eleven full pages in all. The colours used are red, green, yellow and brown. Three categories of motifs make up the ornament: spirals, trumpet-patterns, triskeles and pointed ovals, representing the La Tène heritage, ribbon interlace from the Mediterranean area, and animal interlace from Northern Europe.

The first page in the Book of Durrow is typical of many of the full-

Fig. 47. Book of Durrow:
fo. 192 v. *c.* 650 A.D.

page illuminations in the manuscripts of its family. They present one unbroken sheet of ornament arranged in a more or less symmetrical overall design and they are, for this reason, generally termed 'carpet pages'. The cruciform pattern which occupies a central position on another Durrow page is also typical, being found, for example, in the Book of Kells (Plate 16). A third Durrow carpet page bears a symmetrical design of interconnected circles of ribbon interlace, surrounding a central roundel containing an equal-armed cross with expanded ends (Plate 15). The long rectangular panels of step-pattern, embedded in a spread of ribbon interlace, which appear on yet another of these pages, provide a more diversified, if not a more artistic design. These two last pages also show the beginnings of the corner ornaments of the frame which were to attain such luxuriant magnificence in the later Book of Kells (Plates 16, 19, 21). A new element is introduced in a fifth carpet page where, except in the central medallion, the decoration is entirely zoomorphic, the top and bottom being filled with two panels of broad-bodied intertwined beasts and each side with a procession of three, which fasten on each other with their long flexible jaws (Fig. 47).

Both the ribbon and the zoomorphic interlace of these carpet pages are competent but uninspired – the former heavy and slack, the latter devoid of movement. It is curious that by far the freshest and liveliest decoration in the manuscript is that which is composed of the most archaic elements: a large panel of spirals, set within a border of interlace, now incomplete owing to the mutilation of one end of the page (Plate 14). The circular knots of interlace, with their inner pattern of small round loops, seem designed to echo the structure of the central mass of spirals. The spirals are framed by trumpet-patterns, and the deft precision so evident in the drawing of their whirling cores is in marked contrast to the laborious exactitude of the interlace which surrounds them. A threefold arrangement of the motifs in the spirals is repeated over and over again; in the two uppermost spirals it bears a striking resemblance to the design in a silver panel in the Moylough belt-shrine described later (Fig. 66). Perhaps the most imaginative handling of decorative motifs in the book is to be found in the enlarged letters of the opening words of each gospel which, in some cases, diminish in size from the initial inwards. The orthodox contours of the letters are retained but spirals, interlacing and trumpet-pattern are added and inserted. The letters appear against a background of red dots, a device which has a corresponding version in metalwork in the stippled frieze enclosing the letters incised on the Ardagh Chalice (Plate 29, Fig. 64).

A full page is devoted to the symbol for each evangelist, the symbol occupying the centre of a field within a wide border of ribbon interlace. The three animal symbols, all shown in profile, exhibit no trace of naturalism. Limbs, heads and tails are drawn as separate entities so that the creatures appear to have been fitted together from a number of

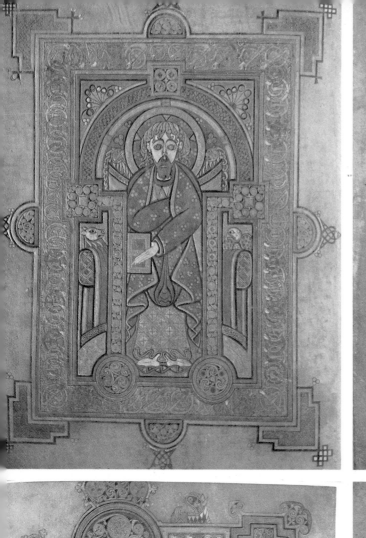

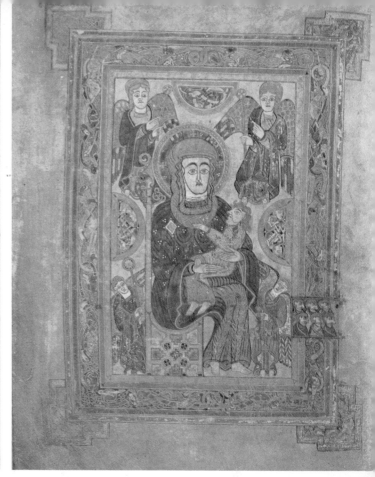

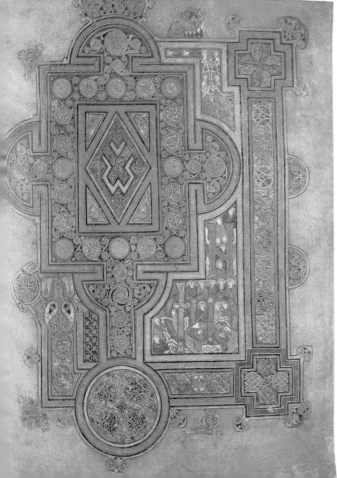

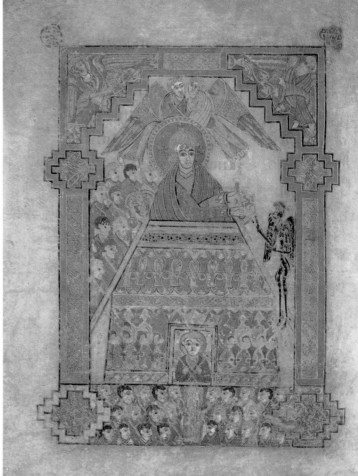

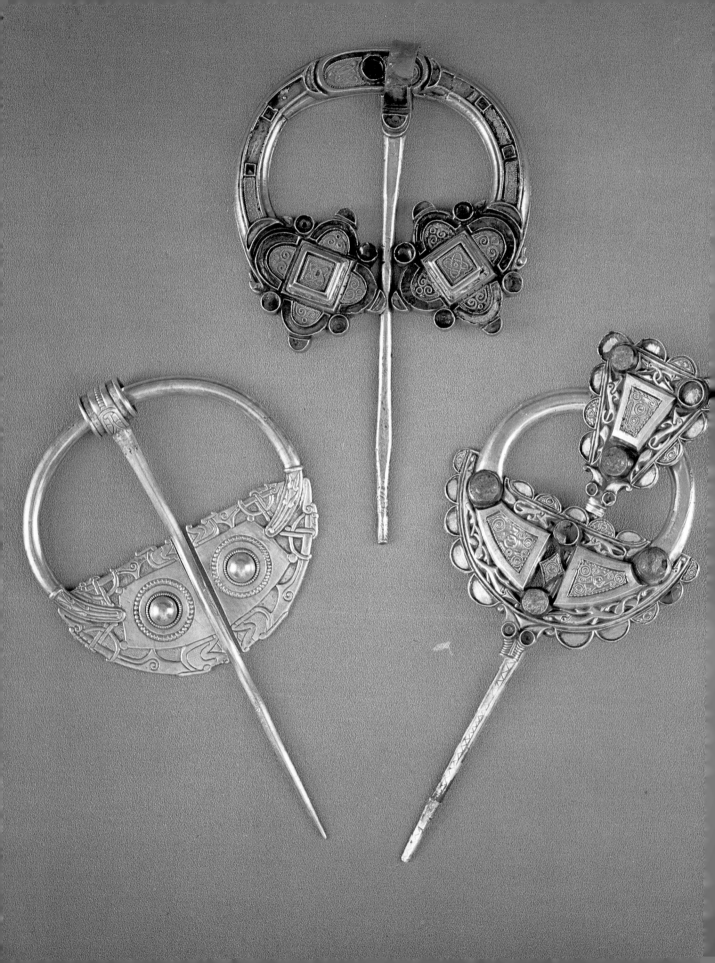

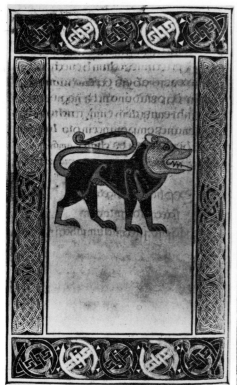

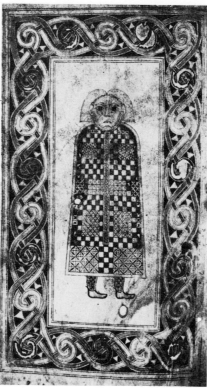

Fig. 48. Far left: Book of Durrow: fo. 191 v., symbol of St Mark.

Fig. 49. Left: Book of Durrow: fo. 21 v., symbol of St Matthew.

parts (Fig. 48). Conventionalisation is taken still further in the case of the man symbolising St Matthew (Fig. 49). The neckless head is pure geometry, no arms are shown, the long cloak is absolutely rigid in surface and outline, while the incongruous hint of reality in the profile legs and feet turns the heraldic into the grotesque. Yet this strange figure, with its ears set high on the head, is very much part and parcel of the Irish artistic tradition. Even more drastically schematised, it reappears in force on the high cross of Moone (Figs 113, 116) and variants of it can be seen on an unlocalised fragment of a bell-shrine (Fig. 68), on a cruciform bronze mount from Cloyne (Plate 34) and on the top of the bell-shrine known as the *Corp Naomh* (Fig. 70). It has been suggested that the head of the Matthew symbol shows the Celtic tonsure crossing the front of the head from ear to ear and that the chequer-board pattern on its cloak derives from millefiori glass or from tile patterns copied from Roman floors in Britain.

From about the second half of the eighth century there comes an illuminated manuscript, in comparison with which the Book of Durrow appears like the effort of a promising apprentice and its sister codex, the Lindisfarne Gospels, the work of an able and conscientious but completely uninspired master. This is a copy of the gospels known as the Book of Kells. It is written on vellum in the Irish majuscule script and

Plate 25. (Opposite) Left: Silver brooch, Drimnagh, Co. Roscommon. D. 9·5 cm. 9th cent. A.D. Middle: Silver brooch, Kilmainham, Co. Dublin. D. 9·5 cm. 8th cent. A.D. Right: Silver brooch, Roscrea, Co. Tipperary. D. 8·5 cm. 8th cent. A.D.

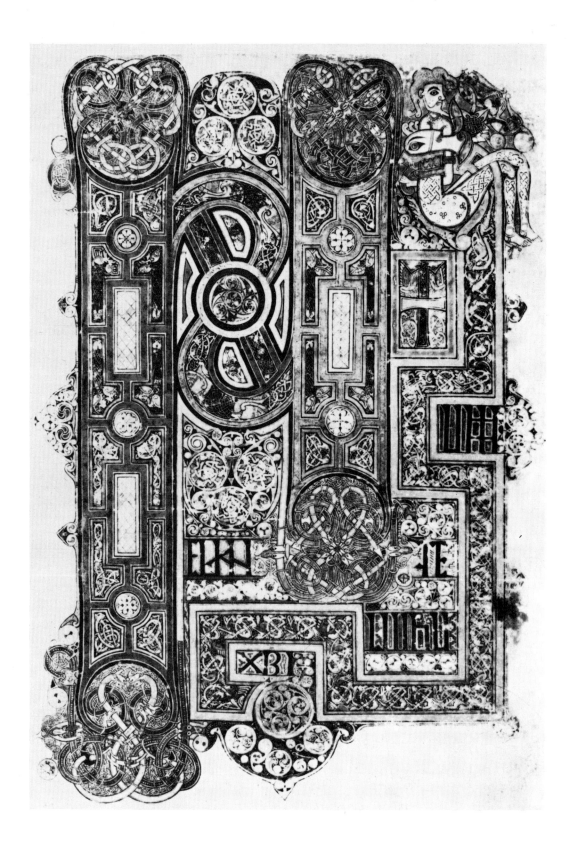

340 folios survive. They now average 330 mm. by 250 mm. but as they were unfortunately trimmed by a bookbinder about 150 years ago there has been a considerable loss to the original margins. The text is written in black ink, and a variety of colours, including reds, blues, yellows and purples, are employed in the illumination. Ruled lines ensure the regularity of the script which, in general, runs across the page, although in a few cases double columns are used. Contractions are rare, but where a gap would have occurred at the end of a short line, matter from the line below is sometimes lifted to fill it, a slanting line, an animal or a symbol being inserted to indicate that the words which follow it are to be read as a continuation of the line below. Numerous devices are employed to keep the right-hand margin of the text intact: ornament may be inserted, letters drawn out of shape or written sideways or even above or below the line.

No surviving manuscript approaches the Book of Kells either in the elaborate nature of its general scheme of decoration or in the richness and variety of its details. The Eusebian canon tables which are prefaced to the sacred text are framed in an architectural setting of columns and arches (Plates 17, 18). Each gospel is introduced by a portrait of its author or some other figure (Plates 19, 21), together with a page showing the symbols of the evangelists, and another page having a gigantically enlarged initial letter surrounded with ornament in which the remaining letters of the word are capriciously embedded (Plate 23, Fig. 50). There are, in addition, other full pages of illumination scattered throughout the text. Full-page illumination on this lavish scale constitutes, however, only a fraction of the decoration for the initial letter of each paragraph, frequently numbering three or four to a page, is also decorated while quadrupeds, birds, floral motifs, geometric devices and calligraphic flourishes are liberally dispersed in and between the lines of text. Although the manuscript contains such a wealth of decoration, the original plan of illumination envisaged something even richer, for pages destined for ornamentation have been left blank and unfinished portions occur in some of the most magnificent pages.

In her analysis of the decoration Françoise Henry apportions it among a number of illuminators whose individual styles and preferences for certain modes of treatment are detectable in it. The Eight-Circle page (Plate 16), the Chi-Rho monogram (Plate 20) and the initial pages of all the gospels, except that of Luke, are, apparently, the work of one man whose gifts for fantasy found expression in the infinite multiplication of the minutest ornament, with a special predilection for the spiral in every conceivable combination with other motifs. He filled roundels, borders and isolated rectilinear panels with ribbon and animal interlace of such incredible delicacy that the unaided eye is quite incapable of appreciating its microscopic perfection and

Fig. **50**. Opposite: Book of Kells: fo. 130 r., initial of St Mark's Gospel. *c.* 800 A.D.

75

intricacy. He had a peculiar genius for grappling with spaces of irregular or curvilinear shape, peopling them so brilliantly with motifs of minute but contrasting size, arranged with such endless invention, that they seem to be in a state of perpetual vibration.

To another illuminator have been ascribed the portraits of the evangelists (Plates 19, 21) and the *Quoniam* page at the beginning of St Luke's gospel (Plate 23). The portraits illustrate the overpowering strength of the native tradition which has transformed into dehuman-ised symbols the naturalistic figures from which they have, directly or indirectly, been derived. The faces are rigid hieratic masks, all con-structed to the same formula, and the hair is treated as pure decoration and sometimes frankly as interlace. The folds of the drapery exist as patterns which bear little relation to the natural folds or fall of cloth. In one instance, for example, the scalloped margin of a tunic is totally inconsistent with the stiff mathematical trellis which covers its surface (Plate 21), and in another a fold of cloth elevates its edge in defiance of the force of gravity. The architectural niches in which the figures on these two pages are seated have no real existence. Their columns have functionless circular bases integrated into the border of the picture, as are the imposts of the arches. Nor are the figures in any rational spatial relationship with their setting, for the contours of one are, for the most part, in contact with the adjacent columns (Plate 21), while, in the case of the other, its right foot obtrudes in front of the base of a column and its left shoulder is slightly eclipsed by the top of the opposite one. This ghost of architecture has been altogether abandoned on another page, with an immense gain to the unity of the composition and some approach to reality in the connection between the figure and the chair in which it is seated (Plate 19). This change of setting has not, however, brought naturalism any nearer, for the legs are straddled in completely uninhibited adaptation to the outline of the border and the draperies even more weirdly involuted and the perspective of the feet even stranger than before. In a final break with all antecedents, even the conception of the border as a frame for the picture has been abolished by anthropomorphising it by the addition of feet, hands and head (the last mutilated by the binder's trimming), to transport it completely from the classical world where it began into a Celtic one where real things must first be dismembered and then pieced together again according to a different law. In the absence of manuscripts showing the successive stages of the process, we shall probably never fully under-stand how the hard-won gains of the European pictorial tradition came to be jettisoned so casually by the insular scribes; had they kept them, however, the result might have been pallid and flaccid com-pared with the strange two-dimensional world which they created. Patterns of pattern though they be, these portraits are, nevertheless, endowed with a haunting majesty.

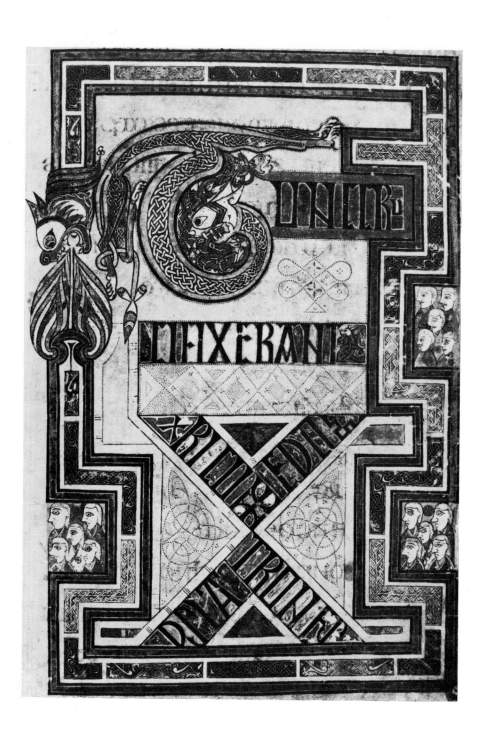

The hand of yet another artist has been detected in a number of other pages, including those of the Virgin and Child (Plate 22), the *Tunc crucifixerant* page (Fig. 51), the scene showing the temptation of Christ by Satan (Plate 24) and the symbols of the evangelists. In some of these pages there is no pretence at erecting an architectural setting and in the first three mentioned even the borders are interrupted: in the first by an inset panel of six male busts; in the second by three such panels and by a great beast breathing flames; in the third by a whole vista of human heads. This artist seems to have had a real interest in people and a desire to impart a personality to his figures. The small profiles in the border panels display a considerable degree of individuality and the faces of Christ and of the two angels above him in the Temptation scene and of the Virgin and her attendant figures are far removed from the depersonalised masks of the evangelist portraits. More surprisingly still, the frozen pose of the evangelists has melted into a suggestion of movement in attitude and gesture, most evident in the angels which surround the Virgin. The Temptation page is one of the few attempts in Irish art, apart from sculpture, to represent a scene, but the treatment is so curious that the subject is not immediately apparent. Christ is shown on the pinnacle of the temple with the winged, black, emaciated figure of Satan below him to the right. The temple takes the form of what was, presumably, an Irish house of the period, a type also reproduced in stone on top of some of the high crosses, e.g. that of Muiredach at Monasterboice (Fig. 117). The roof is covered with ornamental wooden shingles and the walls with decorated boards. The heart-shaped object to the right of Christ and its fellow to his left, which is partly concealed by his hands, represent the gable finials formed by the carved upper ends of the barge boards and which were occasionally reproduced in stone on some of the later churches (Fig. 130). In the middle of the wall the head and shoulders of a figure appear in an opening which may represent either a door or a window. The serried figures below and to the left are intended to depict a crowd of people around the temple. The preoccupation with people and the predominance of natural forms over abstract patterns so evident in this page give it a unique position in the manuscript, it being approached in this regard only by that of the Virgin and Child. It is unusual, too, in revealing a conscious effort at pictorial composition, for the lines of the temple roof and the figure of Christ coalesce in a pyramid which is answered above by the smaller one formed by angels' wings and the slope of the stepped border. Remarkable, also, is the real illusion of height above the throng of people below which is conveyed to the commanding figure of Christ. The man responsible for these pages was, in many respects, a man out of his time, and yet he was so much a part of it that in the top right-hand corner of the Temptation page he could, with an utter disregard for nature, put a vase lying on its side on

the topmost step and trail its flourishing vine down the steps beneath.

A fourth artist is believed to have worked on his own and in collaboration with the others to furnish the book with the inexhaustible variety of its smaller capital letters and the living creatures, real and imaginary, which appear between the lines of text or tucked away in small corners amid a welter of interlace and spirals. His contributions include the two moths which can be seen on the top left of the Chi-Rho page, the cats and mice which appear at the bottom left of the same page, and the otter with a fish in its mouth to the right of them (Plate 20). Their naturalism, which in the art of another country would leave them as tolerably well-drawn commonplaces, makes them landmarks in the uncompromisingly non-representational art of Ireland. Other creatures of an identifiable kind scattered throughout the pages include a goat, a rat, hares, dogs, horses, a domestic cock and hens and fishes. Some of these are quite naturalistic; others, like the cock and hens, are unmistakable in pose and outline but a synthesis of conventional motifs in detail. Some are shown in active movement, like the dog which chases the cat around the contours of an initial, and of the large number of birds which put in an appearance, some are shown in flying or preening postures. By far the great majority of this animal population, however, consists of fanciful beasts in every imaginable attitude, natural and contorted, and all are executed with such virtuosity that, no matter how fantastic their convolutions, the final impression has all the liveliness of a sketch or the gusto of a caricature. To this repertoire of creatures which live a free existence outside the interlacements there must be added a small number of illustrations of human beings, including two men on horseback, a seated man holding a goblet and a standing figure with a book (Fig. 52).

The small capital letters in every page of the text are voluble of the fertile inventiveness of the scribes. The bodies of quadrupeds, birds and humans are wound and laced upon themselves to form the main structure of the letters; their limbs, hair and tongues are entwined to fill the spaces and embellish the contours with delicate rhythmic patterns. Alternatively, the outlines of the letters may be completely orthodox and the spaces they enclose filled with disciplined animal or ribbon interlace or jewel-like insets of purely geometric ornament in step-, fret-, key- or rosette-patterns. Like acts of self-denial among this luxuriance, there occur letters where the spaces are filled only with spreads of colour. It is not uncommon to find letters executed in these various styles following one another on the same page. Every occasion which the text presents for innovation in the treatment of capitals is avidly seized upon. The Generation of Christ, every line beginning with the words *Qui fuit*, is an example. It extends over five pages and all the initials on a page are consolidated into a single column, the letters in the first three pages being treated as animal interlace and in the fifth

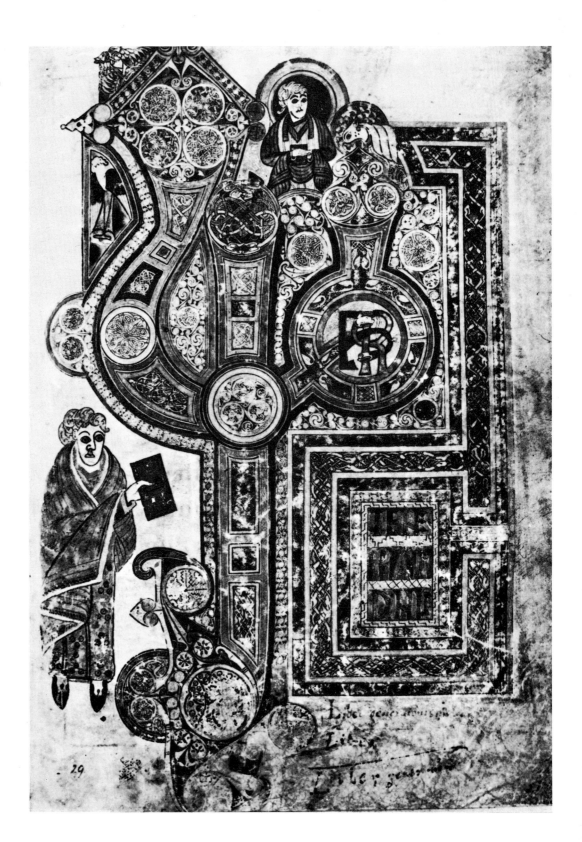

as rectilinear units. The column on the fourth page, however, presents a mixed treatment, the letters at the top being formed of interlaced humans and the remainder of simple outlines of two different kinds. In the Beatitudes page the capital letters are similarly united in a single pattern, the upper four being developed as interlaced humans and the lower four as interlaced beasts.

Formal in design though they be and presenting only a limited surface awkwardly subdivided for decoration, the eight pages of canon tables afford perhaps the most striking illustration of the genius of the Kells illuminators (Plates 17, 18). For the full realisation of this they must be compared with the sixteen pages of canon tables in the Lindisfarne Gospels where, almost without exception, the same pattern is mechanically reproduced on all the columns of each page and where, compared with those of Kells, the individual patterns are nerveless and pedestrian. The narrow shafts of the Kells columns are decorated with designs formed from trumpet-patterns, coils, spirals, step-patterns, and interlace of ribbons, birds, beasts, plants and humans. The panels in the bases and capitals exhibit a similar diversity. The pose and arrangement of the evangelist symbols in the tympana of the arches are alike in no two instances. On one page the four are united in one of the finest figure compositions in the whole manuscript (Plate 17) and on another those of Matthew and John are superbly set above the arch, their wings forming the upper frame, while those of Mark and Luke are poised on the tympanum below with exquisite grace (Plate 18). This latter page heralds, too, the unprecedented feats of imaginative treatment found throughout the illumination in the manner in which the columns under the centre of the arches are projected upwards as the maned necks of two great monsters which seize the tops of the arches between their jaws. On another page the same bold imagination has transformed the inert frame of the tables into a node of dynamic action at the summit, where a strangely beautiful figure with a six-pointed beard grasps the long tongues of two opposed beasts, the tongues knotting themselves around his naked arms (Plate 17). Unlike the Lindisfarne illuminator who was stolidly content to reproduce the same column throughout his sixteen pages, the Kells artist was constrained only by a sense of symmetry into matching those on opposite pages, impatiently changing the design when the page was turned. If he understood columns and arches as architectural realities at all, he was prepared to sacrifice any architectural logic in drawing them to the more imperious demands of his instinct to pattern. By completing the three sub-arches on one page as full circles to accommodate his chequerboard and triskele spiral-patterns he made nonsense of his columns, perhaps without understanding, but certainly without regret (Plate 17). Indeed, his instinct was a far surer guide to successful design than whatever elementary knowledge of classical architecture he may have absorbed from what-

Fig. 52. Opposite: Book of Kells: fo. 29 r., initial letter.

ever source, as can be seen on the last two pages of the canon tables where, abandoning all pretence at a column in favour of something more like a strap, disrupting arch and tympanum with a monster neck and head and, on one page, substituting living forms for the harsh lines of the upper frame, he created two pages more unified, reposeful and beautiful than those preceding them (Plate 18).

The ancestry of the art of the Book of Kells is a very mixed one. Even the most ostensibly native elements in it, the Iron Age motifs of spiral, trumpet-pattern and triskele which had been domiciled in the country for centuries before, have their ultimate source far distant in Celtic Europe. In addition to the animal interlace from Northern Europe and the ribbon interlace from the Mediterranean area, Greek, Syrian and Coptic styles are thought to have influenced it. But no more than a man's character and personality can be evaluated as the end product of his genealogy, no more can the art of the Book of Kells be evaluated as a synthesis of these various elements. A glance at any of its pages is enough to show that questions of lineage are irrelevant except as matters of scientific scholarship; its strange, endless beauty is entirely independent of them. In the spaciousness of its plan, in the incredible intricacy, wealth and variety of its decoration, in the skill of hand and concentration of mind which its execution entailed, it is perhaps the greatest single project that we know of to have been conceived and carried into effect by the Irish mind.

In addition to the Books of Durrow and Kells, there are in existence a number of other illuminated manuscripts, some of which were written in Ireland and others produced in Irish monastic foundations abroad, either by Irish monks or by illuminators who came under the influence of the Irish school. Among those of Irish provenance is the Book of Armagh, which is of early ninth-century date. It contains a collection of documents relating to St Patrick, the New Testament and a life of St Martin of Tours. It is written in double columns in Irish minuscule script, with decorated capitals but without colour. Besides separate drawings of the evangelist symbols, it contains two versions of the four together. One is a full-page delineation of the individual symbols (Fig. 54), the other a small and very elegant composite presentation in which only the eagle is shown in full, the other symbols appearing in three roundels, one on its body and one on each wing. Another manuscript, St Maelruain's Gospel (the 'Stowe Missal') contains part of the gospel of St John embellished with a portrait of the saint (Fig. 53). It is framed by a border with panels of rather poorly drawn ribbon interlace and diagonal fret. His forehead curls closely resemble those of the Kells portraits and the two stiff tubular folds in the baroque bravura of his drapery are almost identical with those in the Matthew symbol in the Book of Armagh. His symbol above, with its wings framing his head, completes a succinct and virile sketch. A few

decorated psalters testify to the continuation of illumination through the tenth into the early eleventh century, but a great bulk of the manuscripts which must have existed perished in the troubles of those and later years.

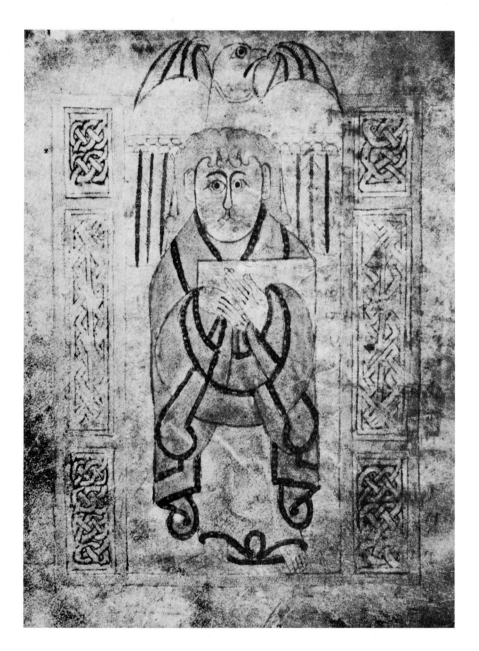

Fig. **53**. St Maelruain's Gospel ('Stowe Missal'): fo. 11 v., St John. *c*. 800 A.D.

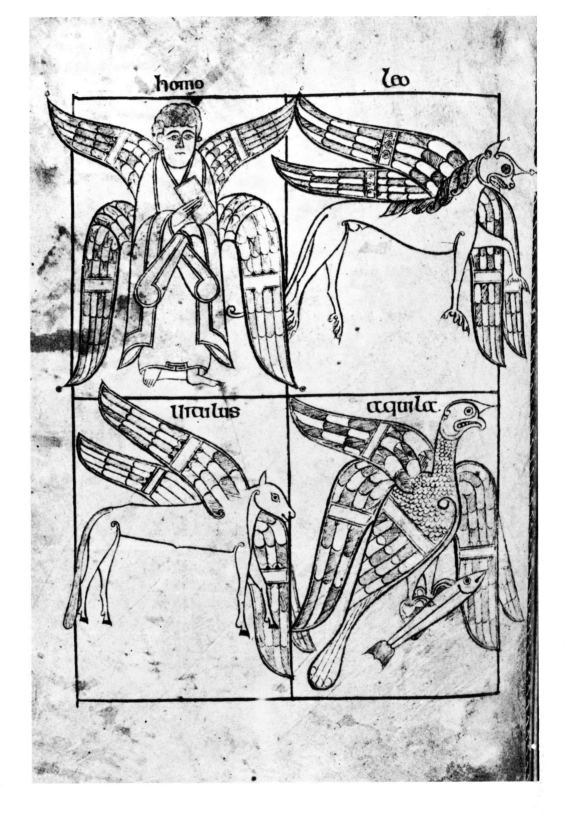

Metalwork

TECHNIQUES

Before proceeding to describe some of the principal items of the ornamental metalwork of the period, it will be advantageous to summarise such information as is available about the techniques in use at the time. Bronze, cast or in sheet form, continued to be the basic raw material. It was, for special features or to produce special effects, enriched by gilding. Silver was also extensively used, although to a lesser extent than the cheaper bronze, and it, too, was frequently gilt. Except as gilding or filigree, gold was sparingly employed. Metal was also drawn into wire and used functionally and decoratively. In the former role it can be seen in the tubular silver chain attached to the side of the Tara Brooch (Plate 26). As a decorative element, silver and copper wires were woven into the flat rectangular panels which were inserted in the flange of the foot of the Ardagh Chalice (Plate 30). The commonest use of wire was in the formation of the almost microscopic filigree patterns which embellish many of the metalwork objects. Gold wire was generally employed for this purpose. Different effects were produced by using wires of various types, singly or in combination. For some the wire was plain and round in section and utilised as single strands or as a number of strands twisted together. For others the wire took the form of flat ribbons placed on edge. For added richness of surface the wires were often beaded. Having worked the wires into one of the innumerable patterns at his command, the craftsman soldered them down on a background of sheet gold. Associated with filigree, but occasionally used by itself, is the allied technique of granulation, by which tiny globules of metal, arranged in lines or disposed in nests, were applied to the surface to be decorated. Circlets of granulation can be seen on the terminals of the Cavan Brooch (Plate 28) and on one of the glass studs on the handle escutcheons of the Ardagh Chalice (Fig. 63). Although preference was given to the sharp relief produced by cast and filigree work, *repoussé* effects, with their softer play of light and shade, were occasionally employed, as in the spiral-decorated silver panels on the Moylough belt-shrine (Fig. 66). Several exceptional techniques are dealt with in the description of the Tara Brooch below.

The metalwork techniques, various and complicated as they are, by no means exhaust the resources of the craftsman of Early Christian

Fig. 54. Opposite: Book of Armagh: fo. 32 v., symbols of evangelists. *c.* 800 A.D.

85

Fig. 55. Above: Bone 'trial piece', Dooey, Co. Donegal. Carved with patterns of single- and double-lobed spirals. L. 12 cm. 5th-6th cent. A.D.

Ireland. From the preceding Iron Age he had inherited the art of working in glass and enamel. The latter is found, in colours of red and yellow, on a limited number of objects and is generally set in narrow rectilinear panels, often L-shaped or T-shaped (Figs 67, 83, 97). Millefiori continued in use and glass was also cast to provide the studs – red, blue or polychrome – which decorate articles of many different kinds, a particularly good example of skilful casting being the two small human heads on the hinge of the Tara Brooch (Plate 26). A remarkable development in the use of glass is to be found in many of the studs on the Ardagh Chalice, where a delicate silver grille divides the surface of the stud into compartments filled with red and blue glass in striking alternation (Plate 29, Figs 62, 63). The same object provides another instance of the wedding of glass and metal, for the studs in the roundel on the underside of the foot have three minute C-shaped arcs of beaded gold wire embedded, back to back, in their tops (Plate 30). Studs were also enhanced by having set below them a paillette or patterned piece of metal foil, the design of which was visible through the coloured glass. The flat blue studs on the underside of the foot flange of the Ardagh Chalice are enriched in this manner (Plate 30).

A substance employed in much the same way as glass was amber, which was sometimes decorated with gold, as on the Tara Brooch, where studs of it have gold granulation set on small gold discs applied to them (Plate 26). It seems probable, in some cases at least, that the studs were moulded from powdered amber rather than cut out of the solid. A new departure in the handling of this material is to be seen on the handle escutcheons of the Ardagh Chalice, where the large glass studs are encircled by a ring of amber set in a silver frame over a backing of blue-green malachite, used, apparently, to modify the colour of the amber by reflection through it (Fig. 63). Precious stones, in the strict definition, do not appear on any of the surviving objects but rock crystal was utilised for some insets, e.g. on the underside of the Ardagh Chalice and on the Cross of Cong (Plates 30, 37).

Sketches and working drawings may have been made on waxed tablets, vellum or parchment but the only material of this nature which has been discovered are the so-called 'trial pieces' of stone or bone. Some of these may be the work of apprentices learning their trade under the direction of a master craftsman. In some, however, the patterns are so well executed that it has been surmised they were used to impress the wax models from which the designs were cast in metal (Figs 55, 56).

The extant Early Christian material, having survived purely by chance, must be assumed to represent merely an average sample of what was formerly in existence. It contains such a high proportion of items of outstanding quality that it is a fair conclusion that the material now lost was equally rich in them. This conclusion is reinforced by the

extremely varied technical accomplishments summarised above, for their very existence presupposes a large output of works of first-class craftsmanship, providing ample and continuous opportunity for generations of craftsmen, not merely to acquire these skills as apprentices and transmit them to others as masters, but also, as individuals, to retain them by their constant exercise and application.

BROOCHES

Of the decorated metalwork of the Early Christian period, a series of large and richly ornamented ring-brooches forms a striking and coherent group. They were used for fastening on the breast or shoulder the ample woollen cloak which was the outer garment of both men and women. These brooches were preceded by one of simpler style, derived from a type introduced from the Roman world in the first centuries after Christ. This consisted of a penannular ring, the ends of which were slightly expanded and decorated. A long pin, with a looped head sliding on the ring, was pushed through a pinched-up fold of the overlapping edges of the cloak and the protruding end of the pin lifted through the opening in the ring. The end of the pin was then moved over to rest on the front of the ring where it was held in place by the pull of the imprisoned fold of cloth. In the eighth century there appeared a more elaborate version in which the ends of the ring and the head of the pin were expanded into large plates, the pin being usually attached to the ring by means of a loop at the back of its head. In many brooches of this kind the original opening of the ring disappeared, the terminal plates being either fused together or joined by connecting strips, but the terminals continued to retain their individual identity in the disposition of the ornament. Decoration is concentrated on the front of the brooch and especially on the terminals and pin-head. The ring may be flat on both faces or flat on the back and convex in front. In some instances the whole front surface of the ring bears ornamentation, in others it is confined to a panel on the top opposite the terminals. Of the large number of these brooches in existence, no two are identical and they exhibit extreme diversity in details. The terminals may be triangular, trefoil, quatrefoil or square in shape, and there is an equal variation in the shapes of the heads of the pins, while the variation in the applied ornament is much greater still.

 The most splendid of all the surviving examples is the so-called Tara Brooch, which dates to early in the eighth century (Plates 26, 27). Its

Fig. **56**. Above: Bone 'trial piece', Lagore, Co. Meath, carved with patterns of simple and animal interlace. The finished designs were intended to be ultimately transferred to metal. L. 22 cm. 8th cent. A.D.

association with Tara, the seat of an ancient kingship in Co. Meath, is purely fictitious for it was found in 1850 at Bettystown on the coast of that county. It belongs to a family of brooches having large terminals in the shape of triangles with curved sides. The main element in the decoration of each terminal is a triangular panel, conforming to the outline of the terminal and having at its apex a round stud. This triangular panel and its accompanying stud also appear on the head of the pin. The brooch is of silver, the ring and pin-head being gilt. The ring is flat on both faces and is 8 cm. in diameter. In casting it, hollows were left for the reception of the inset panels of ornament. On the narrow part of the ring in front, these were originally five in number, that at the top occupying a separate compartment where it was framed between two D-shaped amber settings, while the others were separated by keystone-shaped amber studs. All the studs remain, but only one of the panels, which bears interlace in gold filigree, has survived. The terminals are fused but, in memory of their former separation, each is treated as an entity in itself. The central feature on the front of each was a triangular panel of gold filigree, the one which remains bearing animal interlace carried out in twisted and beaded wires and gold granulation. The panel is framed by a narrow band of amber bordered by a series of gold filigree panels, similar to but slightly narrower than those in the ring and separated from each other by small circular glass studs. The line of formal demarcation between the terminals is occupied by a vertical compartment containing two filigree panels of gold interlace, having between them a large lozenge-shaped stud of blue glass and with a round stud at each end, flanked by a pair of amber studs pointed oval in shape. Only the lower of the pair of round studs remains. It is of amber and dome-shaped with, on top, a minute disc of gold foil covered with granulation and bordered by twisted gold wires. At the point where the ring joins the terminal on either side is a similar amber stud, one of which is surmounted by a gold disc bearing a central globule surrounded by three C-shaped arcs of beaded gold wire, the incoiled ends of which are topped by gold globules. The gold disc is missing from the second stud but the end of the minute gold tube to which it was attached is visible.

The back of the brooch is better preserved than the front and is as elaborately decorated but in a different style and technique. The general treatment is a simplified version of that on the front. As on the front, the top segment of the ring is a separate compartment with a D-shaped amber stud at each end. Between the amber studs, on copper overlaid with gold, are engraved three spirals, each composed of different elements, the exposed copper appearing as if inlaid in gold (Fig. 57). In the space between the ends of this compartment and the terminals there is on each side, cast in one with the brooch, a panel containing four spirals in a running frieze, each spiral differing from its fellows in its

88

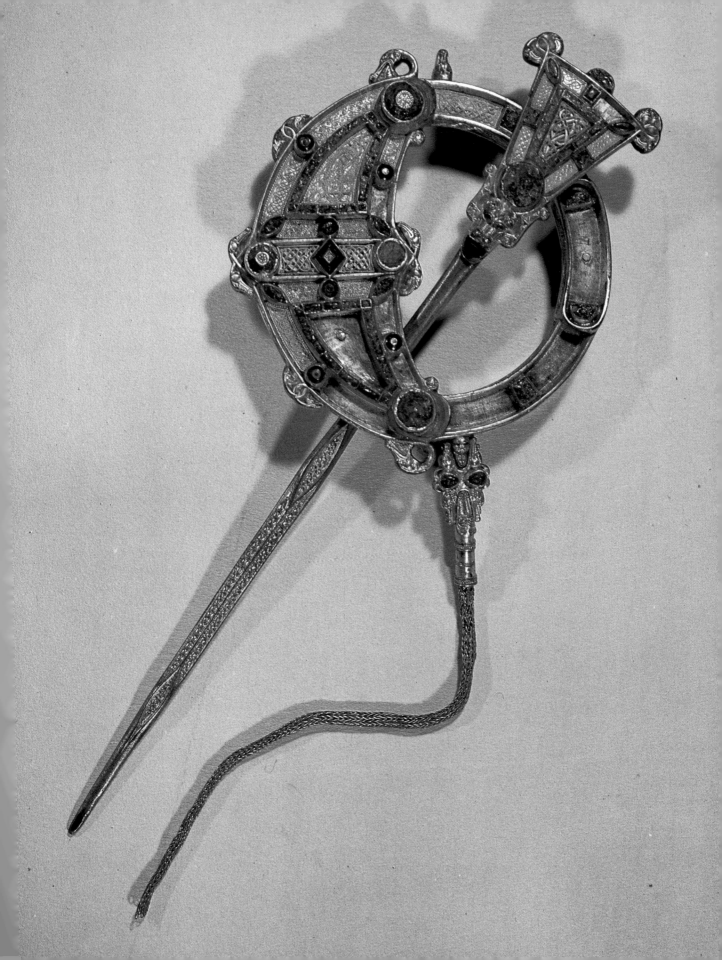

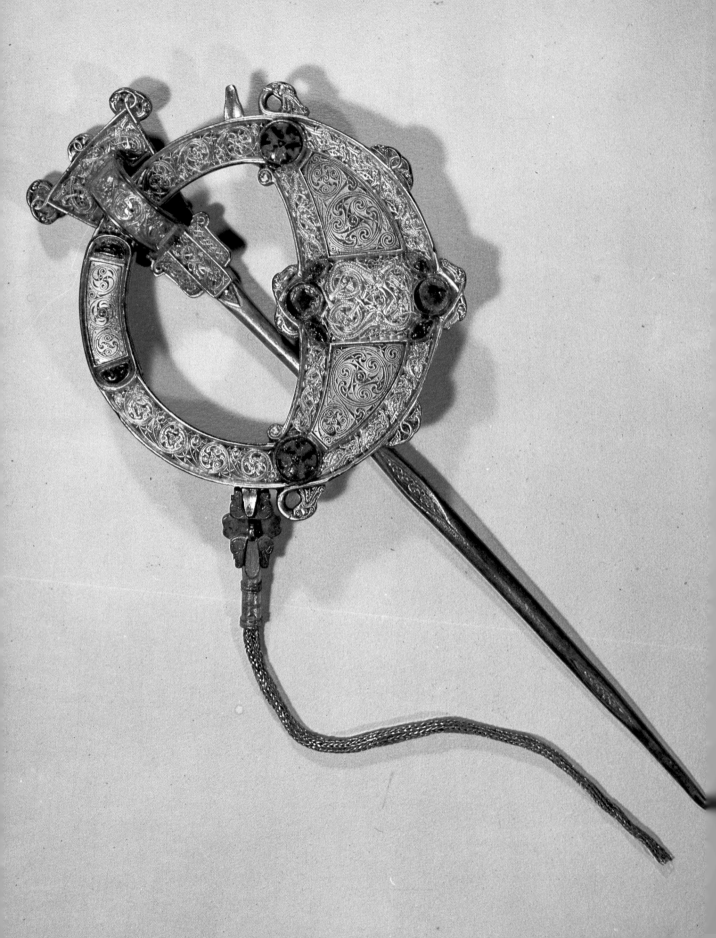

component elements but all showing a basically triskele arrangement of these. Allied motifs of La Tène descent fill the large triangular panels occupying the centres of the terminals but a fresh technique was used to reproduce them. They were first outlined on a copper plate and the background was then lowered to leave them standing out in slight relief. Silver was then floated over the surface of the plate and subsequently removed from the patterns in relief, leaving the design in copper silhouetted against a silver background (Plate 27). The terminal panels decorated by this complex and unusual technique are separated by a single panel bearing two animal figures whose limbs are interlaced in a pattern of astonishing intricacy, while above they are bordered by two narrow panels with similar animal interlacements and below by two having a line of birds, each gripping in its beak a leg of the one in front. The four large circular studs and the four lenticular ones on the front of the brooch have their counterparts on the back, two of the former kind retaining their domed glass insets and all of the latter their amber insets.

The outer edge of the ring is decorated with 'Kerbschnitt' interlace. Common to the front and back of the ring are the six creatures in relief whose serpent bodies follow the outline of the circumference of the brooch and the upper line of the fused terminal plates and whose heads and tails project from the margin. Those on the circumference of the ring are arranged in pairs, the members of each pair being linked together by the intertwining of their raised three-lobed tails midway between their heads. One beast of each pair is in a quiescent posture with closed jaws and the heads of these two, necks crossed, lie back to back at the lowest point of the ring. The other beast of each pair is in a state of activity, its fanged jaws opened wide, its head turned backwards on the body with the neck forming a closed loop. The pair on the upper margin of the terminal plates have hooked bird-like beaks. Their heads lie back to back at midpoint on the margin to balance those at the bottom of the ring, while the tail of each is coiled into a small spiral in the angle where the ring meets the terminal. From both sides of the ring, immediately above the open-jawed beasts, there projects a small, highly stylised animal head with rudimentary ears and a long snout, seen, as it were, in plan. Joined by a rivet to one of these heads is what might be described as an H-shaped attachment, the uprights of the H consisting of four animal heads, while the cross-bar bears two tiny human heads of amethyst-coloured glass set chin to chin. Pivoting on a rivet in the outer opening of the H is an animal head, the neck of which forms an open cylinder for the reception of one end of a tubular chain woven from silver wires. The other end of the chain was probably equipped with some kind of device, additional to the pin, for securing the brooch to the wearer's clothing.

The pin of the brooch, which is 22.1 cm. long, is provided with a

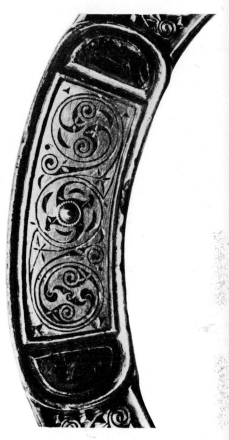

Fig. 57. Tara Brooch. Panel at top of ring on back. Of copper overlaid with gold, the scroll design being made by cutting away the gold to reveal the copper.

Plate 27. Opposite: Tara Brooch, Bettystown, Co. Meath: back. D. 8·5 cm. Early 8th cent. A.D.

91

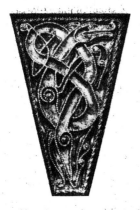

Fig. 58. Above: Tara Brooch. Central panel in head of pin with a convoluted animal executed in gold filigree.

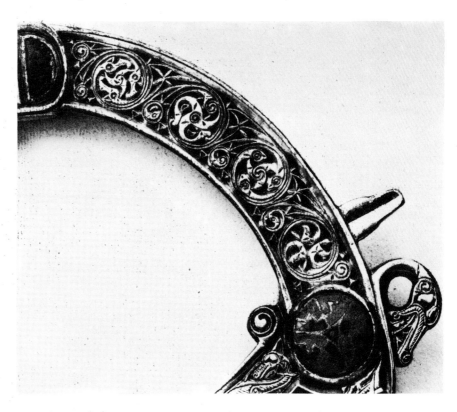

Fig. 59. Right: Tara Brooch. Segment of back of ring with design of scrolls and triskeles cast in one with the ring.

large flat head, an isosceles triangle in shape, with its apex directed towards the centre of the ring. Although the patterns of the filigree panels are different, its decorative scheme in front is exactly the same as that of the terminals, except that the three small round studs midway on the sides of the amber frames in the terminals are replaced by three square amber ones. The large circular amber stud at the apex delicately mutes the angularity of both the inner and outer triangles, and beyond it the downward sweep of the sides of the triangle is continued in slower rhythm by the strange feature which completes the head of the pin. It consists of a stylised animal head, the skull and duplex snout being composed of spirals. Below it, and rounding off the end, is a D-shaped glass stud. The upper part of the animal head is bordered by two narrow wings of 'Kerbschnitt' ornament, the spiral ends of which diverge above to support in caryatid fashion the frame of the large amber stud. The back of the head of the pin is covered with an overall pattern of zoomorphic interlace, while, in contrast, on the back of the loop fastening the pin to the ring the decoration reverts to older patterns consisting of spirals wound round birds' heads and of other motifs. On the corners of the head are two lobes, each composed of two bird-headed creatures with intertwined necks whose bodies margin the perimeter of the pin-head. The tail of the uppermost creature of each pair links with that of the other in the centre of the top margin

to form a small lunette. The tails of the beasts are visible only on the back of the lunette, the front being filled with amber. The front of the pin itself bears two long, exquisitely balanced, pointed oval panels filled with gilt 'Kerbschnitt' interlace, which are connected by a two-facet spine of similar gilt interlace. On the back of the pin, the oval panels are repeated but the spine is omitted.

It has been thought advisable to give this detailed account of the Tara Brooch not only because it is the finest of the brooches and one of the supreme achievements of Irish artistry and craftsmanship but because it exemplifies the wealth and diversity of the technical accomplishments of the period. The almost classical simplicity of its general outline and of the main masses of its ornament survive the unbelievable profusion of detail by the miracle of skill which has subordinated the detail to them in scale. The harshness of the mathematical symmetry of its form is dissipated by the astonishing variety of the ornament. Its creator seems to have been gifted with an unerring instinct for proportion whether in mass or line and his work is full of subtlety. The open-jawed animal heads projecting from each side of the ring give the extra width exactly where it is required, while the height and curvature of the lunettes formed by the intertwined tails and by the pair of heads are calculated to modulate the contour of the lower half of the circumference of the ring to contrast with the unbroken arc of the upper half. The wiry curve of the bird-heads on the pin-head is adapted to the acute angles of the corners and contrasts with the sleepy repose of the pair which cross in a wide angle in the middle of the upper line of the terminals. With the exception of the attachment for the chain, originality cannot be claimed for any particular feature of the brooch. As has been already mentioned, it shares with a number of others the same general ornamental plan. Paired and single bird-heads project from the margins of the Hunterston Brooch in the National Museum of Antiquities of Scotland, and the Londesborough Brooch in the British Museum, and the corner lobes of the Tara pin-head resemble some of the corner ornaments on pages in the Book of Durrow. The details of its cast and filigree ornament can be paralleled elsewhere in both manuscript illumination and metalwork but the unapproached wealth and perfection of its decoration on both front and back, the multiplicity and virtuosity of its techniques make it one of the masterpieces of its epoch.

A brooch of obvious kinship with the Tara one is the silver specimen from Roscrea, Co. Tipperary (Plate 25). The fused terminals and the pin-head have triangular panels of gold filigree inset in narrow silver frames with a domed amber stud at the apex of each. The minute static intricacy of these panels contrasts with the lively movement of the bold dragonesque creatures which wriggle around their borders. The spaced lunettes on the edge of the Tara Brooch are replaced by a continuous

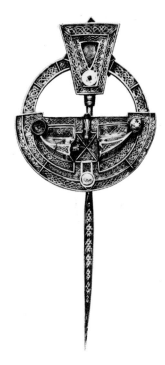

Fig. 60. Gilt silver brooch, Ardagh, Co. Limerick. The central panels of the terminals are in the form of birds in relief with a smaller bird above them. The blank panel in the centre of the pin-head was probably occupied by a similar bird. D. 14·5 cm. 8th cent. A.D.

frill of them, those on the lower half of the ring being delicately gradated, increasing in size from above downwards to lead into the pendent animal mask, while another animal mask, reminiscent of that on the Tara Brooch, terminates the pin-head. The lunettes were originally filled alternately with amber and gold filigree and a few of these insets still remain.

A very unusual brooch of this family formed part of the hoard found at Ardagh, Co. Limerick, in 1868, which included the famous chalice. It is a large specimen of silver brightly gilt (Fig. 60). The decoration consists exclusively of bold 'Kerbschnitt' interlace, giving an overall effect of great richness but with little subtlety of detail. As in the Tara and Roscrea Brooches, the central panels on the terminals and pin-head are triangles with a round stud at the apex of each. In a striking break with tradition, however, the artist, while keeping the ancestral triangular shape, cast the panel in high relief and, by adding a duck-like head to it and treating the long sides of the panel as wings, with a spiral joint and three rows of tiny feathers on each, turned it into the figure of a brooding bird, the adjacent stud being incorporated as an expansion of its tail. The head of one of these birds is missing but the two originally met above the centre of the terminal plate. To complete the threefold motif which haunted the Irish imagination in art and literature, he then substituted a smaller bird, beak to beak with the others, in place of the orthodox round stud on the line of demarcation between the terminals of the Tara and Roscrea brooches. The central panel of the pin-head is missing but, bearing in mind the standard repetition on the pin of the central motif of the terminals, there can be little doubt that it was occupied by a bird, with its head pointing to the top of the pin-head and with the stud below forming an expansion of its tail.

The Cavan Brooch, which would appear to date to the late eighth century, is a fine specimen of the type with three-lobed terminals (Plate 28). It is of cast silver, heavily gilt all over. The ring is flat on the back and convex in front, the latter being decorated with two rows of simple interlace, interrupted at the top by a now empty lozenge-shaped setting flanked by two animal heads. Two other animal heads on the terminal plates hold, as it were, the ends of the ring in their mouths. Almost the whole area of each terminal is occupied by a rounded trefoil pattern in high relief, its lobes separated by three further animal heads. On their inner aspect, the lobes are deeply ridged and slope downwards to the base of a conical eminence in the top of which there is inset a gold disc, having a central nest of granulation surrounded by simple filigree patterns. The outer slope of the trefoils is banded with 'Kerbschnitt' interlace and the small flat area on the terminals is filled with animal interlace. At each end of the narrow space between the terminals is a small human head, reminiscent of the glass pair on the Tara Brooch. The pin-head is a replica of the trefoils on the terminals

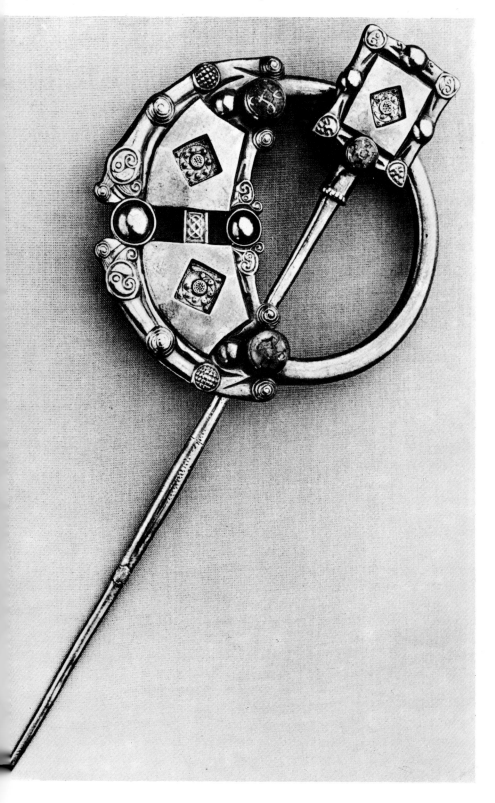

Fig. **61**. Silver brooch with gold insets in terminals, Killamery, Co. Kilkenny. L. of pin 31·4 cm. 8th cent. A.D.

95

but its central gold disc bears a smaller circlet of granulation which is surrounded by four filigree C-curves with spiral ends arranged in a cruciform pattern.

Less refined in outline, less rich in surface texture and less integrated in decoration is a large silver brooch from Killamery, Co. Kilkenny, dating to the eighth century (Fig. 61). Gilding is restricted to the decorated surfaces, which are themselves limited to small areas symmetrically arranged. The plain ring is flat on the back and convex in front. The large deep terminals give a drooping effect to the ring. The lower edge of each is bordered by a highly stylised animal, its body decorated with three bosses and its head opposed to that of its fellow to support a large boss between their mouths. Two smaller beasts on the upper margins of the terminals similarly support a proportionately smaller boss between their mouths. At the junction of ring and terminals is a large green glass stud with an inset silver grille. The central area of the terminal is occupied by a rhomboid plain silver sheet backed by lead, in the middle of which is a lozenge-shaped recess containing a circlet of gold granulation ringed by filigree of twisted gold wire. This is, in turn, surrounded by a circle of cones of gold wire surmounted by gold globules, enclosed by a further band of filigree, and the design is completed by a single cone of gold wire in each corner. A similar gold lozenge set in sheet silver decorates the square pin-head which is bordered by two stylised animals supporting between their mouths the gilt boss on the upper edge. The centre of the lower margin is decorated by a glass stud inset with a silver grille and in each corner is a pear-shaped panel, the upper two bearing scroll patterns, the lower two small human heads.

Brooches with quatrefoil terminals are exemplified by one found at Kilmainham, near Dublin (Plate 25). The ring is flat on both faces and the front has panels of gold filigree separated by square settings, now empty. The upper panel is a separate compartment which, in its shape and the presence of the crescentic settings at the ends, recalls that similarly placed on the Tara Brooch. The arcs of the quatrefoil were filled with red glass, as were, presumably, the roundels in the angles and the D-shaped projections on the three free lobes. The panels in the arcs and the square central eminence are filled with patterns in gold filigree on a background of gold foil. The head of the pin is missing.

The various types of these highly decorated brooches have many less ornate counterparts in bronze and, to judge by the large numbers of these which have survived, they must have been extremely common during the period. Its practical use as a dress-fastener ensured the continuation of the ring-brooch throughout the Early Christian period but, although the essentials of its form remained unchanged, the style of decoration altered very considerably. The later brooches are almost invariably of silver and have wide terminals which, by a reversion to

the archetypal form, are separated by a gap through which the pin can be raised, so that, like the earlier ones of their kind, they can be locked in place on the garment. The pin is no longer furnished with a large flat head but, as was the case in many of the earlier brooches, terminates in a short tube through which the ring passes. A typical example comes from Drimnagh, Co. Roscommon, the bosses on the terminal plates of which are bordered by two pairs of confronted beasts with massive heads and interlaced limbs executed in slight relief (Plate 25). In other specimens the recessed background of the ornament disappears to leave an openwork pattern of zoomorphic interlace. The commonest type of this brooch has on each terminal a small central boss which is joined to a number of similar bosses by radiating lines which divide the surface into small angular panels filled with animal interlacements.

ARDAGH CHALICE

One of the few relics of Early Christian Irish metalwork where the artist was free to express himself in form relatively unhampered by having to adhere closely to a strictly traditional formula is a large two-handled cup found in 1868 in Ardagh, Co. Limerick, along with another smaller bronze cup and four ring-brooches. Besides being of singularly graceful shape and a masterpiece of design in applied ornament, it is also a veritable archive of the technology of its time. It dates to the early eighth century and is evidently a Holy Communion chalice (Plate 29). It has a round-bottomed silver bowl, wider than it is deep and swelling gently in the middle, a short straight stem, and a conical foot with a broad flat flange, and is 24 cm. in diameter and 17.7 cm. high. The handles are simple flanged loops with escutcheons on the bowl below them. A richly decorated roundel lies midway between the handles on each side, and encircling the bowl below the rim is a girdle decorated with studs and panels of gold filigree. The stem and its accompanying mountings are of gilt bronze, while the decoration of the flange of the foot is of astonishing complexity. Concealed from view, in the underside of the cone of the foot, is an exquisite design in gilt bronze and gold filigree (Plate 30).

The bowl and the cone of the foot are each hammered out of a single piece of silver. The gilt brass rim is fastened by rivets, but the silver girdle below it embraces the cup without any attachment. The mouldings of the girdle are stippled with minute circular punchmarks, and the divisions of its twelve compartments are marked by blue and red glass

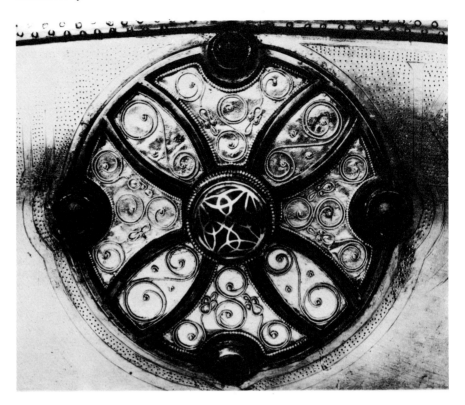

Fig. 62. Ardagh Chalice, Ardagh, Co. Limerick. Roundel on bowl with Greek cross formed by silver ribs, the spaces filled with gold filigree spirals set on gold foil and with central stud of blue and red glass with silver interlacements. Early 8th cent. A.D.

Plate 28. Opposite: Gilt silver brooch, Co. Cavan. D. 11·5 cm. Late 8th cent. A.D.

Plate 29. Overleaf: Ardagh Chalice, Ardagh, Co. Limerick. D. 19 cm. Early 8th cent. A.D.

studs with silver grilles of different patterns set in their surfaces. The panels inset in the compartments are of gold filigree interlacing, geometric, zoomorphic and ornithomorphic in type. The roundel on each side of the bowl is a circular silver plate fastened by four rivets which are concealed beneath small glass and amber studs on the margin. Radiating from a central glass stud with an inset silver grille are eight silver ribs forming a Greek cross. The spaces between them are filled with delicate gold filigree forming spiral and zoomorphic patterns set on gold foil (Fig. 62). The handles and their escutcheons are sumptuously decorated. The handles themselves are divided into small compartments arranged in three interlocking rows. The centre row has panels of gold filigree; the outer ones have glass insets, in colour blue or red or both combined. The escutcheons have three large glass studs, parabolic rather than domed, each set with a silver grille dividing its surface in a pattern of blue and red, the lowermost stud having a nest of gold granulation on its summit. At its base, each stud was originally encircled by a ring of amber backed by malachite, the silver frames of which were linked by curved ribs forming the outer edge of the escutcheons. Three straight internal ribs divide the surface into four compartments of different shapes, perfectly proportioned to each other and to the whole. The gold background in each is set with gold filigree interlacements, wonderfully adapted to the shapes they fill (Fig. 63).

98

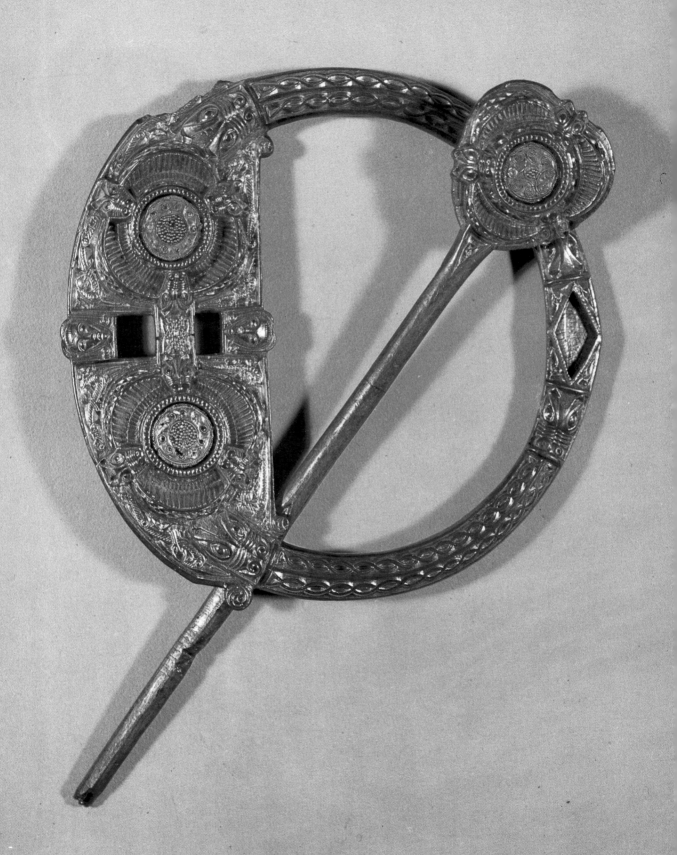

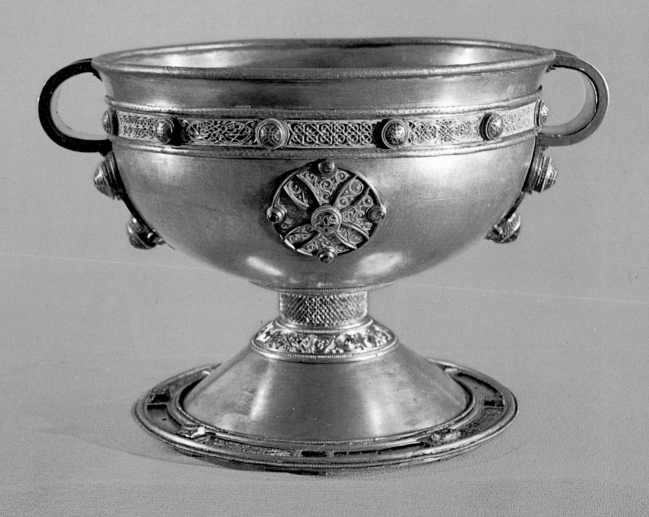

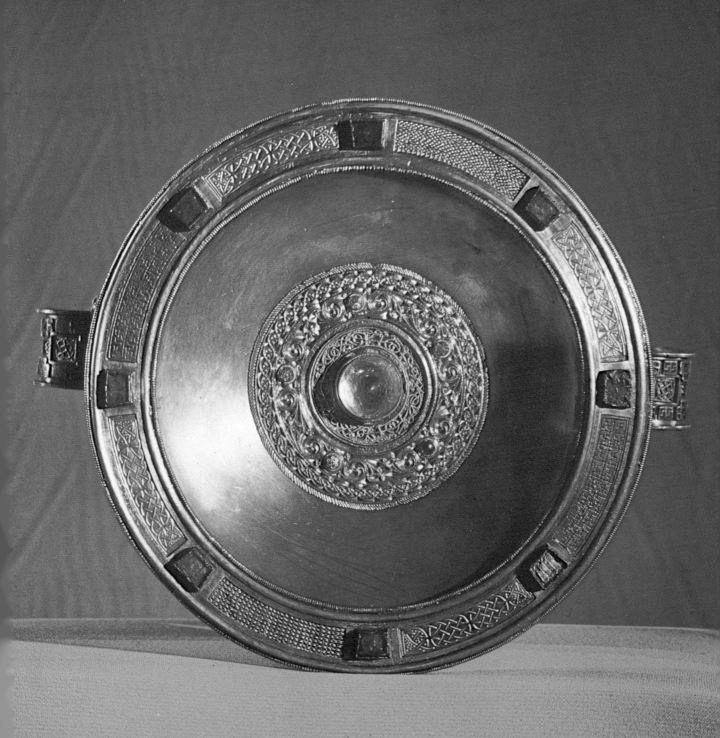

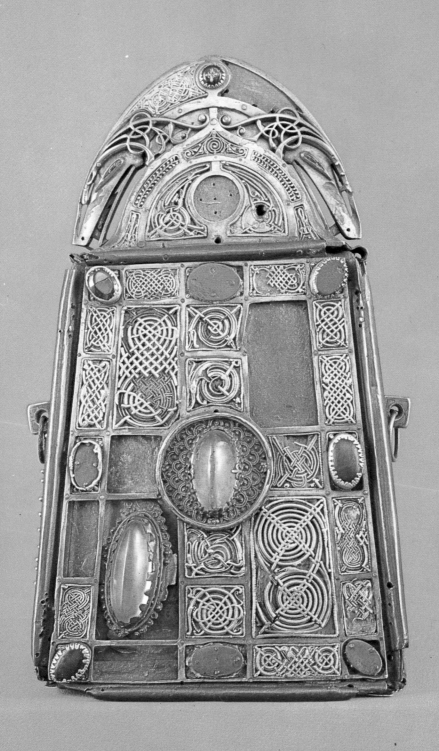

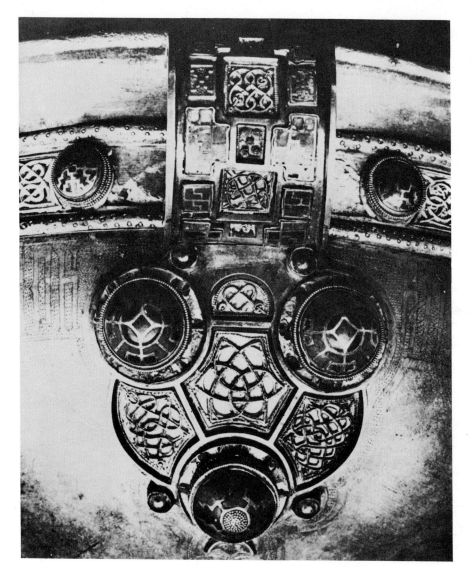

Fig. 63. Ardagh Chalice, Ardagh, Co. Limerick: handle and escutcheon. The former has settings of red and yellow enamel and interlacements in gold filigree; the latter has panels of similar filigree and three studs of red and blue glass inset with silver grilles, the lowest being crowned with a nest of minute gold granulations. Early 8th cent. A.D.

Girdle, roundels and escutcheons form conspicuous areas of enrichment in relief, but they are united by being incorporated in a frieze of now almost invisible surface decoration. This consists of a deep band encircling the bowl below the girdle, bearing the names of eleven of the apostles and of Paul, who is substituted for Judas. The lower border of the band is led around the roundels and the escutcheons and developed into panels of animal interlacing below them (Fig. 64). Letters and patterns are lightly incised and their entire background surface is stippled with close-set and almost microscopic punchmarks (Fig. 64). Ringing the bowl immediately above the gilt bronze mounting on which it sits is a band of key-fret pattern executed by the same technique.

Plate 30. Overleaf: Ardagh Chalice, Ardagh, Co. Limerick: Underside of foot. D. 16·2 cm. Early 8th cent. A.D.

Plate 31. Opposite: Shrine of St Patrick's Bell: front. H. 20 cm. 1094-1105 A.D.

Fig. 64. Ardagh Chalice, Ardagh, Co. Limerick. Early 8th cent. A.D.

Right: Panel of bird interlacement executed in gold filigree on girdle of bowl. Below it, part of an inscription containing the names of the Apostles on a stippled background.

Below: Animal ornament engraved on bowl below the escutcheons of the handles.

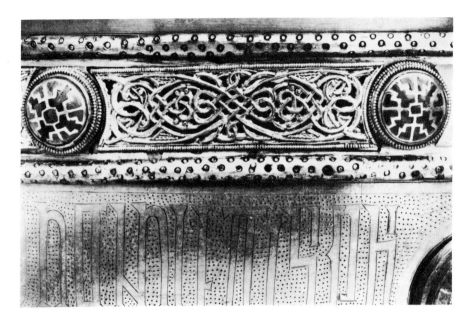

104

The stem and its mountings on bowl and foot are three separate components tightly fitted together and their bold 'Kerbschnitt' patterns and gilt surfaces stand out vividly against the silver which surrounds them. The stem itself bears a close pattern of simple interlace and the flanges are banded with scrolls, triskeles, frets and animal interlace, in striking contrast with the microscopic delicacy of the filigree on the upper part of the bowl. There can be little doubt that the relative ruggedness of this area of 'Kerbschnitt' work is deliberately intended to lend an appearance of strength to a stem which, treated otherwise, might have seemed too weak.

At the apex of the underside of the foot cone is a large conical rock crystal ringed by an amber setting and a border of zoomorphic interlace in gold filigree. Outside the filigree is a channel, now empty, which formerly held amber or some other inset. Surrounding this are two zones of cast bronze ornament gilt, the inner consisting of running scrolls relieved by five glass studs set with beaded gold wire, the outer of simple interlace. This roundel, the foot cone, the stem with its mountings and the bowl are all held together by a single copper bolt, the gilt domed head of which is visible on the inside of the bowl but the lower end of which is hidden beneath the conical rock crystal under the foot (Plate 30).

The broad flange of the foot bears an upper and lower silver ring. These closely resemble the bowl girdle and have moulded edges and eight equal segments cut out of each. On the lower ring the bridging pieces bear flat square studs of blue glass backed by tiny silver plates with embossed geometric designs. The chalice rests on these studs, as on eight low feet. The bridges of the upper ring are set with similarly shaped studs of blue glass with a red or yellow cross in the centre of each and angle pieces alternating with it in colour. In the spaces between them four of the original eight inset panels remain. They have gilt bronze open fret-patterns backed by sheets of mica which reflect through the open spaces. All the corresponding panels of the lower ring are preserved. Four, of silver, have identical embossed designs of simple interlace; the others, arranged symmetrically between them, are of two kinds, one pair, of copper, having an embossed key-pattern, the second pair consisting of silver and copper wires closely woven to produce two different designs (Plate 30).

Out of the hundreds of separate parts which, it has been estimated, went to the making of the chalice, the artist built for himself a monument to his superlative skill, his perfect sense of design and his unswerving integrity. His creation presents complete balance of form and decoration, no matter what the beholder's point of vision, including, to our latter-day surprise, the superb picture seen from below of gradated zones, each with its own carefully calculated accent, like concentric pulses spreading out from the central crystal (Plate 30).

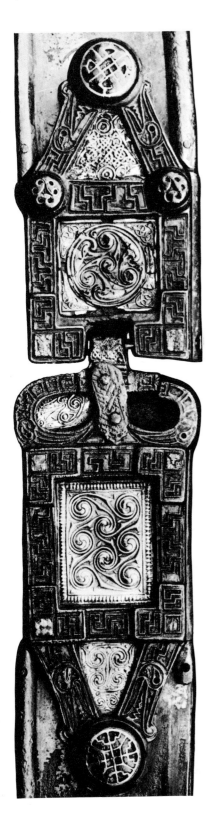

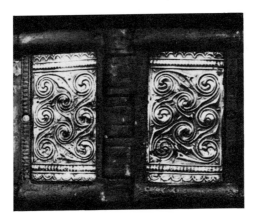

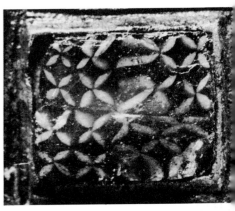

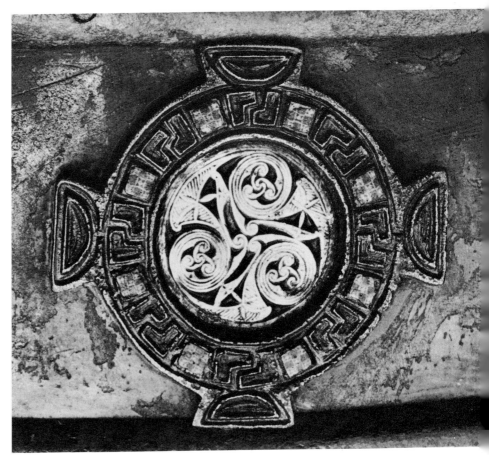

Fig. 65. Left: Belt-shrine, Moylough, Co. Sligo. Early 8th cent. A.D. Simulated buckle with inset silver panels, and blue glass studs with silver grilles. The borders are decorated with enamel and plaques of millefiori.

Fig. 66. Above left: Two inset silver panels with *repoussé* spirals flanking a hinge joining two sections of the 'belt'. Above right: Enlargement of millefiori plaque of blue and white glass.

MOYLOUGH BELT-SHRINE

Another object of early eighth-century date is a remarkable reliquary found in a bog in Moylough, Co. Sligo, in 1945. It takes the form of a belt, made up of four curved sections hinged together and provided with a non-functional buckle (Fig. 65). Each section encases a portion of a leather strap and, as Irish hagiographical literature contains frequent recitals of miracles worked by saints' belts, it is likely that it was made to enshrine a belt attributed to one of the native saints. Although ingeniously constructed and, like the Ardagh Chalice, exhibiting restraint in decoration, it fails in overall design. The component segments are too few to allow of their being arranged in any closer approximation to the ideal circle than an awkward square or parallelogram with bulging sides. The reliquary is made of sheet bronze, originally tinned. Both ends of each segment terminate in rectangular cast bronze frames enclosing silver panels of openwork and embossed ornament in relief. On the inner side of the frame at the buckle is a triangular extension, presumably simulating the end of the strap, which is balanced by another triangle on the opposite segment, both triangles being proportioned to the rectangular frames which they subtend. The sides of the triangles are open-jawed animals holding glass studs with inset silver grilles. The rectangular frames at the buckle plates are set with a fret of yellow and red enamel and the four corners of the larger and two of the smaller are set with blue and white millefiori, the remaining corners of the smaller frame being occupied by two round glass studs set with silver wire. The frames enclose silver panels, with designs embodying thick-lobed spirals, trumpet-patterns and interlace. A circular mount occupies the centre of each segment of the belt. Two are in the form of ringed crosses, while the other two have open centres. The mounts themselves are richly decorated with millefiori and red and yellow enamel, while the two with open centres have inset silver panels (Fig. 67). These have spirals and trumpet-patterns in a complex threefold arrangement which can be resolved into many different triskeles and which bears a close resemblance to motifs in the spiral page in the Book of Durrow (Plate 14). As the inner side of the reliquary is absolutely plain, it has been concluded that it was intended to be displayed on a statue or some solid mount; this may account for its feeble contours when seen in isolation.

Fig. 67. Opposite centre: Belt-shrine, Moylough, Co. Sligo. Silver roundel with spirals and triskeles bordered by ring set with millefiori plaques, between which are key-patterns originally filled with red and yellow enamel. Early 8th cent. A.D.

BELLS AND BELL-SHRINES

In both the hagiographical and the profane literature of Ireland, every ecclesiastical figure is invariably thought of as the possessor of two articles: a staff and a bell. Representations of clerics in metalwork and sculpture show them carrying these insignia of their calling (Fig. 86, top). The cult of the bell goes back, evidently, to the very beginnings of Christianity in the country, and an extremely ancient tradition connects one surviving specimen with St Patrick. This is made of sheet iron coated with bronze and, with its rectangular mouth, sloping sides and loop handle, it is representative of the general type of early Irish bells. Some of these remain but, as the majority are of iron, they are sadly decayed and are, in any event, of no artistic merit. Some, however, are of cast bronze. Perhaps the finest of these is that from Lough Lene, Co. Westmeath, which is decorated on both of its broad sides with a ringed cross and a border of fret-pattern around the mouth. Another good example is the Bell of Armagh, which bears an Irish inscription asking for a prayer for Cumascach, son of Ailill, who has been identified as a person who died in 908 A.D. (Fig. 69). The Lough Lene bell belongs to the same century.

Customary as it was to enshrine all manner of personal possessions associated in fact or in legend with men of conspicuous holiness, it is only to be expected that such cherished belongings as their bells would have found patrons to commission craftsmen for that purpose. No complete early bell-shrine is known but from the eighth century there is a fragment generally considered to be the top of one (Fig. 68). It is a half-oval in shape and is of cast bronze with one face heavily gilt. The latter shows a stylised human figure between two roundels with two beasts whispering, as it were, into its ears. Its bearded face is enclosed in a lozenge-shaped frame and the body appears to be clad in an embroidered cloak. The whole design is curiously asymmetrical and of inferior workmanship. The back bears a strange cross formed of four human limbs radiating from an amber stud, a border of single-strand interlace and a silvered or tinned panel with spiral- and trumpet-patterns reminiscent of La Tène work.

Except for a few fragments, all the other surviving bell-shrines belong to the end of the Early Christian period and date to the eleventh and twelfth centuries. One of these, having the puzzling name of *Corp Naomh* or 'Holy Body', although stripped of most of its original ornament, retains some interesting details (Fig. 70). A large rock crystal and a crucifixion figure have been inserted on the mutilated front of the shrine. This figure is starkly conventionalised and exhibits transitional features in the treatment of the theme in Irish art. The rendering of the

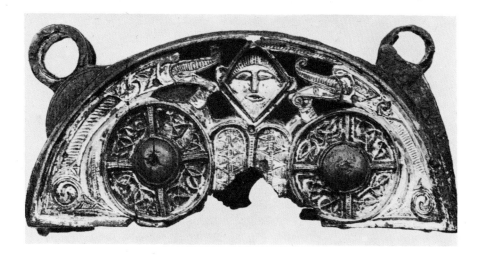

Fig. 68. Top of bell-shrine, find-place unknown. W. 13 cm. 8th cent. A.D.

hair and the horizontal position of the arms follow the Irish tradition, but the crossed feet and the substitution of the loincloth for the full garment of earlier versions reflect influence from abroad. Only the top of the shrine remains in anything approaching its original condition. It is of bronze with the usual curved outline. The front shows a number of figures symmetrically placed to depict a scene of some kind. A disproportionately large bearded figure, his head in high relief, occupies a central position. He is dressed in a cloak and tunic and a horseman approaches from either side. The birds fitted into the spaces above the riders show the immemorial spiral on the joints of their wings.

By far the most splendid of the bell-shrines is that commissioned for St Patrick's Bell between 1094 and 1105 A.D. (Plate 31). It is made of bronze plates and its shape conforms closely to that of the bell. The front of the body is covered with an openwork silver frame of thirty-one panels, the smaller ones in the centre following a cruciform arrangement. Four are empty, and in ten of the remaining panels ovals of rock crystal and coloured glass have been inserted which detract considerably from the appearance of the shrine. The remaining insets are interlacements in imitation gold filigree made from gold-plated bronze or copper wires, no two patterns being alike. The front of the top of the shrine is elaborately ornamented with gilt silver interlacing and elongated silver scrolls, between which are panels of gold zoomorphic interlace on a gilt background. The back of the body is covered with a sheet of silver pierced by equal-armed crosses to form a diaper pattern and has an Irish inscription on the margin recording the names of the maker and of his patrons. On top there is an openwork design in cast silver composed of two confronted birds, the wings, tail, neck and beak of each being enmeshed in the spiral turns of a snake-like creature with long slender jaws which fuses with its fellow to give an impression of a stylised vine with two symmetrically wreathed tendrils

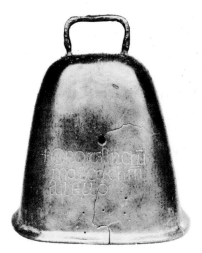

Fig. 69. Bell of Armagh, Armagh, Co. Armagh. A bronze hand-bell with an inscription in Irish asking a prayer for Cumascach, son of Ailell. H. 32 cm. *c.* 900 A.D.

109

Fig. **70**. Bell-shrine (*Corp Naomh*), find-place unknown. H. 22·7 cm. 11th-12th cent. A.D.

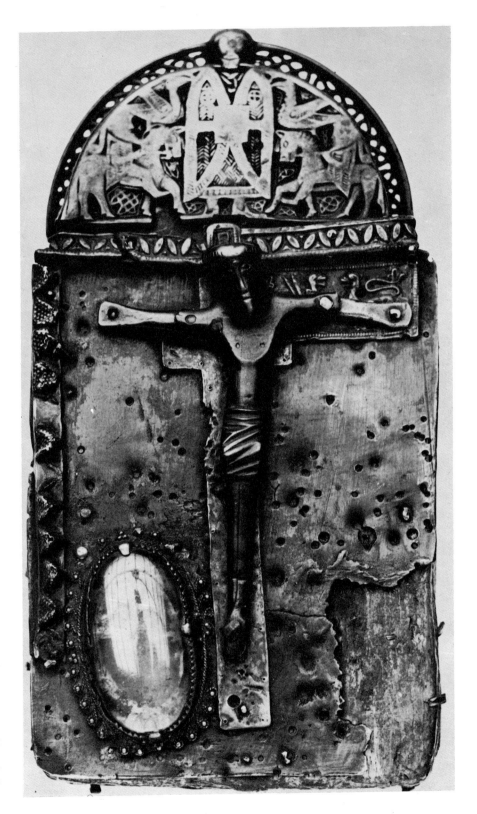

Plate **32**. Opposite: Gilt bronze crucifixion plaque, Rinnagan, St John's, Co. Roscommon. H. 21 cm. Late 7th-early 8th cent. A.D.

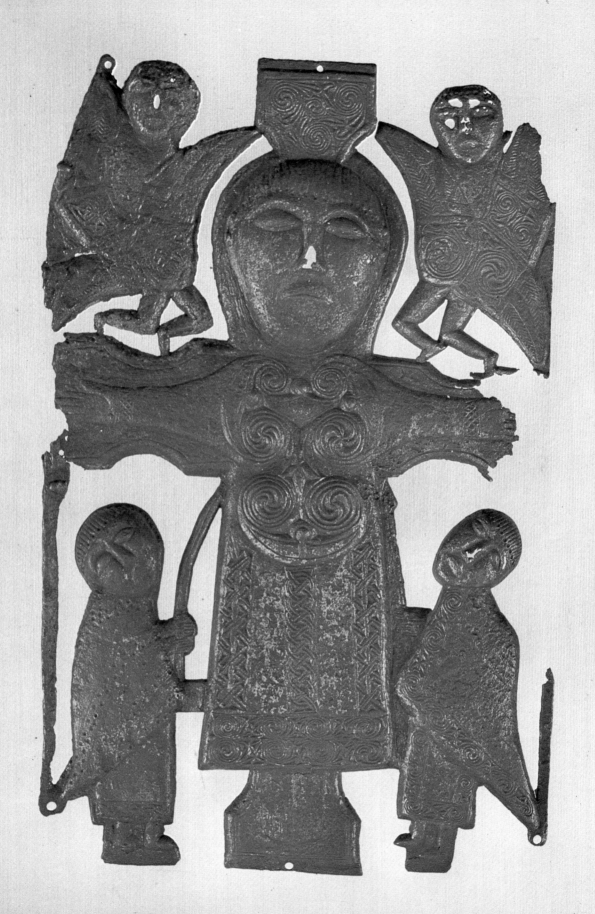

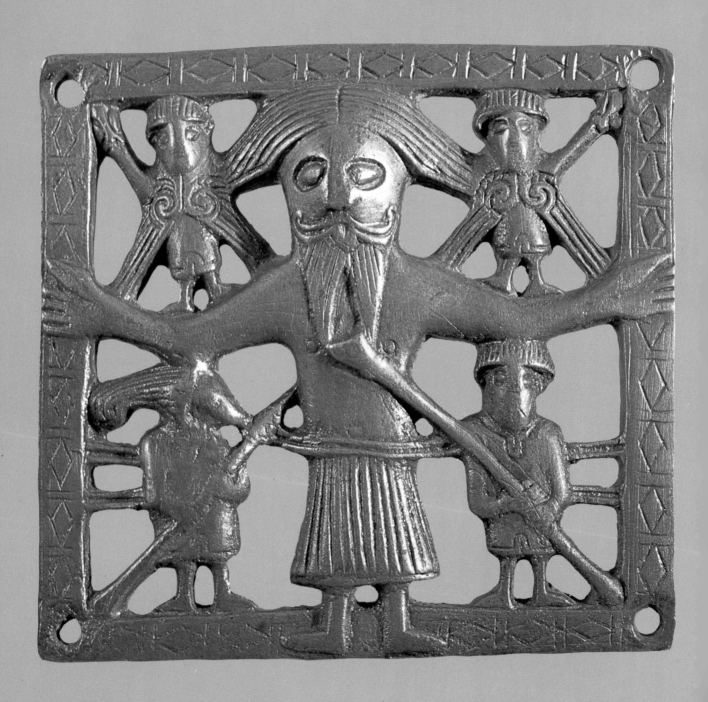

(Fig. 72). In many respects the sides of the shrine are its most impressive features, the greater part of their surfaces being covered by a bold openwork interlace in sweeping curves. This is of cast silver, originally gilt, and is set off against a brightly gilt background. At about two-thirds of the height is a circular silver frame, with four embossed panels of gold-plated interlace, from the centre of which projects a decorated square knob, pierced to take a carrying ring (Fig. 71).

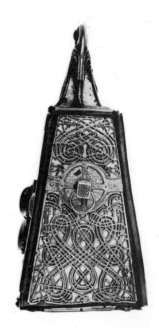

Plate 33. Opposite: Bronze crucifixion plaque, find-place unknown. H. 7·3 cm. *c.* 1100 A.D.

CROZIERS

Perhaps to a greater extent even than his bell, the saint's staff is the emblem of his status and the vehicle of his supernatural power. As a shepherd boy, with instructions to keep the calves and cows apart, he draws a line on the ground with it between them which neither calf nor cow dare cross; if he forgetfully leaves it sticking in the ground, it grows into a huge and venerated tree; if he needs water to baptise a convert, he strikes the earth with it to cause a well to appear; if he is fording an icy stream, he signs the current with it and it becomes warm; if he wishes to inscribe a cross on a rock, the point of the staff cuts the stone as if it were soft clay. He curses with it, he blesses with it, he heals with it, and he uses it to quell his enemies, human, bestial and demonic. A blow of it on the ground, and things long buried will suddenly emerge or the earth will open to swallow a sinner or an adversary. If he stands in such favour with God that he is permitted to bring the dead to life, he works the miracle by a touch of his staff. When he dies, it becomes one of the most treasured possessions of his community.

So much we learn from pious legend but there is also ample historical evidence to show that the cult of the saint's staff was a very old and widespread one. A penitential which is not later in date than the end of the eighth century prescribed forty years on bread and water for the theft of a crozier; the rigour of this sentence contrasts with the mere seven years' penance which the same text lays down for the theft of a gospel book. The annals contain many references to staffs attributed to certain saints: their enshrining, their theft, their profanation, their destruction, their use as talismans in battle or for swearing oaths and affirming agreements. The Irish name for such a staff was *bachall*, a loan-word from the Latin *baculus*, and the most famous of all was the *Bachall Íosa* or 'Staff of Jesus' which, legend said, St Patrick had received directly from heaven. It is repeatedly mentioned down the centuries but it was burned in Dublin as an object of superstition during the religious troubles of the sixteenth century.

Fig. 71. Shrine of St Patrick's Bell: side view showing openwork bronze interlacements silhouetted against a sheet of gilt bronze. 1094-1105 A.D.

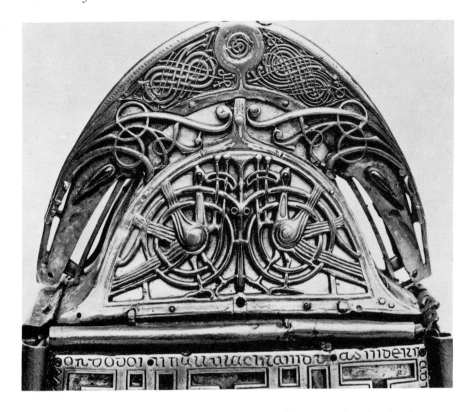

Fig. 72. Right: Shrine of St Patrick's Bell. Back of crest, with two confronted birds (peacocks?) enmeshed in the spiral turns of stylized animals, the long jaws of which are threaded through the birds' beaks. 1094–1105 A.D.

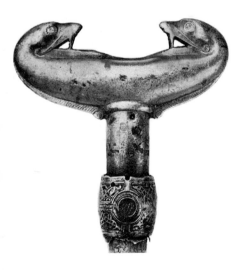

Fig 73. Above: Tau crozier, Co. Kilkenny, with two seal-like animals with open mouths. w. 15 cm. 12th cent. A.D.

No early example of an enshrined staff has survived; the known specimens all date to the eleventh or twelfth centuries, with the exception of a few to which ninth- or tenth-century dates have been attributed. As most of the intact examples have a wooden core, it has been assumed that they had a dual character, being at once functional croziers and shrines for venerated staffs associated with the saints. Two types were in use in Ireland, the more usual being the crooked staff but the tau or T-headed kind, common in some eastern churches, was also known, as representations on the high crosses and shrines show. Only one example has so far come to light: a cast bronze head with portion of the shaft, including a single knop, which was found in Co. Kilkenny (Fig. 73). It takes the form of the opposed heads of two seal-like animals with short upright manes and two fangs in the upper jaws of their open mouths. Their eyes are of pink glass and the knop is divided into panels of interlace by bands of silver inlaid in the bronze.

The other type of Irish crozier differs from its European congeners in the absence of the sinuous crook which, in the former, is a simple curve with a short and usually perpendicular drop at the end, the top of the crook being almost invariably fledged with a crest. For preference, the decorative elements of the crest are chosen to permit the composition of an openwork pattern: a line of birds or quadrupeds, rendered in a tolerably naturalistic fashion, as on the Clonmacnoise

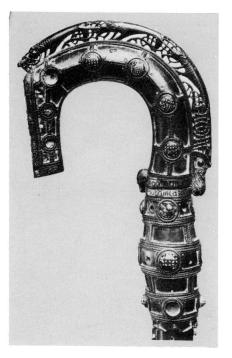

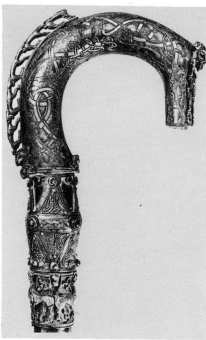

Fig. 74. Far left: Lismore Crozier, Lismore, Co. Waterford. w. of crook 15·2 cm. 1090–1113 A.D.

Fig. 75. Left: Crozier of Abbots of Clonmacnoise, Clonmacnoise, Co. Offaly. w. of crook 14·9 cm. *c.* 1125 A.D.

Fig. 76. Below: Crozier of Abbots of Clonmacnoise: front of crook in form of a human mask which forms a canopy for the figure of a bishop. *c.* 1125 A.D.

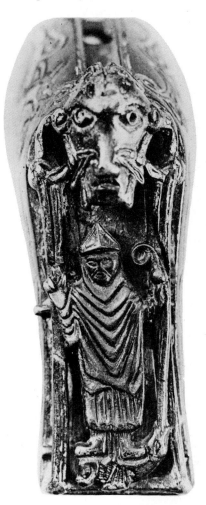

Crozier (Fig. 75), or intertwined monsters, as in the Lismore Crozier (Fig. 74). Bronze is used for both head and shaft, the latter usually having three knops and a tapering, sometimes polygonal, ferrule. The surface of the head is often covered with a reticulation of bands or ribs in relief, calculated to subdivide it into a large number of small panels, producing a faceted appearance and making the distribution of the applied ornament more manageable. The knops, which tend to be biconical in shape and are designed to break the long line between crook and ferrule and enhance its visual rigidity, are similarly treated. The outer side of the drop frequently bears a male head in high relief or the full-length figure of an ecclesiastic.

The two croziers mentioned above will serve as typical examples of those belonging to the last phase of the Early Christian period. That from Lismore, one of the most lavishly decorated, contains a yew-wood staff which may, conceivably, have been associated in tradition with St Carthach or Carthage of Lismore who died in 638 A.D. (Fig. 74). At the base of the crook the crozier bears an inscription in Irish asking prayers for Niall Mac Aeducáin, Bishop of Lismore from 1090 to 1113, who commissioned it and for Nechtan, the artificer who made it. The crest consists of three large beasts and the massive head of a fourth. The small inset panels of the crook and upper knop are missing, except those on the flat outer face of the drop. The middle line of the side of the crook has a row of large round glass studs with mosaic patterns in red, blue and white. The presence of millefiori plaques along the edge

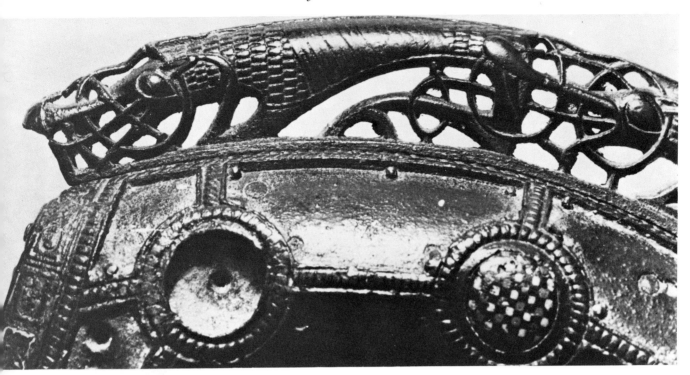

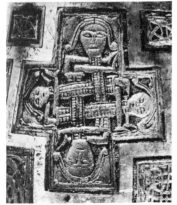

bordering the drop indicates the late survival in Ireland of this decorative feature. The upper knop has similar studs and others with geometric designs. The panels of the middle knop are filled with zoomorphic interlace, and those of the lowest one bear interlace both zoomorphic and anthropomorphic in character, a standing figure and four men with interlaced limbs (Fig. 77).

The crook of the Clonmacnoise Crozier is not divided into panels but is covered with an overall interlace of silver ribbons inset in the bronze (Fig. 75). The pattern is of Urnes complexion and its sweeping loops and slender tendrils are so perfectly adapted to the area and curvature that they seem to sheathe the surface like an organic skin. On the drop is the mitred figure of a bishop, one hand raised in blessing, the other holding a crozier with a spiral crook, its point thrust into the mouth of a winged demon on which he stands (Fig. 76). This is perhaps a later addition, but the grim mask which forms a canopy above is an original feature. The crest, half of which is missing, is a lively procession of dog-like animals, each biting the rump of the one in front. The upper and lower knops have a reticulated design of small triangular panels with *champlevé* patterns. The dividing ribs have flanking strips of copper and silver inset in the bronze, the upper and lower halves of the knops being separated by wider horizontal ribs set with panels of simple interlace and studs of deep blue glass. The barrel-shaped middle knop has a loose geometric interlace of silver bands. Below the upper knop the shaft is encircled by a band with sprightly quadrupeds in

pairs (Fig. 78). Their shoulders and hips are decorated with spirals, their clawed forelegs interlocked, and their heads turned to stare out at the spectator. The tail of each is knotted in a triquetra above its body, and its tip approaches that of the beast behind it to support between them a bodiless animal head. Despite the conventionalisation of their anatomy, they succeed in being among the most animated creatures in Irish art.

Fig. 77. Opposite: Lismore Crozier. 1090-1113 A.D. Above: Animal in crest. Centre: Human figure on lowest knop. Below: Four men with interlaced limbs on lowest knop.

CRUCIFIXION PLAQUES

Apart from the sculpture, only a limited number of crucifixion scenes have survived but all show a remarkable uniformity in general treatment. One of the earliest known is an openwork plaque of late seventh- or early eighth-century date from St John's, Co. Roscommon (Plate 32). To judge by the rivet holes in the remaining portions of the narrow frame, it was a mount for a shrine or book cover. It is of gilt bronze with rich surface decoration. As in all early Irish representations of the crucifixion, Christ is shown clothed in a long garment, arms outstretched horizontally and feet side by side, in a standing rather than a hanging position. The cross itself protrudes above his head and below his feet and his arms are outlined against the transom. Although this and the upper shaft have the incurved edges typical of the ringed cross, no ring is shown. The lance-bearer and sponge-bearer standing below and the two angels above in the act of alighting on the arms of the cross form a symmetrical group about the central figure. As so much else in Irish art, it betrays no interest in the human form or in the expression of any emotion. The faces are bland, blank masks, there is no distinction between the body and its garment and the visible parts of the limbs are almost casual appendages to the outline. The sleeves of Christ's robe have cuffs with interlace, the hem two bands of interlocking spirals, each side a border of diagonal key-pattern, and down the centre there runs a panel of two-strand interlace. What, at first sight, appears to be a large breastplate independent of the robe is, in fact, of quite different origin. The two sleeves and skirt of the garment are treated as three individual units, each ending on the body in two spirals, united by a crescent formed by two trumpet-patterns. Taken by themselves, the spirals with their accompanying trumpet-patterns form a rhythmic composition of great sophistication; they are gradated in size from above downwards to harmonise with the expanding lines of the body. The standing figures are in profile and dressed in decorated cloaks and tunics. Each angel above has a pair of wings rendered by a convention

117

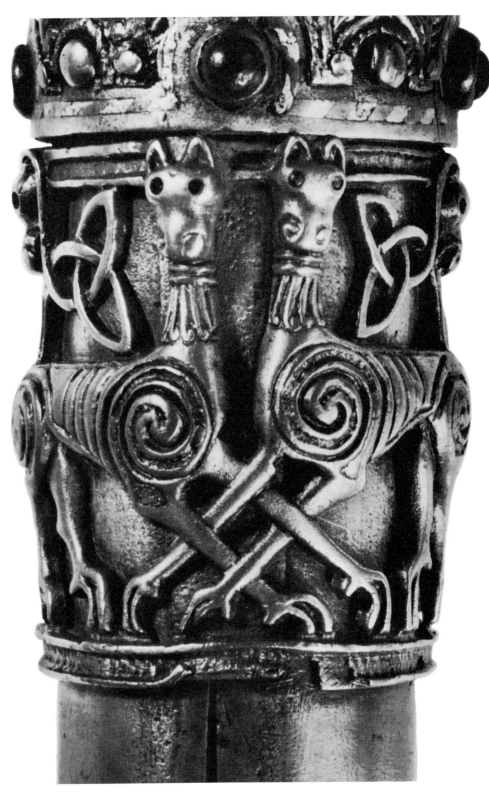

Fig. 78. Crozier of Abbots of Clonmacnoise: detail showing two confronted animals. *c.* 1125 A.D.

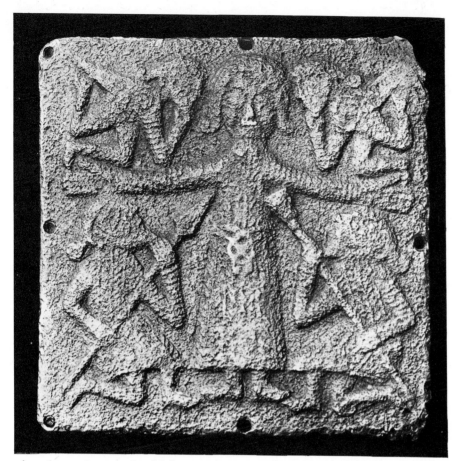

Fig. **79**. Bronze crucifixion plaque with lance-bearer and sponge-bearer below and two angels above, find-place unknown. L. 7·7 cm. 11th cent. A.D.

already ancient and which was to persist for centuries later: spirals on the joints and lines of hatching representing the pinions. The improbable position of the wings in relation to the bodies can hardly be due to mere ineptitude and seems to arise solely from a desire to provide a frame for the head of Christ, the inner edge of which splays out below to join with the ends of the transom in the same way as it connects with the upper shaft of the cross on top.

This version of the crucifixion continued to be reproduced in metalwork in later times, the known examples dating from the tenth to the twelfth centuries. Of these, four are of openwork and one cast in the solid. In composition, the last is much superior to the others, exhibiting a remarkable freedom of gesture and movement (Fig. 79). Vertically, it obeys the iron law of symmetry but it is partitioned horizontally by Christ's extended arms into two pleasantly balanced parts which mitigate the rigidity of the arrangement as a whole. The cross is not shown and Christ wears a full-length robe, girdled with a belt knotted in front to form a simple interlacement. His hands are disproportionately large and his feet are seen in profile. The lance-bearer and sponge-bearer, with upturned faces, kneel on one knee, the shafts of the lance

and sponge-cup forming the midribs of a pyramidal series of lines converging on the face of Christ. The angels which fly down from both sides are almost a phenomenon in Irish art, being studies in movement which embraces body and limbs. They are probably the only completely successful effort among the few attempts in that art to suggest motion in flight. Their hands raised to their chins are, in all likelihood, intended to portray them in the act of whispering words of comfort into the ears of the dying Christ, and it is just possible that this pose is a reverential adaptation of the constantly recurring theme of two animals whispering into the ears of a human figure standing between them.

The type and style of the openwork plaques are illustrated by one, the find-place of which has not been recorded (Plate 33). It resembles the one just described in general plan but is inferior in composition and crude in execution. The openwork technique necessarily calls for careful planning of the tie-points where the figures are joined to each other and to the frame to form a rigid whole, but the craftsman who cast this plaque gave little thought to the problem, as is witnessed by the helpless artifice of fusing Christ's hair with the shoulders of the angels and the liberty which he took in, as it were, cutting up the girdle of his kilt into convenient lengths to tie the lower figures to the frame. No cross is visible, Christ's hands and feet being fastened to the surface of the frame, although the angels which appear to stand on his arms probably imply a tacit assumption that it is concealed behind his body. The kilt which he wears first appears in Irish crucifixions about the beginning of the twelfth century. The design on the border of the plaque is exceedingly rudimentary but for all its shortcomings it has a certain primitive rugged strength. A gilt bronze plaque found at Clonmacnoise shares the same arrangement of the figures but depicts Christ in a long-sleeved garment (Fig. 82).

HANGING BOWLS

There is comparatively little material for the study of the Irish treatment of form in itself, as distinct from form as a vehicle for applied ornament. Pottery was, to all intents and purposes, unknown throughout the whole of the Early Christian period except in a limited area in the north and east of the country and as a rare import elsewhere. All the domestic vessels were made of wood and finds of these are numerous in bogs, but it is difficult to attribute any of them with certainty to the period in question. Most of them are, in any event, purely utilitarian in character but exhibit a nice sympathy for the qualities of the medium

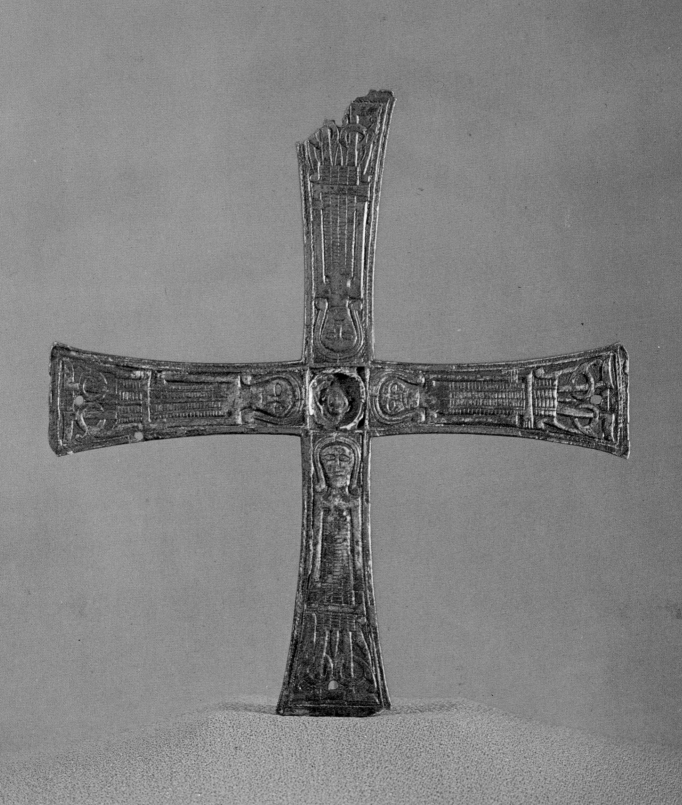

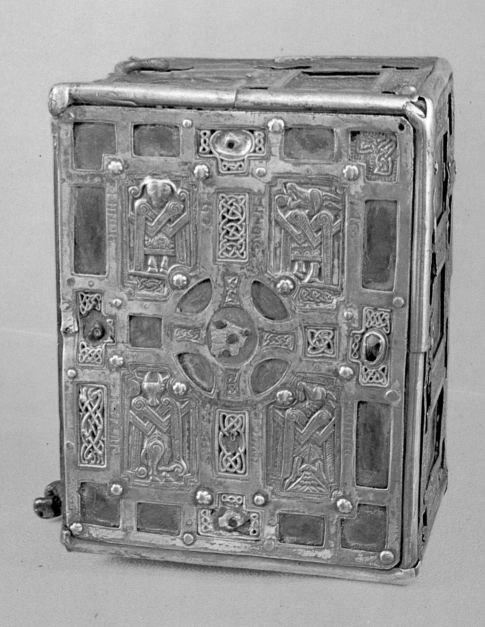

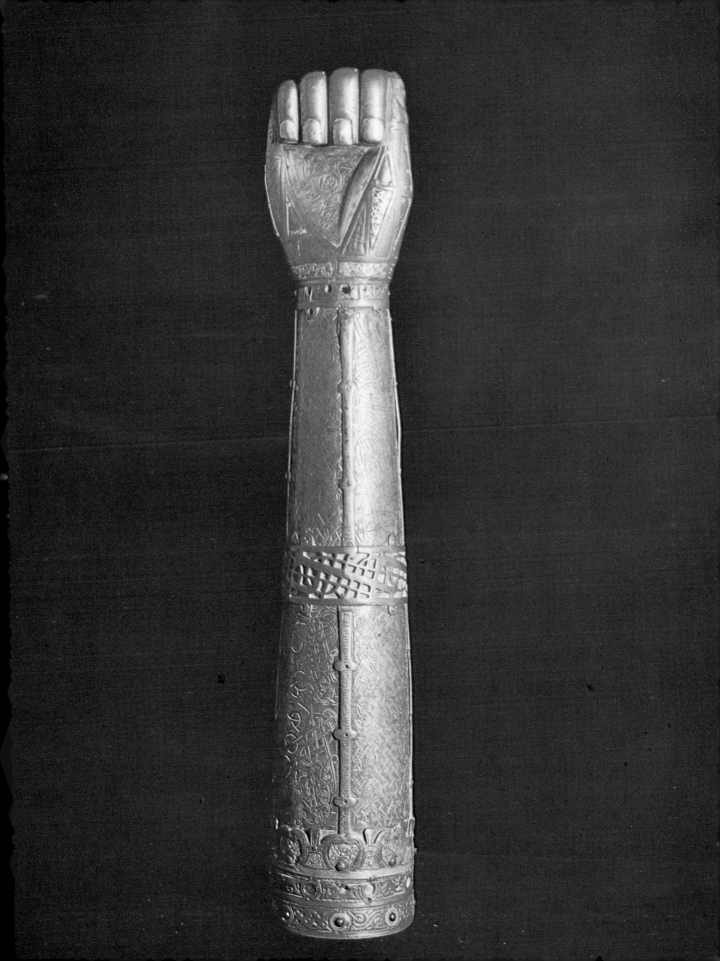

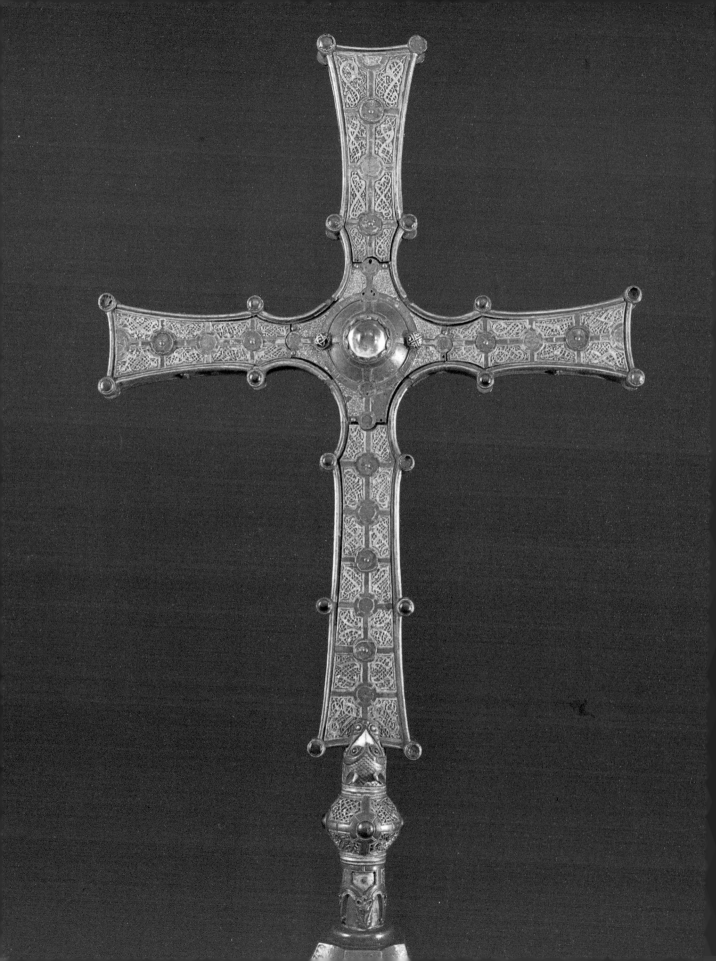

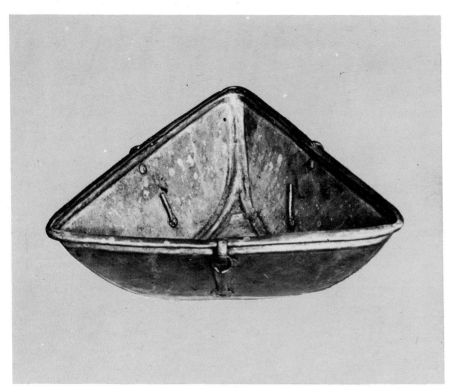

Fig. 80. Bronze hanging bowl, Kilgulbin East, Co. Kerry. W. 24·8 cm. Tentatively dated to *c.* 400 A.D.

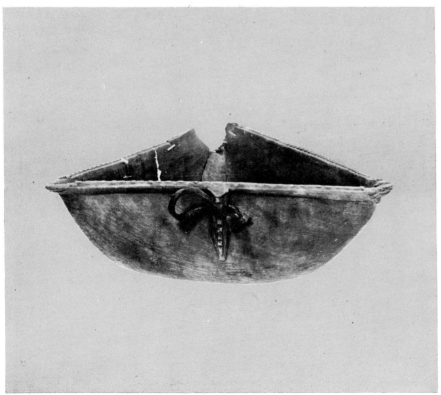

Fig. 81. Wooden hanging bowl, Cuillard, Co. Roscommon. W. 28 cm. Tentatively dated to *c.* 400 A.D.

Plate 36. Overleaf: Shrine of St Lachtin's Arm. H. 37·9 cm. 1118-1121 A.D.

Plate 37. Opposite: Cross of Cong, Cong, Co. Mayo. H. 75 cm. 1123-1136 A.D.

and a functional simplicity which contrasts with the elaboration of the metalwork. There is no archaeological evidence for the extensive use of metal vessels and the few which have come to light include a number of small hanging bowls or lamps, late representatives of a type found in Roman contexts in Europe in the second century A.D. and which seems to have been introduced into Ireland some centuries later. It has been claimed that many of those found with Saxon burials in England and with Viking burials in Scandinavia are of Irish origin. The earlier examples were frequently decorated with hook escutcheons and applied discs with patterns set off with *champlevé* enamel in red and yellow and, occasionally, millefiori glass (Fig. 83). Although some fitments for them have been found, no early bowls have been discovered in Ireland, but specimens dating certainly to the seventh century and possibly considerably earlier are now known. They include a surprising range of shapes. One from Derreen, Co. Clare, is hemi-

Fig. 82. Right: Bronze crucifixion plaque, Clonmacnoise, Co. Offaly. L. 7·8 cm. 11th-12th cent. A.D.

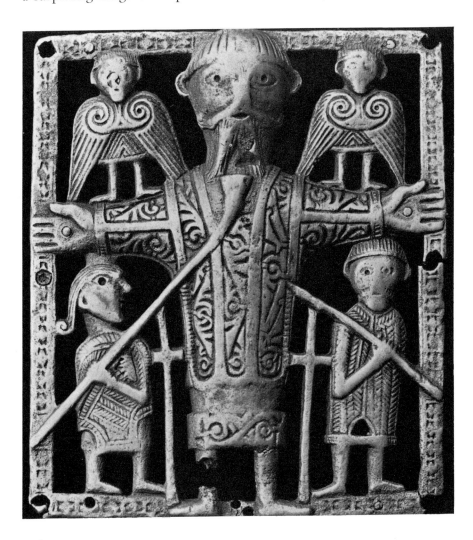

spherical; one from Kilgulbin East, Co. Kerry, is triangular; while one from Ballinderry, Co. Westmeath, seems to combine both forms, for it is pear-shaped in plan and has a rounded bottom. The Kilgulbin bowl is made of a single sheet of bronze, beautifully proportioned and with a deep moulding below the rim which conveys to the eye the strength which it physically imparts to the metal (Fig. 80). A suspension ring was fastened in the centre of each side by a hook in contact with the rim: it combines with its escutcheon to reproduce the bird form more naturalistically rendered on some of the earlier bowls. A wooden bowl, found in a bog in Cuillard, Co. Roscommon, in 1963 is, very remarkably, almost identical in shape and size with the Kilgulbin one (Fig. 81). It is carved from a single piece of timber and retains one of the three leather loops by which it was suspended. It is a daring and successful experiment in reproducing in one medium a form proper to another. This series of vessels, to which must be added a round shallow stone bowl with three suspension lugs from Ballynacourty, Co. Waterford, shows a very considerable freedom in the treatment of form and an enterprise in experimenting with the possibilities of various media.

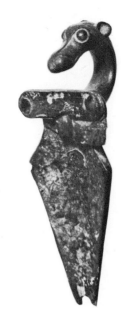

BOOK-SHRINES

While there is literary evidence for the custom of enshrining books from the ninth and tenth centuries, and although there is no reason why books, whether on account of their intrinsic or associative value, should not have been enshrined at a much earlier date, those book-shrines which have come down to us belong mainly to the eleventh and twelfth centuries, although even later examples exist. They all take the form of comparatively small rectangular boxes and all bear signs of repair, remodelling and redecoration at different times. One of the most coherent is that known as the *Soiscél Molaise* or 'Gospel of St Molaise', which was, presumably, the manuscript for which it was made (Plate 35). An inscription dates it to between 1001 and 1025 A.D. It is made of bronze; one narrow side is missing and openwork silver plates are riveted to the remaining sides. That on the front contains a series of small panels forming an equal-armed ringed cross. Between the arms are four large panels depicting the symbols of the evangelists and around the edge there is a row of narrow panels, the whole arrangement bearing a strong resemblance to that on the shrine of St Patrick's Bell (Plate 31). The insets of many of the panels are missing, those that are left being of inferior gold filigree. The evangelist symbols are of gilt silver and each has the name of the symbol and that of the evangelist inscribed on the margin. They are curiously varied in pose:

Fig. 83. Two views of suspension hook of hanging bowl, the escutcheon decorated with red and yellow enamel, Clonmacnoise, Co. Offaly. L. 7 cm. 7th–8th cent. A.D.

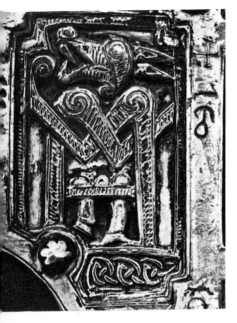

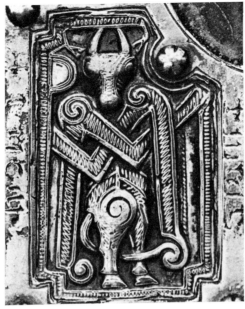

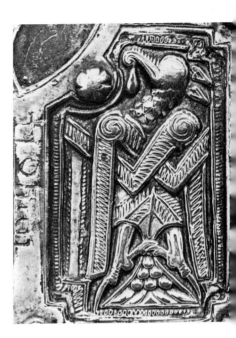

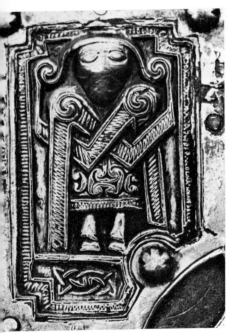

Fig. 84. Evangelist symbols from book-shrine (*Soiscél Molaise*). 1001-1025 A.D. Above: Man (St Matthew). Top left: Lion (St Mark). Top centre: Calf (St Luke). Top right: Eagle (St John).

the man is seen wholly frontally, the lion wholly in profile, the calf with head frontally and hind legs in profile, the eagle with head in profile and body as if viewed from the back (Fig. 84). All four have highly stylised wings, crossing in front and falling perpendicularly to frame their sides. The figures, in their details, demonstrate the remarkable continuity of archaic motifs in Irish art: the spirals on the wing joints and the hip-joint of the calf, the peltae on the man's dress, and the trumpet-patterns out of which the lion's head has been constructed. They are very characteristic, too, in displaying the irresistible temptation to join one thing to another to form a closed circuit, as in the tail of the calf spiralled into its wing tip and the wings of the man into the curls of his hair, and the *horror vacui* which dictated the insertion of the semicircular bulge and the twin projections from the margin beside calf's head and the droplet hanging from the eagle's beak. Despite the limitations inherent in the observance of these stylistic canons, the artist has given us four strangely impressive figures, monumentally serene and full of a bizarre heraldic dignity.

Dated by its inscription to between 1045 and 1052 A.D. is another book-shrine, commonly known as the Shrine of the Stowe Missal but the traditional name of which is the Shrine of St Maelruain's Gospel, an illumination from which has been already described (Fig. 53). It is an oak box covered with silver plates (Fig. 85). The front is an addition of the fourteenth century and shows the total submergence of the native tradition by a generalised European style. The sides, mutilated though they be, preserve some very interesting features. On one is a delightful group formed by two clerics in cloaks and tunics, one hold-

ing a crozier of typical Irish form, the other a typical bell, and, between them, a small seated man playing a harp, with a winged angel above him (Fig. 86). The flanking figures and the angel, with their rigid frontal pose and the smother of formalism in line and drapery which covers them, surround, like a passive shell, the dynamic kernel formed by the clean profile outline of the body and limbs of the little harper. The central panel on another side shows a man with a long spade beard and a sword in his hands. He is flanked on each side by two hound-like animals, the upper one of each pair having its head twisted to whisper in his ears (Fig. 86). The man appears to be seated and the lower pair of creatures may represent the carved legs of a stool or chair on which he sits. This tiny figure is noteworthy in being one of the very rare portrayals of the nude or near nude in a lay context in the whole range of Early Christian Irish art. If these two panels savour of innovation, nothing could be more conformist in conception or execution than the two roundels on the other sides of the shrine which, except for some technical details, might have come out of a workshop of the eighth century. The two creatures whispering in the angel's ears and whose

Fig. 85. Shrine of St Mael-Maelruain's Gospel ('Stowe Missal'). w. 16 cm. 1045-1052 A.D.

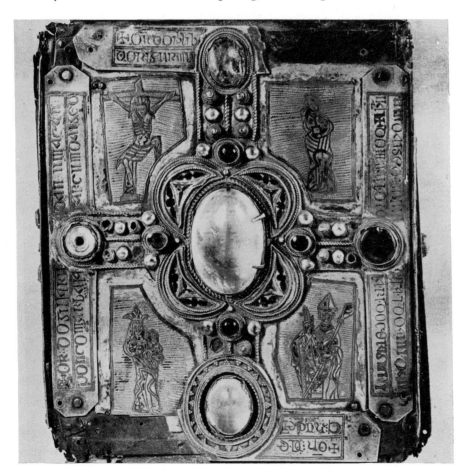

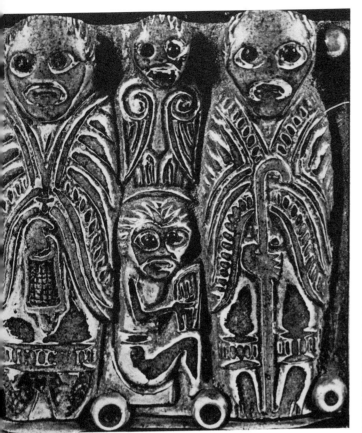

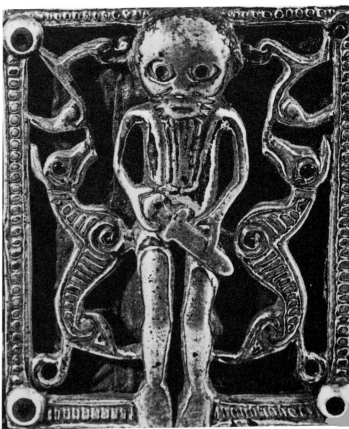

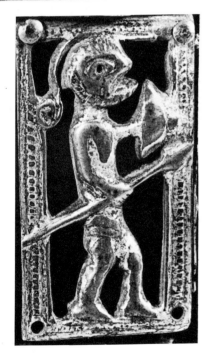

bodies from the frame of a roundel at once recall those on the bell-shrine fragment already described (Fig. 68). The eyes are small studs of dark blue glass, the spirals on the angel's wings are of the same glass inlaid with silver wire, and the bodies of the animals are filled with ultramarine glass similarly inlaid.

MISCELLANEOUS SHRINES

One of the earliest types of Irish reliquary is a shrine in the shape of a house or tomb, and a number of eighth-century date have been discovered. A late representative is that known as the *Breac Moedóic* (Fig. 87). The name means 'Moedóc's Speckled One or Thing', the person in question being a sixth-century saint associated chiefly with Co. Wexford. It is almost completely denuded of its original features and it is of interest mainly on account of the figure panels which have been attached to it. Some fragments of what may be the primary decoration are attributable to the ninth century but it is generally agreed that the

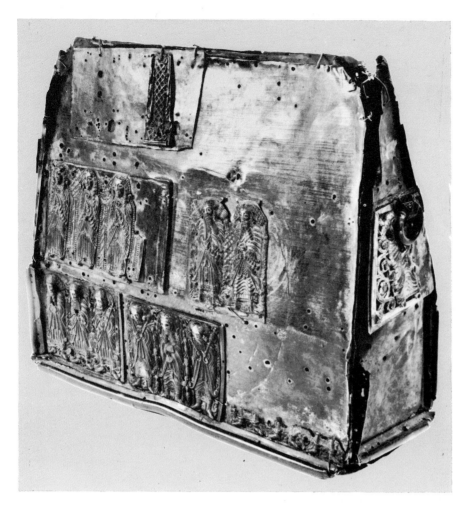

figure panels are of eleventh- or twelfth-century date. Four, rectangular in shape, are on one side of the shrine and a fifth, triangular in outline, on one of the ends. They are of bronze, originally gilt, and the four rectangular ones embrace a total of eleven figures, made up of three groups of three and one group of two. In many respects both the figures and the ornamental details are unique in Irish art. Each figure is framed between two column-like panels of ornament so that it seems to occupy a niche in an arcade. Whatever their prototypes may be, the penguin-like birds and their human-headed companions which form two of the 'columns' have no recognisable relatives among the creatures to be found in the Irish repertoire. One panel shows three female figures, virtually identical one with the other (Fig. 89). The archaic simplicity of the drapery of their long cloaks and tunics contrasts strongly with the flamboyance of that of their male counterparts, as do also their lank ringlets with the electrified hair of the men. The artist seems to have been at pains to create an impression of feminine demure-

Fig. 86. Opposite: Three panels from shrine of St Maelruain's Gospel ('Stowe Missal'). 1045-1052 A.D. Above left: Two ecclesiastics with harper between them and angel above. Above right: Man with sword. Below: Warrior with shield.

Fig. 87. This page: House-shaped shrine (*Breac Moedóic*). w. 22·3 cm. 11th-12th cent. A.D.

Fig. 88. House-shaped shrine
(*Breac Moedóic*). 11th-12th
cent. A.D. Two panels, each
with figures of three men.

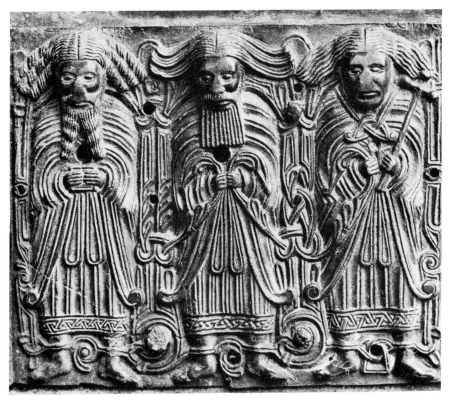

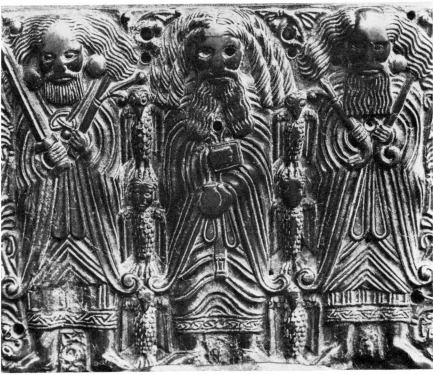

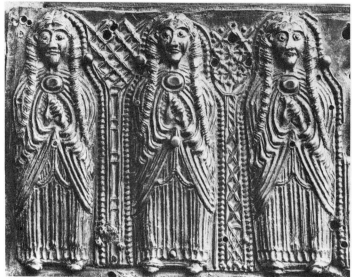 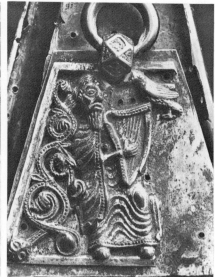

ness, extending the severity of his treatment even to the decorative panels which frame the women. His male subjects seem to have evoked a very different response in him. No two of the eight men are alike in person or dress. Their beards are wavy or straight, long or short, forked or square-cut, and their long hair shows an almost equal variety of style. Their massive heads reveal a wholly unexpected naturalism in features and an even more unexpected realism in the bald crowns of two of the subjects (Fig. 88). The figures have not been identified with certainty but they carry a variety of symbols or insignia: books, three-knobbed crosses, a sword, a phial and what seem to be scourges or flowering rods. One, hand pressed to his cheek, seems lost in thought. It can hardly be denied that these eight small figures of men are the most powerful and realistic representations of the human figure in Irish art. Moreover, although they are undoubtedly ecclesiastics, their emphatic masculinity is the nearest approach to expression of the sexual which the art of the whole Early Christian period has to show.

The triangular panel on the end of the shrine shows the gilt profile figure of a harper with a bird above to the right (Fig. 89). The harp, being the principal and favourite musical instrument of the time, is frequently depicted in the sculpture, and a bird, presumably symbolising music or song, sometimes accompanies it.

A reliquary which combines primitive simplicity of form with the utmost luxuriance of detail is that made between 1118 and 1121 to enshrine a relic reputed to be the arm of the seventh-century St Lachtin

Fig. 89. House-shaped shrine (*Breac Moedóic*). 11th-12th cent. A.D. Left: Panel with figures of three women. Right: Figure of harper on end of shrine.

Fig. 90. This page: Shrine of St Lachtin's Arm: detail of lower part showing silver interlacements inlaid in bronze and bordered by niello. 1118-1121 A.D.

Fig. 91. Opposite: Cross of Cong, Cong, Co. Mayo. Detail of front, showing applied panels of animal interlacements in gilt bronze and spirals executed in beaded gold wire. 1123-1136 A.D.

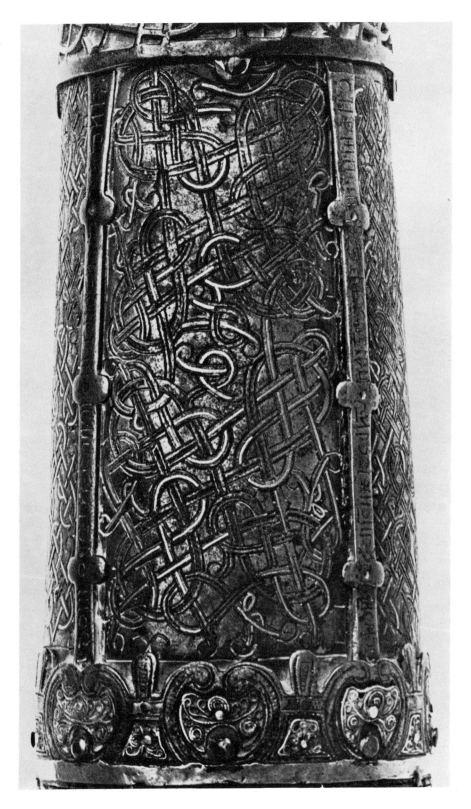

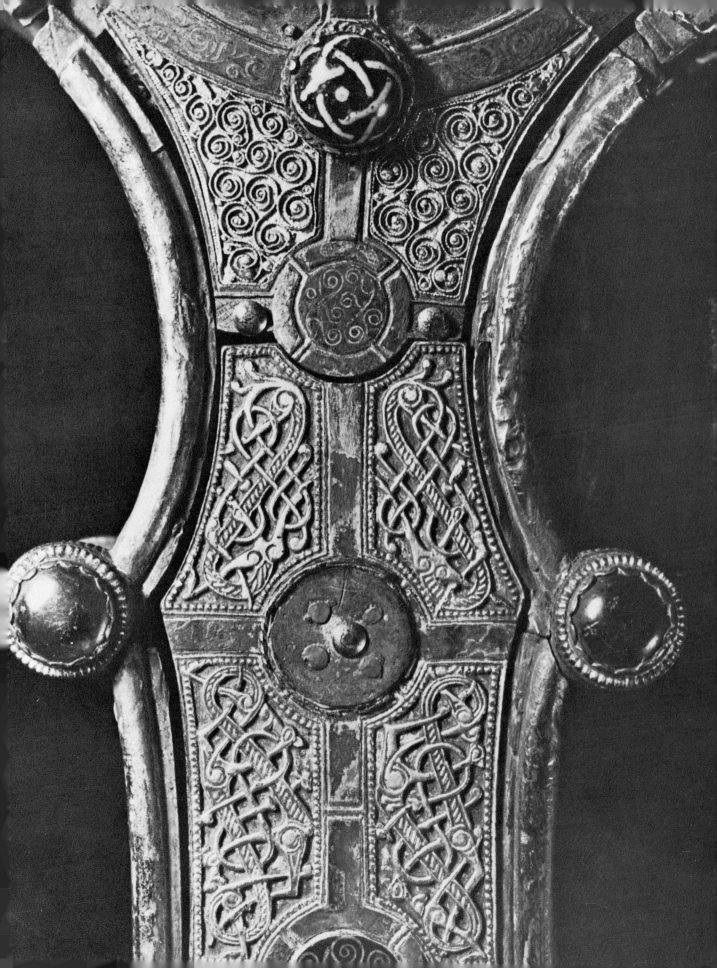

Fig. **92**. Opposite: Cross of Cong, Cong, Co. Mayo. Basal knop set with animal inter-lacements in gilt bronze and with animal head holding the end of the shaft in its jaws. 1123-1136 A.D.

(Plate 36). It takes the form of a forearm with the fingers bent down on the palm and is of bronze inlaid with silver. The arm portion is covered with eight long panels, divided into two sets of four by a broad band of cast bronze interlace in the Urnes style. These panels are filled with sweeping interlacements of silver ribbons inlaid in the bronze and resemble those on the head of the Clonmacnoise Crozier (Fig. 75). The lower end of the arm is bordered by small panels of geometric and animal interlace and glass studs, and above them is a ring of open palmettes set with minute scrolls in silver filigree (Fig. 90). Similar filigree is inset in the panels on the wrist and the triangular ones on the sides and back of the hand. The fingernails are executed in plain silver, and a large triangular silver panel, ornamented with spiral tendrils, fills the palm.

CROSS OF CONG

One of the last and one of the finest artistic efforts of the Early Christian period is the processional cross from Cong, Co. Mayo, which, its in-scription records, was made at the behest of Turlough O'Connor, high king of Ireland, to enshrine a relic of the True Cross (Plate 37). It can be dated to between 1123 and 1136 A.D. As is the case with all the post-Viking metalwork, it does not bear comparison in detail with the eighth-century masterpieces, such as the Ardagh Chalice, but, except for technical minutiae of ornament, it is still wholly in the Irish tradi-tion. In nothing is it truer to its ancient lineage than in its utterly non-representational character. The only overtly Christian elements in it are its cruciform shape, the central receptacle for the relic and the prayers invoked for the persons named in the inscriptions. All else is animal interlace, animal head and geometric pattern. Its purpose alone proclaims its nature and no adventitious signals of its meaning are admitted.

It is made of bronze plates fastened to an oak foundation. The sides, the rounded edges and divisions between the panels on the front are of silvered bronze. The tubular mounts on the margin are set in front with studs of red and green glass alternately and on the back with discs of yellow enamel patterned with red. The front of the cross is covered with a double row of gilt panels of animal interlace in an Irish version of the Scandinavian Urnes style (Fig. 91). The empty circular settings on the median lines probably held glass studs, and the flat discs between them are decorated with silver spirals set in niello. At the crossing of shaft and transom is the large rock crystal which covered the relic. The

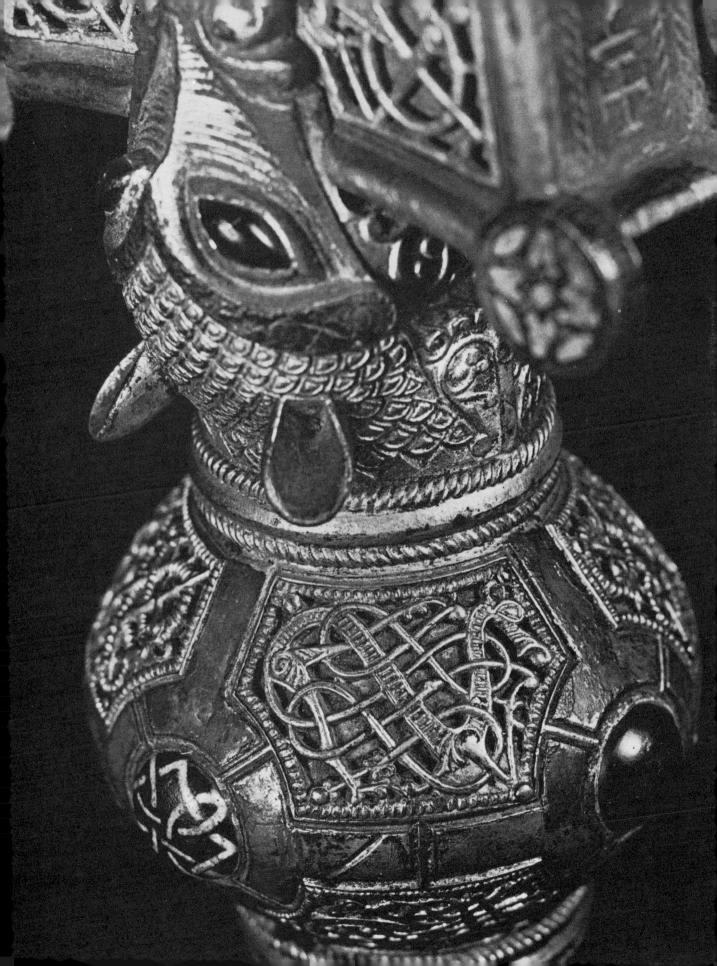

crystal is held in place by a frill of lunettes decorated with spirals and circles in gold filigree and surrounded by eight small panels similarly ornamented. On the back of the cross a single large openwork plate of zoomorphic interlace laid on a gilt bronze backing covered each member, but that on one arm is now missing. The end of the shaft is held between the jaws of an animal, the head of which appears in full on back and front. The knop below the head bears panels of gilt bronze animal interlace (Fig. 92) and four animal heads depend around the tube of the socket for the carrying staff.

The shape of the cross was obviously inspired by the ringed cross from which are derived the four graceful arcs at the junction of arms and shaft and the tubular mounts on the margin which recall the rolls on the rings and in the angles of the arms of the high crosses (Plate 39, Figs 117, 122). Their repetitions on the corners of the arms and shaft at once soften and emphasise the angles and provide a sort of logical conclusion to the converging curves of the adjacent edges. A reminiscence of the even older equal-armed cross is apparent in the way the middle pair of mounts on the margin of the lower shaft fall, not midway on its length but at the same distance from the central crystal as those at the ends of the arms, to form a Greek cross within the Latin one, in which respect it bears a striking resemblance to the much earlier cross on the Tullylease slab (Fig. 108).

Although intended to be seen when mounted on its staff, the cross is so superbly designed that not alone do its proportions remain unimpaired without it but either the cross itself or the cross together with its knopped socket can exist as a self-contained entity. Moreover, the animal head on the socket which holds the cross proper in its jaws is more than a mere decorative joint between one and the other for, both visually and conceptually, it allows the cross to lead the independent existence to which its proportions entitle it. In addition, the subordination in width of the knop to the end of the shaft lends further grace to the airy but firm poise of the cross on its socket.

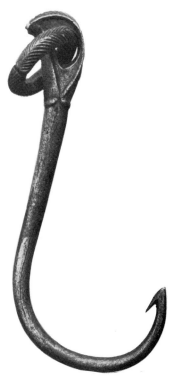

Fig. 93. Bronze fish-hook, Carrownanty, Co. Sligo. L. 6·7 cm. Date uncertain, possibly Iron Age.

MISCELLANEOUS ITEMS OF METALWORK

Although some of them are now mutilated and denuded of many of their former features, the greater number of the items of metalwork previously mentioned are entities in themselves. However, much else of what survives consists of fragments, the original purpose of which it is sometimes difficult even to surmise. This heritage of bits and pieces is, however, far from being valueless for the remarkably large propor-

tion of it which exhibits technical and artistic excellence indicates the general high level of the craftsmanship of the time, while the individual objects often illustrate new facets of accomplishment (Fig. 94). In addition to these detached or broken pieces there are, of course, intact examples of personal ornaments, fitments and equipment of various kinds. These include a bronze fish-hook of uncertain date but which belongs either to the Iron Age or the Early Christian period (Fig. 93). We seem to be still far from understanding the social environment in which so much skill and patience were expended in making this small workaday object a memorable piece of craftsmanship. The expansion for the eye on the top of the shank reproduces in miniature the line of the hook; the mouldings on the edge of the recess coalesce below as if to clamp the shank firmly between them; and a meticulously executed herring-bone pattern decorates the ring for the attachment of the line and forms a crest on the curve of the expansion.

Two bronze belt buckles, both dating to the seventh century, are lavishly ornamented in very different ways. The design on that from Lagore, Co. Meath, consists of three spirals, the hair-like lines emerging from which unite with minute trumpet-patterns to form a tracery that fills the spaces between and around them (Fig. 99). In adaptation to their differing sizes, the internal patterns of the three spirals vary from one to another, and the structures of the individual patterns appear to change as the focus of the observer's attention shifts from one component element to the next. The centre of the largest spiral is occupied by a smaller one that forms the core of a triskele, the tips of the curved arms of which coil inwards to interlock with the hooked ends of trumpet-patterns. In the middle spiral the triskele is replaced by two curved members diametrically opposite each other, an arrangement reproduced in simplified form in the third and smallest spiral. In contrast with the impression of twirling eddies created by these designs, the decorative scheme of the other buckle, which was found on the shore of Lough Gara on the borders of Counties Roscommon and Sligo, is a placid mosaic of red and yellow enamel (Fig. 97). The basic pattern is the cruciform one visible in the Eight-Circle page of the Book of Kells (Plate 16) and the front of the *Soiscél Molaise* book-shrine (Plate 35) but modified to conform to the converging lines of the buckle by a resourceful manipulation of the cross-shaped insets of yellow enamel. The wider end has two hemispherical amber studs and the three small square insets on the median line are filled with green glass. The narrower end bears a large domed glass stud patterned in blue and white.

Although, as has been already observed, the part played by animal motifs in the art of Early Christian Ireland is all-pervasive, naturalistic representations of animals are extremely rare, the recognisably real ones depicted on a tiny scale on the Chi-Rho page of the Book of Kells (Plate 20) and the cats sculptured on the Cross of Muiredach at Monas-

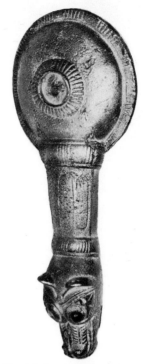

Fig. 94. Bronze mount terminating in an animal head with eyes of blue glass. The vacant setting on the disc originally held a stud, possibly of amber. Islandbridge, Co. Dublin. L. 7·7 cm. Probably 8th cent. A.D.

Fig. 95. Overleaf: Bronze ring-handle with attachment in form of an animal head with a human head engraved on its snout, Navan, Co. Meath. 8th-9th cent. A.D.

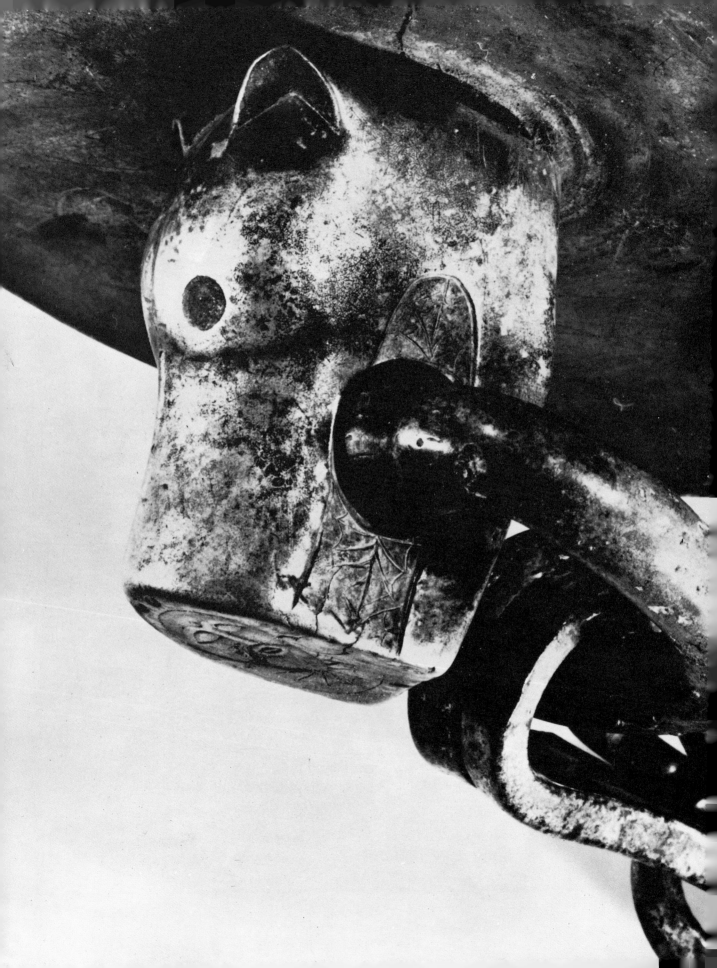

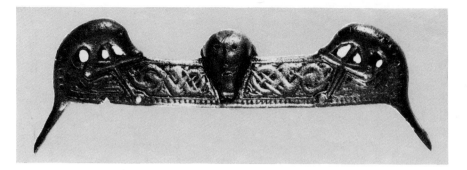

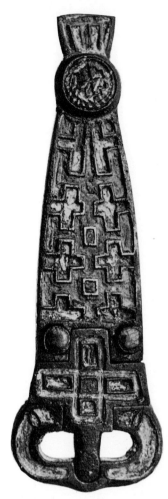

terboice (Fig. 118) being in startling contrast to the legions of stylised beasts which crowd the manuscript illumination and the metalwork. In some situations, however, these stylised creatures assume a lifelike role. They are used to unite one thing with another, the strength of the joint being symbolised by the tenacious grip of their clenched jaws. We have already met an example in the animal which fastens its fangs in the base of the Cross of Cong to connect it with the basal knop (Fig. 92). The intimidating beasts that hold in their massive jaws the rings of two handles or attachments, one from Navan, Co. Meath, the other of unknown provenance, embody the suggestion of an even more unrelenting grip (Figs 95, 98). Other instances of this symbolic use of animal jaws may be seen on the hinge of the Tara Brooch (Plate 26), in the heads at the end of the ring which grasp the terminal plates of the Drimnagh Brooch (Plate 25) and in the reversal of this on the Cavan Brooch where the heads on the terminal plates bite into the ends of the ring (Plate 28).

If animal motifs were used in this fashion to add a pictorial dimension to function, they were also employed to vivify features normally represented as lifeless and inert. Instances involving the transformation of columns and rectilinear borders by endowing them with animal characteristics have been cited previously from the Book of Kells (Plate 18, Fig. 51). A fragment of metalwork, which is probably of eighth-century date, provides another. It comes from a small house-shaped reliquary, of which a number survive. Late classical sarcophagi were, in all likelihood, the ultimate inspiration of their form, but they undoubtedly also reflect the more immediate influence of the style and construction of contemporary wooden buildings. These appear to have had carved wooden ridge-poles, and the fragment in question is a miniature bronze model of a ridge-pole of this kind (Fig. 96). At each end is an animal head with gaping jaws and a long protruding tongue, as if the ridge-pole was to be conceived as two beasts with their heads twisted back to face each other. Between them is a human head, the midway position of which is occupied on several of the surviving shrines by a rectangular prominence which represents the smoke-hole above the central hearth of the original wooden house on which the

Fig. 96. Above left: Bronze ridge-pole of a house-shaped shrine, find-place unknown. It terminates in animal heads with gaping jaws and has in centre a human head flanked by panels of animal interlacement. L. 13·4 cm. Probably 8th cent. A.D.

Fig. 97. Above right: Bronze buckle, Lough Gara, Co. Sligo. Decorated with yellow and red enamel (latter has now disappeared), square green glass studs, two domed amber studs and a large stud of blue and white millefiori. L. 7·7 cm. 7th cent. A.D.

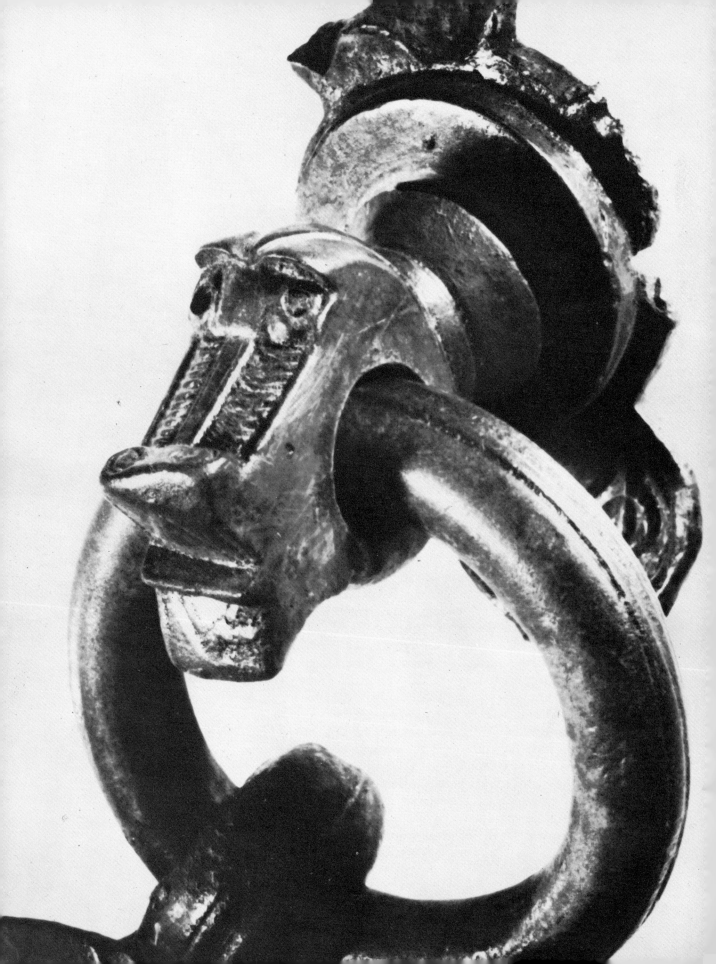

shrine was modelled. We would probably be correct in regarding the transformation of this into a human head and of the ends of the ridge-pole into animal ones as the expression of a version of a theme which occurs over and over again in the art of the period and which apparently goes back to Sumerian times. It consists of a man standing fronting the spectator and flanked by two animals or animal-headed figures which hold their mouths close to his ears. It is to be seen most frequently and conspicuously on the high crosses, where it is usually interpreted as depicting demons whispering temptations into the ears of St Anthony the Hermit (Fig. 116). What appears to be an abbreviated version, in which the beast-headed figures are reduced to pure animal shape and the man to a human head, occurs in many contexts on the metalwork. A version which might be construed as intermediate between these two appears on a fragment of a bell-shrine where the human figure is represented in full but the beasts are depicted in serpentine form (Fig. 68). On the hinge of the Tara Brooch two human heads, chin to chin, replace the single one, and the animal heads, which are usually shown in profile, are seen in plan (Plate 26). Still another variant of the same theme is to be detected in those contexts in which the roundel or stud which appears between the muzzles of two animals seemingly deputises for the human head. Examples of this are to be seen on the false buckle of the Moylough belt-shrine (Fig. 65) and the brooches from Roscrea (Plate 25) and Killamery (Fig. 61).

Besides dress pins in a large variety of types and ring-brooches with bulbous brambled terminals, the personal ornaments of the later centuries of the Early Christian period include large brooches with pendent kite-shaped heads and enormously long pins. One of the finest, the pin of which is of less exaggerated length, has the front of the pendant divided into panels each of which contains a single animal, the outline of the body being executed in gold filigree and its surface covered with granulations (Fig. 101). In order to adapt the animal motif to the triangular shape of the lowest panel representation is limited to the frontal view of a head, the lines of which are echoed by the still more drastically stylised animal head in relief on the point below.

So much of the decoration of the larger metalwork objects consisted of separate panels of ornament riveted in place that detached fragments tend to be unit parts of the original scheme of ornament which can be enjoyed in their own right in spite of being divorced from their larger setting. Such an item is the gilt bronze corner mount from Clonmacnoise with its magnificent openwork triskele and animal interlacements (Fig. 100). Another is a bronze plaque from Holycross, Co. Tipperary, which has a central cross with semicircular expansions and foliage patterns surrounded by panels of animal interlacing of a pronounced Scandinavian complexion (Fig. 102). An attractive little bronze object of lace-like openwork recalls the ridge-pole previously described since it,

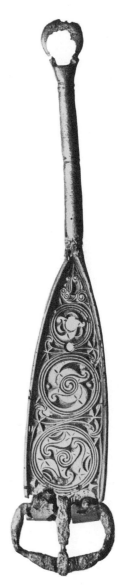

Fig. 99. Bronze buckle decorated with a delicate pattern of scrolls and spirals, Lagore, Co. Meath. L. 16·4 cm. 7th cent. A.D.

Fig. 98. Opposite: Bronze ring-handle with attachment in the form of an animal head, find-place unknown. L. of head 4·3 cm. 8th cent. A.D.

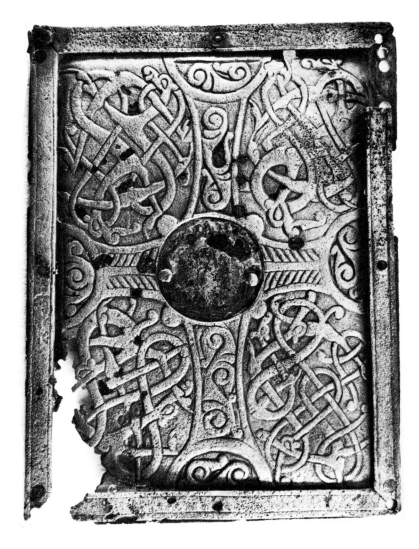

Fig. **100**. Above: Gilt bronze corner mount for shrine or book-cover, Clonmacnoise, Co. Offaly. The centre is occupied by an openwork triskele with curved limbs and the ends are filled with animal interlacements. L. 8·2 cm. Probably 8th cent. A.D.

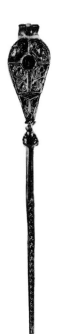

too, reproduces a feature of the contemporary wooden buildings – the carved projecting ends of the barge beams which crossed at the apex of the gable (Fig. 103). This architectural embellishment, which was to be found on timber houses in various parts of Europe in recent times, was translated into stone on many of the Irish Romanesque churches (Fig. 130) and, at an earlier date, can be seen on the temple in the page in the Book of Kells which illustrates the Temptation of Christ (Plate 24). It is also visible on the Cross of Muiredach at Monasterboice, on which, in common with a number of other high crosses of about the same date, the top of the shaft takes the form of a timber church with a steep shingled roof (Fig. 117). Thus, there can be no doubt that our openwork bronze is a finial which decorated the gable of a house-shaped shrine.

144

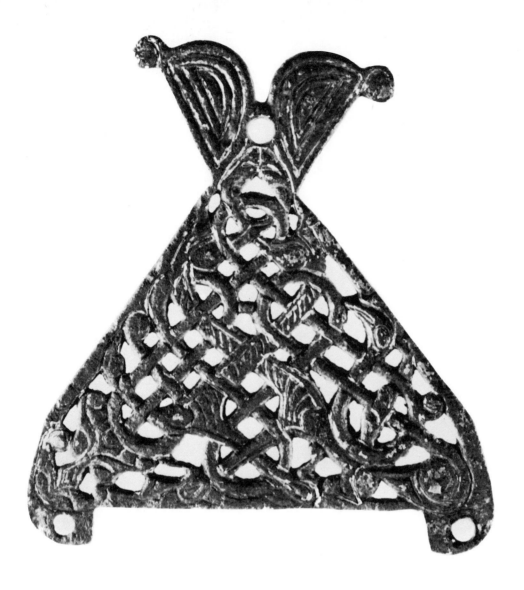

Fig. 103. Above: Bronze openwork gable
finial of house-shaped shrine, find-place
unknown. H. 5·7 cm. Early 12th cent. A.D.

Fig. 102. Opposite above right: Bronze
plaque, Holycross, Co. Tipperary. It has a
central cruciform design and the quarterings
filled with animal interlacements. L. 8·6 cm.
Early 12th cent. A.D.

Fig. 101. Opposite below left: Kite-shaped
brooch, find-place unknown. Of silver with
the head inlaid with panels of gilt filigree. L.
17·1 cm. 9th–10th cent. A.D.

Sculpture

Except for the small amount that can be ascribed to the Iron Age, Irish sculpture is found almost exclusively in religious contexts and can hardly be said to exist as a lay art. Moreover, it is, primarily, a form of applied art, mass and form, in so far as they occur, being to a very large degree accidental to the sculptors' main preoccupation. Its rudimentary beginnings in Early Christian times are visible in the cross-inscribed boulders and slabs still existing at the sites of many of the early monasteries. These bear a Greek cross in a circle or a Latin cross with expanded ends. They are sometimes found on the largely pagan memorial stones which bear, in the Ogham script, the name of the person commemorated, the Ogham letters consisting of one to five lines cut across or to either side of a central stem line (Fig. 109). These crosses may incorporate a schematic representation of the Chi-Rho monogram of Christ. To these basic figures the Irish artists added expansions containing spirals and key-patterns, particularly to the end of the lower shaft (Fig. 105). In the specialised form of funerary monuments, decorated slabs have a continuous history from the seventh to the eleventh century. They exist in large numbers at some of the monastic cemeteries, the greatest concentration being at Clonmacnoise, Co. Offaly, from where between four and five hundred have been recorded (Figs 104, 107). Despite the care and labour lavished on the ornament, only a small minority of the slabs are trimmed either in outline or surface. Most of the slabs bear short inscriptions in Irish, each consisting of the person's name and, usually, a request for a prayer for his soul. There are very few instances where this inscription is integrated either into the ornament itself or into the general design. Nor was any provision made for it when the design was being planned, for the words and letters are usually fitted haphazardly into whatever space is available around and between the ornament, the clumsiness of the arrangement and the irregularity of the lettering being in startling contrast with the symmetry and elegance of the decoration. It seems obvious that the pattern was executed at leisure beforehand but that the inscription was hastily inserted between the death and burial of the person commemorated. While, as might be expected, the cross is an invariable prime element in the design, its treatment displays almost limitless variation. It may be equal-armed or of the Latin kind, free on the stone or enclosed in a round, square or rectangular frame. Its arms may end in triangular, square, semicircular

Fig. **104**. Opposite: Funerary slab Clonmacnoise, Co. Offaly, inscribed 'Pray for Tuathal Saer'. 9th cent. A.D.

147

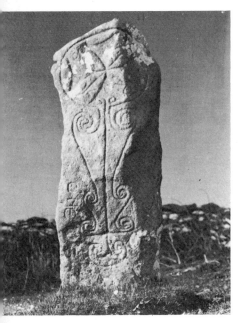

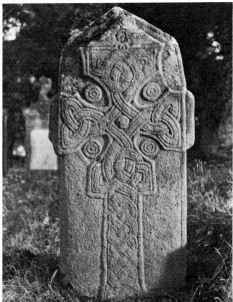

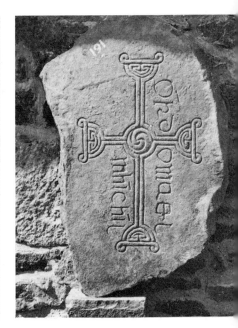

Fig. 105. Above left: Cross-inscribed standing stone, Reask, Co. Kerry. The Greek cross in a circle has an elegant design of spirals forming its stem. It bears the letters DNI (Domini) and possibly dates to 6th-7th cent. A.D.

Fig. 106. Above centre: Cross-slab, Fahan Mura, Co. Donegal. On the other face of the slab is a cross executed in similar broad ribbon interlace with a small standing figure at each side of the shaft. Possibly 7th cent. A.D.

Fig. 107. Above right: Funerary slab, Clonmacnoise, Co. Offaly, inscribed 'Pray for Mael Mhíchíl'. 9th cent. A.D.

Fig. 108. Page 151: Richly decorated slab, Tullylease, Co. Cork, with Latin inscription asking a prayer for Bericheart. 8th cent. A.D.

or circular expansions, plain or filled with interlace or fret-patterns. An expansion, square, rectangular or circular, similarly decorated with interlace, frets, spirals or trumpet-patterns, may be found at the meeting of the arms (Figs 104, 107, 108). On many slabs there are ringed crosses, closely resembling in shape and proportions free-standing crosses of the same type. The designs are all purely abstract and, with the exception of a fish on a slab at Fuerty, Co. Roscommon, and a man and three heads on one at Gallen, Co. Offaly, there is no representation of anything, animate or inanimate. It is also remarkable that the animal interlace so common on other objects of the period is virtually non-existent on the slabs.

The funerary slabs form a self-contained group, following an evolution of their own apart from the mainstream of Irish sculpture, but the line of development of the latter is by no means clear. It is possible to construct a theoretical progression from primitive versions of the crucifixion incised on slabs on the islands of Inishkea and Duvillaun, Co. Mayo, through large slabs with crosses in relief at Fahan Mura, Co. Donegal (Fig. 106), and Glendalough, Co. Wicklow, to monuments such as one at Carndonagh, Co. Donegal, where the slab itself has assumed an approximation to the outline of a cross decorated with broad ribbon interlace and a number of very simplified figures. Even assuming the destruction of a large number of the monuments which might have augmented the series, it is still a very big step from even the last examples in this sequence to the sophisticated proportions and highly developed monumental conception of those high crosses which have been placed earliest in date and it is obvious that much relating to

Plate 38. Opposite: South cross, Castledermot, Co. Kildare. 9th cent. A.D.

Plate 39. Overleaf: High cross, Drumcliff, Co. Sligo. 10th cent. A.D.

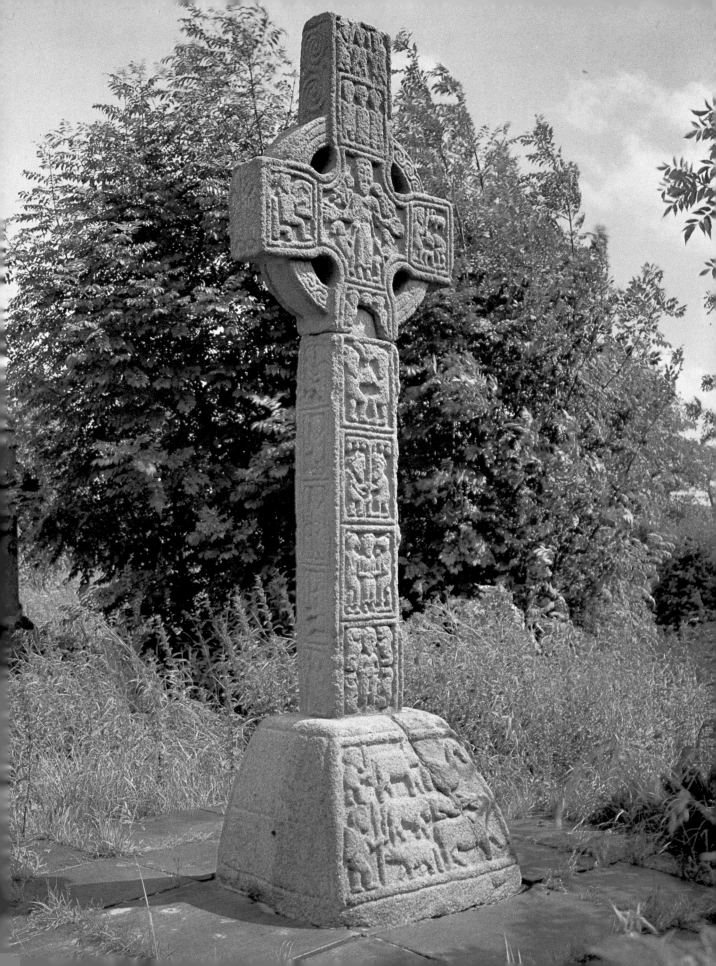

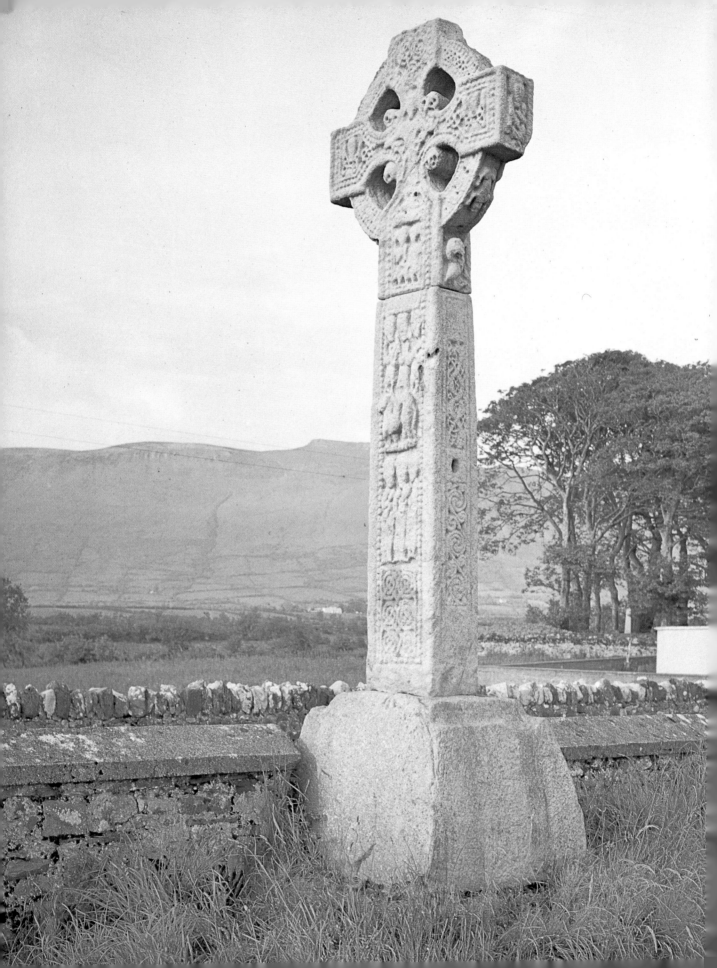

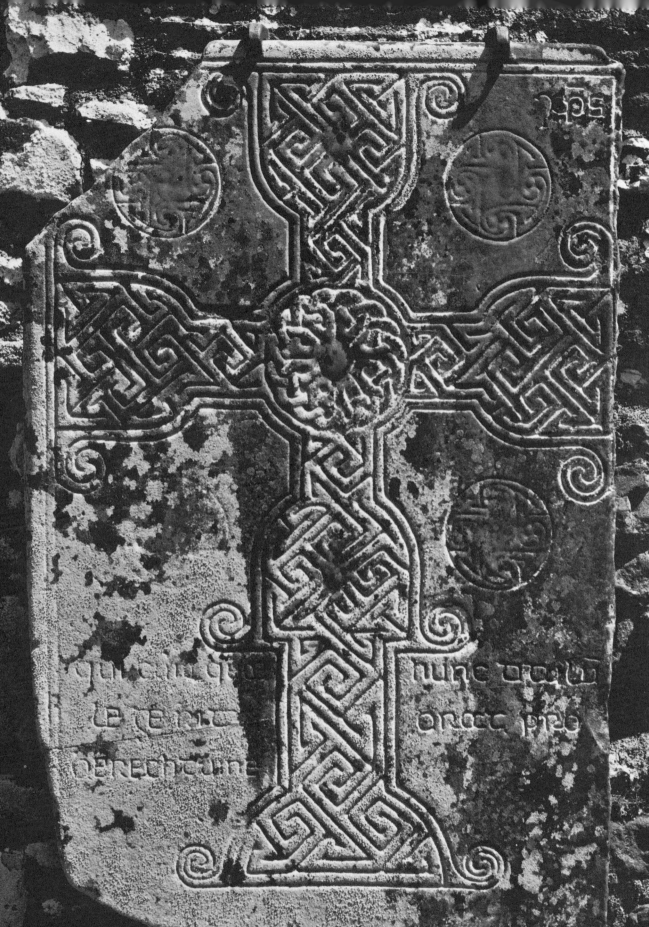

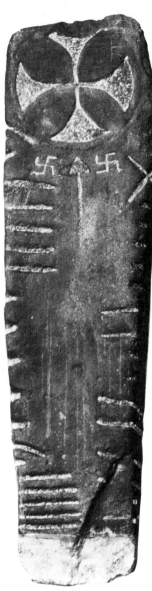

Fig. 109. Ogham stone, Aglish, Co. Kerry. The inscription is cut along the angles and the Greek cross at the top was possibly added at a later date to christianize the monument. H. *c.* 90 cm. 5th-6th cent. A.D.

Fig. 110. Opposite: South cross, Ahenny, Co. Tipperary. The arms and shaft are covered with ribbon interlace and at bottom of latter is a panel of five spirals enclosing triskele motifs. Early 8th cent. A.D.

their origin and development is still obscure. It is apparent, however, that by the eighth century large stone crosses were standing in the precincts of monasteries in many parts of the country. A typical specimen is, perhaps, 3 m. high and has a large base with sloping sides supporting the shaft, which tapers upwards to its junction with the arms, shaft and arms being joined by four great arcs of stone to give the impression of a ring or wheel. Within this general formula there is very considerable variation in size, relative proportions of the component parts, and decorative treatment, but the effect is always one of massive dignity. The blossoming of this monumental sculpture in a relatively short time where, to all appearances, there was only the scantiest tradition of it, and the quick growth of the high technical skill which made it possible are phenomena not yet fully understood.

A comparatively large number of these crosses, whole or fragmentary, have survived, the main concentration being east of the Shannon, with another group in the north of the country and sporadic examples elsewhere. On considerations of style and iconography, coupled with the equation of names which occur on the few inscribed examples with those of historically known persons, a dating scheme has been evolved for the various groups into which the monuments can be classified. Those, like the Ahenny crosses (Fig. 110), in which the decoration is confined to abstract ornament, are placed earliest and attributed to the early eighth century and those, like the Monasterboice ones (Fig. 117), which bear an ordered system of figure panels, are considered to be the latest and assigned to the ninth and tenth centuries. The fact that the sculpting of these elaborate monuments apparently continued uninterrupted by the Viking incursions is one difficulty in the way of accepting the usual view that these raids were responsible for a decline in such other fields of Irish craftsmanship as manuscript illumination and metalwork.

One very distinctive group of crosses is found in an area in the south of Counties Tipperary and Kilkenny and comprises examples at Ahenny, Kilkieran, Killamery and Kilree. The most striking are the two which stand in close proximity at the first of these sites (Fig. 110). The rings are wider in proportion to the length of the shaft than in the majority of the crosses, and the prominent rope-mouldings on their edges leave the surface deeply recessed. Shaft, arms and ring are covered with a web of decoration, with the minimum subdivision into panels, consisting in the main of ribbon interlace and spiral motifs. In the centre of the junction of shaft and transom is a large richly carved boss, having four slightly smaller ones equidistant from it on the shaft and arms. These appear on both front and back of the cross and are so reminiscent of the ornate studs used to conceal rivet-heads in metalwork that it has been suggested that the whole cross is a gigantically enlarged version in stone of a metal prototype. Figure sculpture is confined to the base

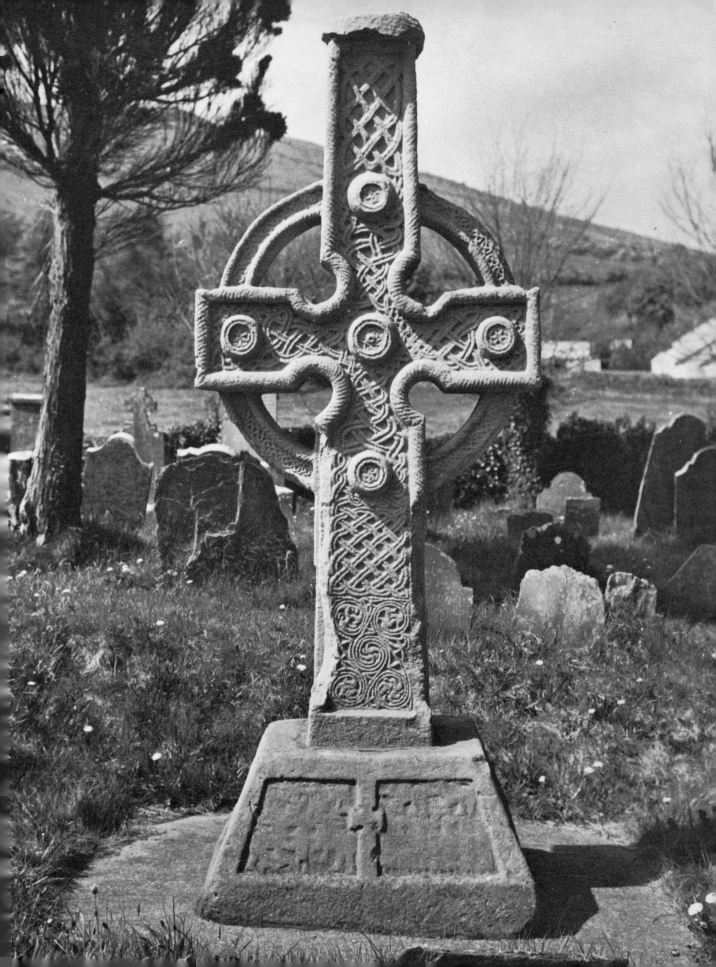

which, on one side of the North Cross, consists of an enigmatic scene showing a man standing beside a stylised tree facing a number of quadrupeds and birds of different kinds, which has been interpreted as Adam naming the animals in the Garden of Eden (Fig. 111). Of the three crosses at Kilkieran not far distant, one is a completely atypical object and another is undecorated but very similar to those at Ahenny in shape. The third, or West Cross, which rises to a height of about 4 m., has mouldings, bosses, interlace and spirals of the same type as on the Ahenny crosses. Three sides of the three-tiered base bear ornament of the same character and the fourth a panel of eight horsemen. The large caps which appear on the Ahenny and Kilkieran crosses are anomalous features and may not be original.

Another group of crosses is to be found in an area north of the last and is associated with monasteries at St Mullins, Co. Carlow, Ullard and Graiguenamanagh, Co. Kilkenny, and Castledermot, Moone and Kilcullen, Co. Kildare. In these crosses the front and back of the shaft and, in some cases, the sides are divided into panels depicting scenes from the Old and New Testaments and abstract ornament takes a subordinate place in the decoration. The west face of the South Cross at Castledermot illustrates some of these scenes which, with minor variations in treatment, are repeated on cross after cross of the figured series (Plate 38). The crucifixion occupies its usual place in the centre of the head and below it, from above downwards, there follow: a broken panel; SS. Paul and Anthony being fed in the desert by a raven; Adam and Eve; two beast-headed figures whispering into the ears of a man between them, sometimes interpreted as the temptation of St Anthony; and Daniel in the lions' den. Above the crucifixion is an unidentified panel of three figures and on top Aaron and Hur support the uplifted hands of Moses. To one side of the crucifixion a seated David plays the harp and to the other Abraham is about to sacrifice the bowed Isaac, above whom appears a ram. A number of these scenes are repeated on one face of the North Cross at the same place. Although, for want of a better word, these panels are described as 'scenes', it will be evident that they were, in reality, not conceived as scenes but as symbols. The unit parts of any one panel are not apprehended as the elements of a picture but rather as the components of a hieroglyph. The only law governing their spatial relationship, one to another, is that they must be near enough to be linked together by a spectator who is familiar with the biblical or legendary incident which they symbolise. Thus free from all constraint to present them as pictures, the artist was completely at liberty to sort them out as patterns and the measure of his success in this can be gauged from such attractive arrangements as that of Daniel with his lions set out heraldically about him, or Adam and Eve, each beneath a bough of the stylised Tree of Knowledge, or the raven descending with its loaf between the hermits Paul and Anthony.

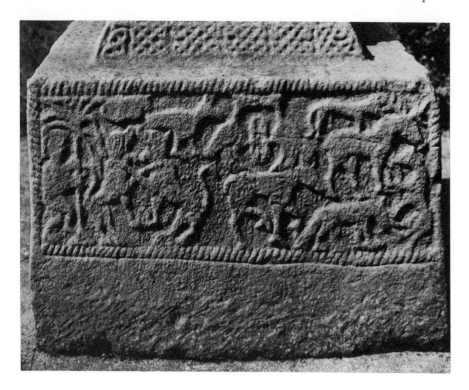

Fig. 111. North cross, Ahenny, Co. Tipperary: panel on base with scene depicting quadrupeds, birds and man beneath tree.

It is this priority given to pattern which explains and justifies the monstrously large hands of the crucified Christ on the South Cross (Plate 38). The abrupt contours of the individual figures, in part due to the hard stone from which the crosses are carved, complement the unflinching forthrightness of their arrangements to make a sharp instant impact on eye and mind.

The Moone cross, although closely connected with the Castledermot ones in shape, iconography and carving, stands apart from all other high crosses in proportions and style, the departure from tradition in both being so remarkable that, on one of the few occasions presented by Irish art, we feel ourselves in the presence of the work of a complete individualist (Fig. 113). In proportions it is conspicuous for the unusual height of its two-stage base, the upthrust of which streams on into the tall slender shaft to give the cross a soaring elegance which contrasts remarkably with the ponderous earthfast stolidity of the vast majority of its fellows. Even more remarkable is the astonishing sculptural shorthand of its figures and ornament. To compare the style of the figures with the punctilious naturalism of those on the Cross of Muiredach at Monasterboice (Fig. 117) and the ornament with the lace-like tracery of the Ahenny crosses (Fig. 110), is to realise that the Moone artist's vision of things was of an entirely different order. He presents the human figure as an outsize conventionalised head sitting on a square or rectangle with two profile feet and no arms. Mere

Fig. 112. This page: High cross, Moone, Co. Kildare: panel symbolising the miracle of the multiplication of loaves and fishes. 9th cent. A.D.

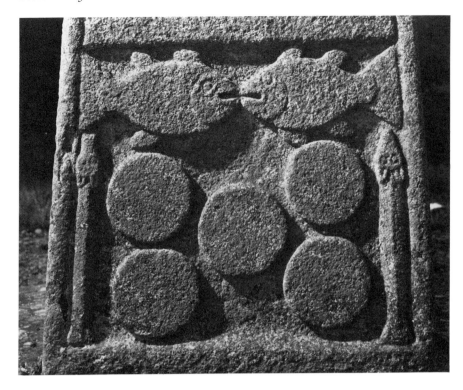

Fig. 113. Opposite: High cross, Moone, Co. Kildare. On base the twelve Apostles and above them the Crucifixion. 9th cent. A.D.

simplification of outline occurs elsewhere in Irish art – in illustration, as in the Matthew symbol in the Book of Durrow (Fig. 49); in metalwork, as in the figure on the bell-shrine fragment described above (Fig. 68); and in sculpture, as in the Castledermot crosses (Plate 38) – but it does so only sporadically and does not preclude enormous surface detail, as in the Durrow figure. The Moone simplification is altogether more radical and all-pervading, applying equally to the human and animal figures and the interlaced ornament (Fig. 114). If the subtle modelling of form displayed by the cross itself did not exclude all suspicion that this simplified treatment is mere primitive naïveté, the effortless ease with which the artist arranges his figures and motifs in brisk designs, perfectly in keeping with their crisp outlines, proves that his abbreviations are purposefully deliberate. It is as if he had planned to make each panel a monument within a monument. Shedding all reminiscences of illumination and metalwork, he sets out his interpretation of each pattern and each scene strictly in terms of stone. His panel symbolising the miracle of the loaves and fishes is almost an architectural composition (Fig. 112), his twelve apostles a cyclopean frieze (Fig. 113), and both are conceived as if larger than life. Even when in his Daniel scene he reproduces the Durrow lion (Fig. 48) almost line for line, every one of his seven versions is a pure creation of the chisel with no hint of pen or brush in its ancestry (Fig. 115). Nowhere can the boldness and freshness of his approach to stone as a

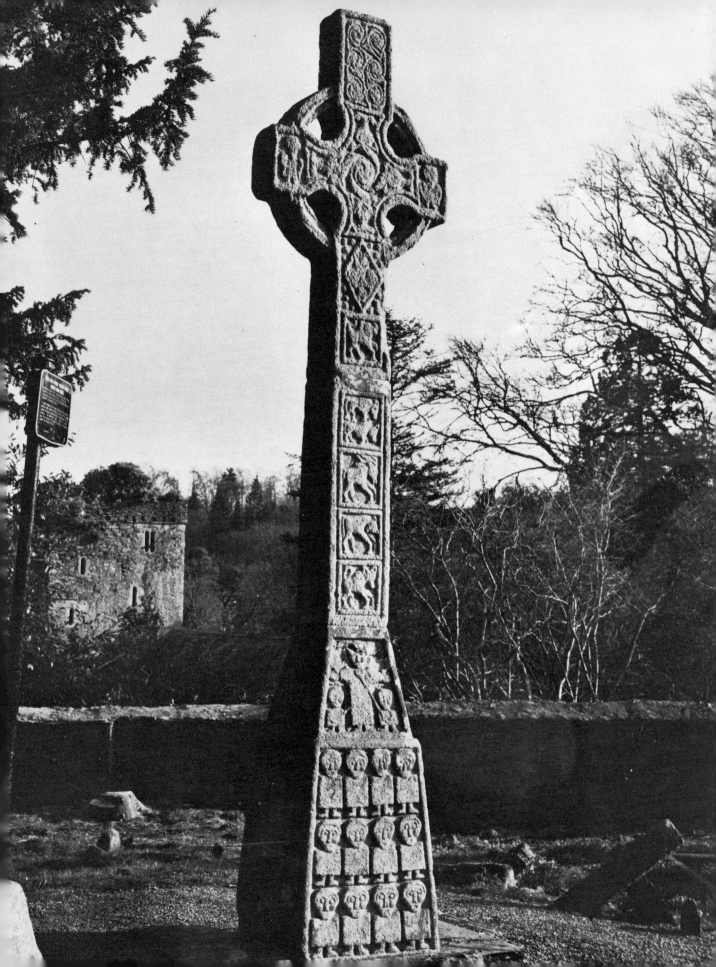

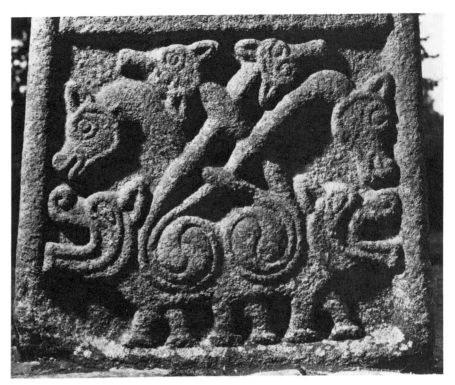

Fig. 114. High cross, Moone,
Co. Kildare: panel of animal
interlacement. 9th cent. A.D.

medium of expression be studied better than in the little panel showing
two animal-headed monsters whispering into the ears of a man standing
between them (Fig. 116). By the maximum use of straight lines, by the
minimum use of excavation and by working in two planes only, he
has achieved a starkly arresting effect. It is, perhaps, in the decorative
panels that the emancipation of the artist from the manuscript and
metalwork tradition, which constrained his fellow sculptors to con-
tinue to treat stone as if it were only a slightly less manageable vehicle
than either, is seen at its most complete (Fig. 114). The motifs are those
of his time but thought out anew in terms of stone. Much has been
omitted, emphasis has been concentrated on essentials and the whole
pattern reconstituted in new terms of balance of line and area. From
every point of view the Moone cross is a masterpiece of one of the most
gifted and original of Irish sculptors.

A further group of figured crosses is associated with a number of
midland and eastern monasteries: Clonmacnoise and Durrow, Co.
Offaly, Kells and Duleek, Co. Meath, Monasterboice and Termon-
fechin, Co. Louth. One of the finest and also one of the best preserved
is at Monasterboice. It is a massive but beautifully proportioned monu-
ment over 5 m. high and, since it bears an inscription asking for a
prayer for a man named Muiredach, it is usually known as the Cross of
Muiredach. It is, perhaps, the most carefully planned of all the crosses,
the arrangement of its panels being completely methodical, almost

158

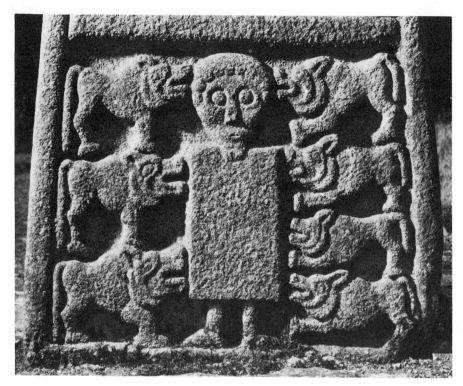

businesslike (Fig. 117). With a few minor exceptions, decorative elements are confined to the sides of the shaft and the ring. The figure panels, each framed by its own moulding, show a surprising degree of naturalism and, unlike the Castledermot crosses, the groups of figures are pictorially conceived in true scenes, as, for instance, in the Adoration of the Magi at the top of the lower shaft or in the panel immediately below it which depicts Moses striking the rock with his rod and the waiting Israelites ranged in two rows in front of him. Indeed, it might be said that the cross attempts something unheard of in Irish art: the expression of an extended narrative. In the centre of the transom Christ stands in judgement bearing the cross and flowering sceptre. On his right are the blessed, preceded by a choir which includes a harpist and a horn-blower; on his left the damned are being driven down to hell by demons, one armed with a trident, while below his feet the archangel weighs in a large balance a soul, depicted as a small human figure, and thrusts his staff into the prostrate devil beneath who tries to tip the scales in his own favour. This face of the cross is unusual, too, in the consistently large number of figures which populate its panels, three being the usual number on the other face and, with exceptions such as those at Kells, the average for the crosses in general. It is further distinguished by a freedom and variety in the pose of the figures and by a portrayal of movement particularly well shown in the scene of the weighing of the soul and in the vigorous kick with which the demon

Fig. 115. High cross, Moone, Co. Kildare: panel showing Daniel in the lions' den. 9th cent. A.D.

Fig. 116. This page: High cross, Moone, Co. Kildare: panel with two animal-headed figures flanking a human one. Sometimes interpreted as demons whispering temptations into the ears of St Anthony the Hermit. 9th cent. A.D.

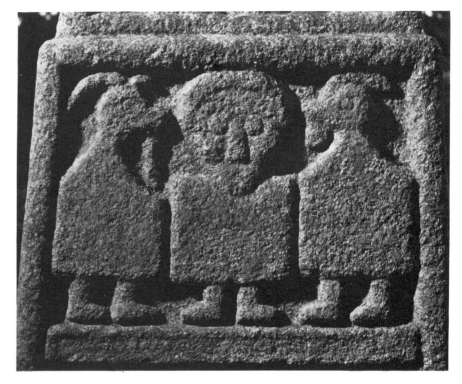

Fig. 117. Opposite: Cross of Muiredach, Monasterboice, Co. Louth. 9th-10th cent. A.D.

propels the damned into the abyss. The abstract patterns and hieratic figures of Irish art do not afford an encouraging environment for humour but the sculptor of this cross insisted on expressing his sense of it, at the cost of enormous trouble to himself in providing the additional plane for the little figures in relief on the four sides of the base of the shaft. On one side he shows two cat-like animals in what is apparently a courtship attitude (Fig. 117); on the opposite side two cats, crouched side by side in exactly the same pose, are curiously contrasted in occupation, for one licks a kitten held between its forepaws, while the other eats a bird, similarly clutched (Fig. 118). On the third side he has carved two cats in a well-observed stance of aggressive alertness and on the fourth two old men, squatted face to face, engaged in tugging each other's beard. The decoration on the sides of the cross includes panels of ribbon interlace, spirals and interlaced men, all marvellously executed (Fig. 119). The weathered and damaged base has a lower register of abstract ornament and an upper one of figures which include animals, centaurs, horsemen and a charioteer. A single massive monolith furnishes shaft, arms and ring, but the top, house-shaped and resembling the temple in the Book of Kells is a separate block.

The West Cross at the same site is the tallest of its kind, being over 6.5 m. high. Its great ringed head seems too precariously balanced on the almost parallel-sided shaft for the cross to achieve the majesty to which its towering height entitles it. The base is very worn, the bottom

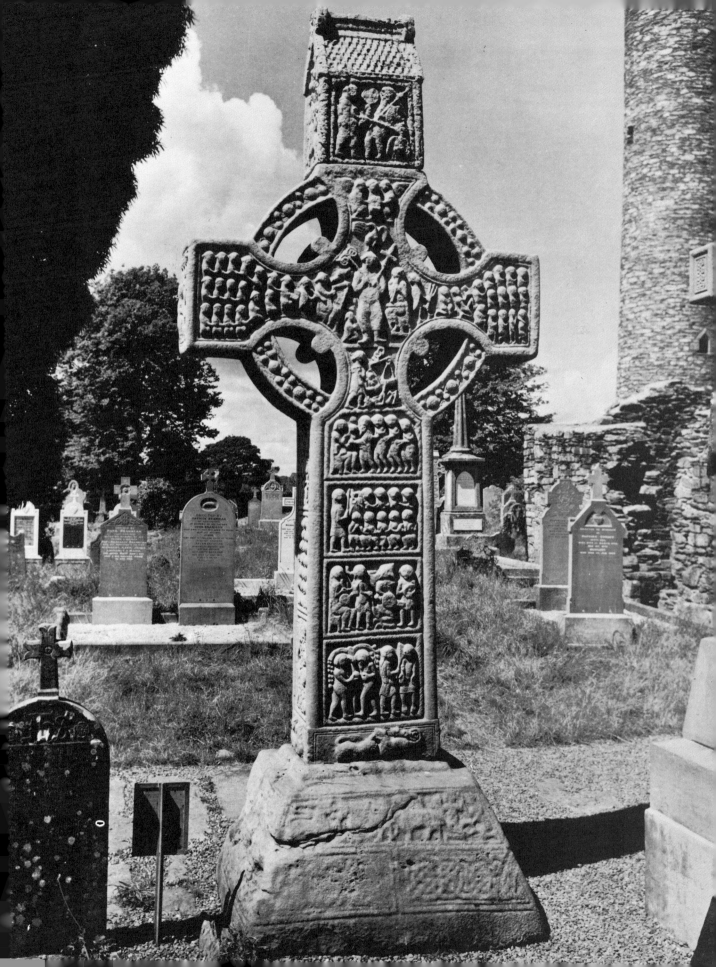

of the shaft damaged and all the panels much deteriorated from weathering. Like the Cross of Muiredach, it is topped by a house-shaped block and closely resembles that cross in the general scheme of its panels and in having many-figured scenes on one face. The readily identifiable scenes on the lower shaft are: at the bottom, David kneeling on the lion's back and tearing its jaws asunder; above it, Abraham sacrificing Isaac; and, at the top, the three children in the furnace, sheltered by an angel with outspread wings, with on each side a man with a faggot of sticks held aloft in a fork.

At Kells, Co. Meath, the monastic remains consist of a round tower, a small stone-roofed building and five high crosses. One of these, which stands beside the tower, is inscribed: *Patricii et Columbae Crux*, 'The Cross of Patrick and Columba'. Its surface is far less rigidly divided into formal panels than in the Monasterboice examples, and areas of abstract ornament and figure sculpture are freely intermingled. The cap which crowned the top is missing but the tenon which held it in place remains. The figure panels on the east face of the lower shaft show, at the bottom, Adam and Eve, and Cain killing Abel, and, above them, the children in the furnace and Daniel and the lions. On one arm Abraham sacrifices Isaac; on the other the raven feeds the hermits Paul and Anthony. The panel on the upper shaft combines two subjects: David playing the harp and the miracle of the loaves and fishes. Christ and David are seated opposite each other, the former blessing the loaves before him and the crossed fishes beneath his feet, the hungry multitude being symbolised by two rows of heads. The west face is unusual in having two subjects which are normally on opposite faces: the crucifixion on the shaft and Christ in glory above (Fig. 122). Of the West Cross, only the undecorated pedestal and part of the shaft remain. In the division of the surface into regular panels and the allocation of figures to the faces and abstract ornament to the sides it resembles the Monasterboice crosses. The figures are stiff and tend to have disproportionately large heads. A rendering of the baptism of Christ is based, like all Irish versions of the subject, on the legend that it took place at the meeting of two rivers, the Jor and the Dan, the sources of which are shown here as two discs. Christ and the Baptist stand in the water with two spectators on dry land to one side, the cloaks of both of whom are fastened on the breast with ring-brooches. In the centre is the descending dove.

Of the two crosses at Duleek, only the head remains of the South Cross. The west face of the North Cross has figure panels; the east face is given over wholly to decorative patterns which include spiral bosses, interlace and frets (Fig. 123). At Killary, Co. Meath, stands the shaft of a small cross not all the panels of which have been identified with certainty, but the second from the bottom on the west face depicts a three-figure rendering of the baptism of Christ which again shows the

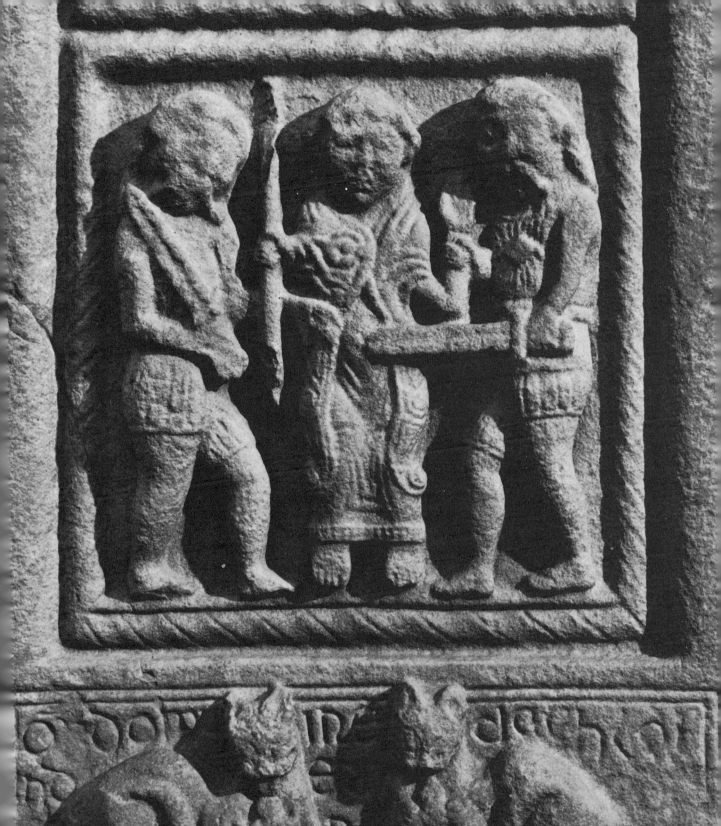

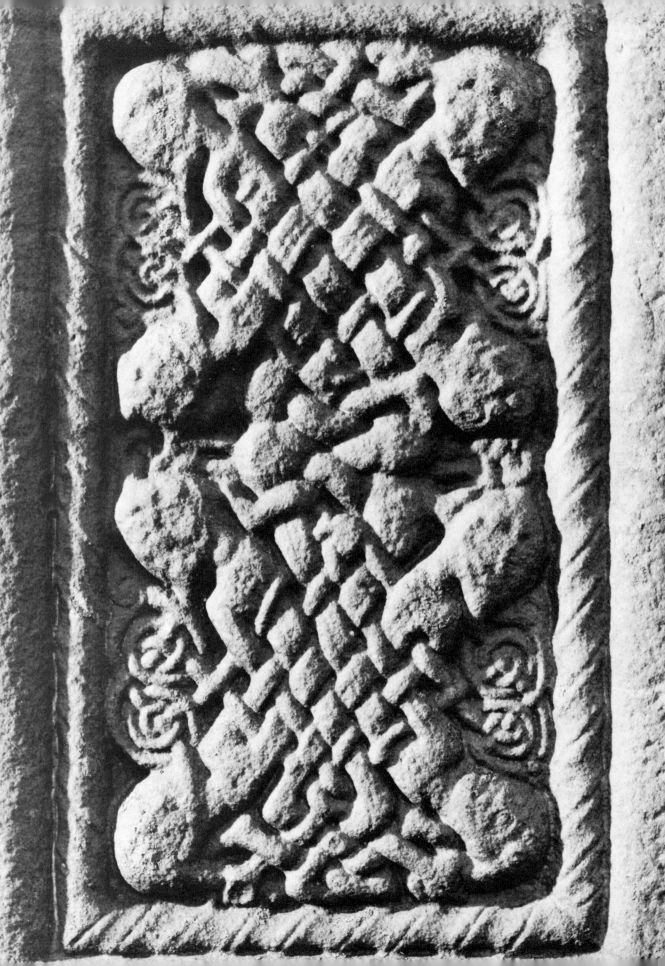

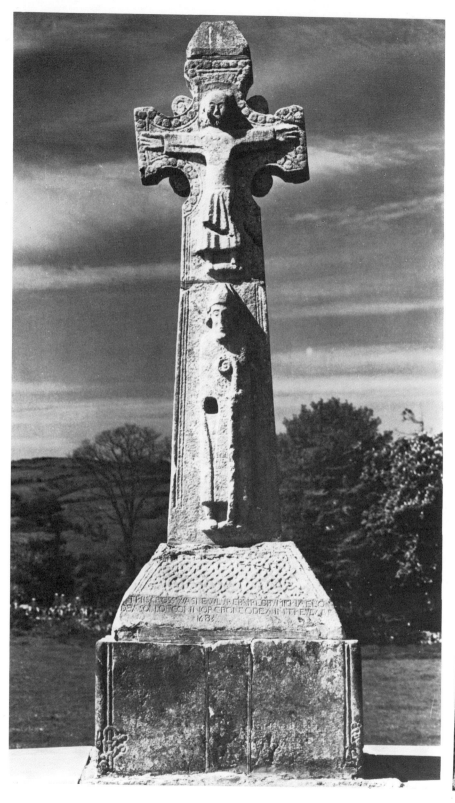

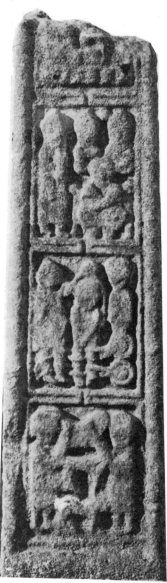

Fig. 119. Opposite: Cross of Muiredach, Monasterboice, Co. Louth. Panel on south side of shaft with design consisting of eight men with interlaced limbs and hair. 9th–10th cent. A.D.

Fig. 120. Left: High cross, Dysert O'Dea, Co. Clare. 12th cent. A.D.

Fig. 121. Below: Shaft of high cross, Killary, Co. Meath. Late 9th cent. A.D.

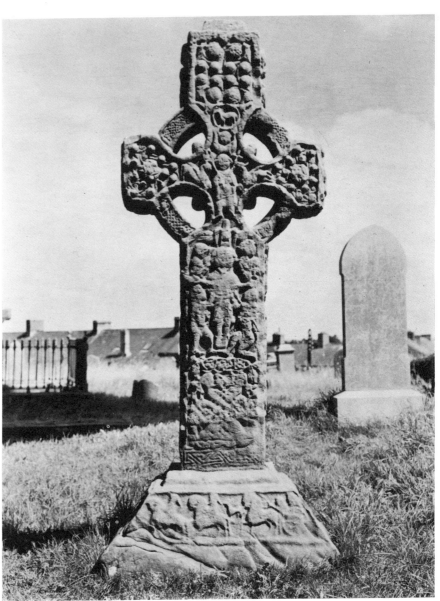

Fig. 122. Cross of Patrick and Columba, Kells, Co. Meath. Early 9th cent. A.D.

twin sources of the Jordan, the water of which is interlaced with the legs of Christ in the centre and those of the Baptist to his left (Fig. 121). Beside the stump of a round tower at Drumcliff, Co. Sligo, is an unusual cross which illustrates the variety of treatment to be found among these monuments (Plate 39). It is remarkable for the number and prominence of its animal figures, including large frog-like creatures on the underside of the ring and a beast with a steeply arched back in the middle of the shaft on the west face. The crucifixion, in the centre of the head, is the only figure subject on this face which can be identified with certainty.

Plate 40. Opposite: St Kevin's Church, Glendalough, Co. Wicklow. Date uncertain.

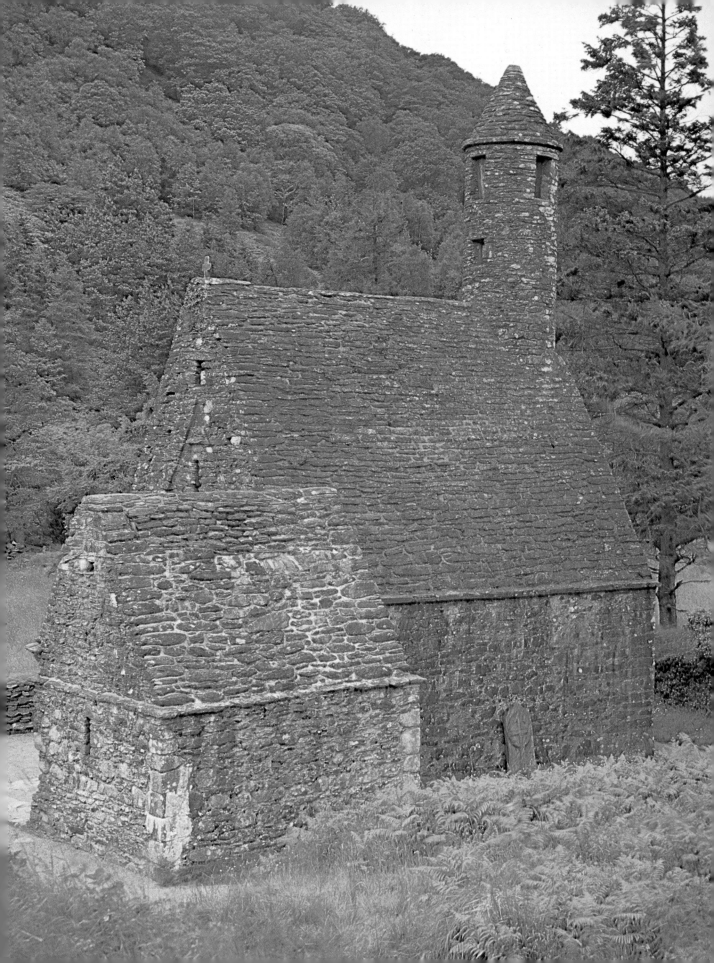

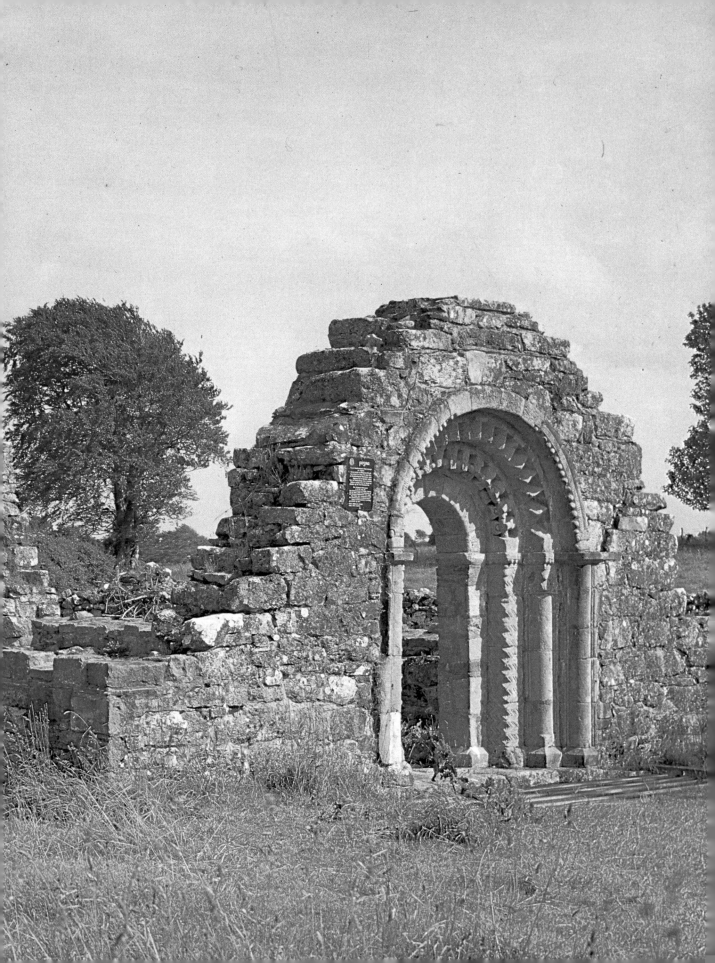

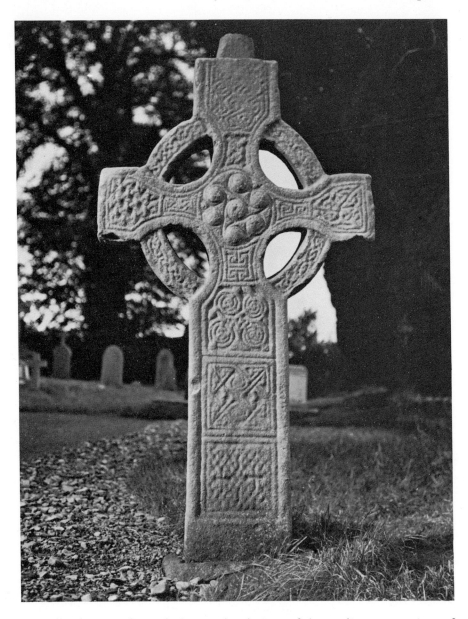

Fig. **123**. North cross, Duleek, Co. Meath. 9th cent. A.D.

As has been indicated above, the dating of the earlier generation of high crosses rests almost entirely on stylistic criteria, and the relationship in time between the various groups is still far from clear. The comparatively few crosses erected at later dates are probably to be regarded as a revival of the tradition rather than as a continuation of it. They have been assigned to the late eleventh or early twelfth centuries and the most important examples are to be found at Tuam, Co. Galway, and at Kilfenora and Dysert O'Dea, Co. Clare (Fig. 120). They have tall tapering shafts and relatively small heads. The greater part of the surface is covered with flat shallow decoration in interlace and fret-

Plate **41**. Opposite: Nun's Church, Clonmacnoise, Co. Offaly. *c.* 1166 A.D.

patterns, closely resembling that on the contemporary metalwork and which, if subdivided into panels, is bordered by flat bands instead of the raised mouldings of the older crosses. The Dysert O'Dea monument lacks the ring on the head but retains the rolls in the angles. The back and sides are covered with panels of zoomorphic interlace of Scandinavian Urnes type and step- and fret-patterns. The front of the head has a crucifixion figure quite as archaic as that of the St John's plaque (Plate 32), and on the shaft below is a mitred ecclesiastic with a crozier whose stiff attenuated figure, frozen features and high-set ears are all very much part of the Irish tradition.

Architecture

In the earlier centuries of Irish Christianity virtually all buildings, domestic and ecclesiastical, were built of wood. It is uncertain when the custom of building stone churches began. Certainly some of the most primitive, and possibly the earliest, stone structures of the Early Christian period are the clochans or unmortared beehive cells which are scattered along the west coast from Donegal to Kerry and some well preserved specimens of which mark the site of the ancient monastery on the tiny rocky islet of Skellig Michael, off the coast of the latter county (Fig. 125). The use of stone in such situations may be due to the extreme exposure of these coastal sites and a local scarcity of timber. Although circular externally, some of the Skellig clochans have a square internal plan, and this type may have given rise to another kind of structure, numbers of which are to be found in Kerry. It is a diminutive church, rectangular in plan and built of unmortared stone, with slightly sloping gables and arching side walls which meet on top in a ridge. In one gable is a square-headed doorway with sloping jambs and in the other a small window. As the side walls are fundamentally unstable, only a single intact example still stands, that known as Gallarus on the Dingle peninsula (Fig. 124).

While it is possible to reconstruct an evolutionary sequence of Irish stone-roofed churches, commencing with structures of the Gallarus type and ending with Cormac's Chapel at Cashel, it is as yet by no means established that the buildings in the series really represent successive stages of development. If the validity of the sequence were accepted, then the little church at Glendalough, Co. Wicklow, which is familiarly known as St Kevin's Kitchen, would be considered as occupying an intermediate position in it (Plate 40). This building, to which a date in the ninth century is usually attributed, has an almost semicircular vaulted ceiling supporting the corbelled roof, the load on the vault being relieved by the insertion of a small croft above it which is lit by a small window near the summit of the gable. The round tower on the gable and the little sacristy at one corner, also stone-roofed, are considered to be additions of a somewhat later date. A noticeable feature of the church is the gentle inward slope or 'batter' of the walls. This is a characteristic of all Irish buildings, early and late, mortared and unmortared, and one which persisted in native building tradition into the eighteenth and, in vestigial form, even into the nineteenth

171

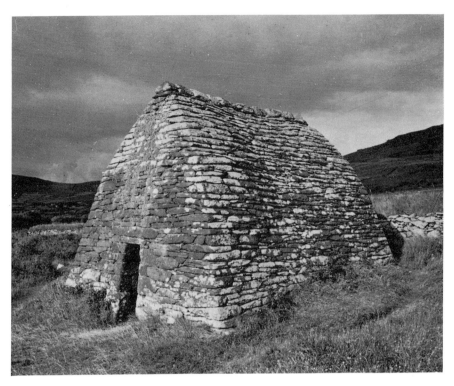

Fig. 124. This page: Gallarus Oratory, Co. Kerry. Built of unmortared stone and the only intact example of a number of similar structures in Co. Kerry. Date uncertain (8th–12th cent. A.D.).

Fig. 125. Opposite: Beehive cell (*clochán*) of unmortared stone at site of island monastery of Skellig Michael, Co. Kerry. Possibly 8th cent. A.D.

century. Stone-roofed churches, rather similar to St Kevin's Kitchen, exist at several places throughout the country, including Killaloe, Co. Clare, Kells, Co. Meath, and St Doulagh's, Co. Dublin.

The largest and finest building roofed in this fashion is Cormac's Chapel at Cashel, Co. Tipperary, which was dedicated for worship in 1134 (Fig. 126). It forms part of a complex of buildings picturesquely crowning the summit of a rocky outcrop. It consists of a nave and chancel with twin towers in a transeptal position. The towers, the blank arcading on the walls and the character of much of the carved work betray Germanic influence, received through the links which the Irish church maintained at the time with various foundations of Irish origin in Germany. The church is built and decorated in the version of the Romanesque current in Ireland in the period. The north doorway has receding orders of columns with carved capitals and a tympanum where the hulk of a great lion-like beast almost crowds out the centaur who twists back to aim his arrow at it (Fig. 127). Tympana are exceedingly rare in Irish architecture but there is a second one in this church over the south doorway, which is also carved with an ungainly beast. The interior is vaulted and has arcaded side walls richly decorated. Interior arcading also occurs on a church at Kilmalkedar, Co. Kerry, and it is found externally on the gable of one at Ardmore, Co. Waterford (Fig. 131). Besides the chapel, Cashel contains a tenth-century round tower, a broken stone sarcophagus boldly carved with interlace

172

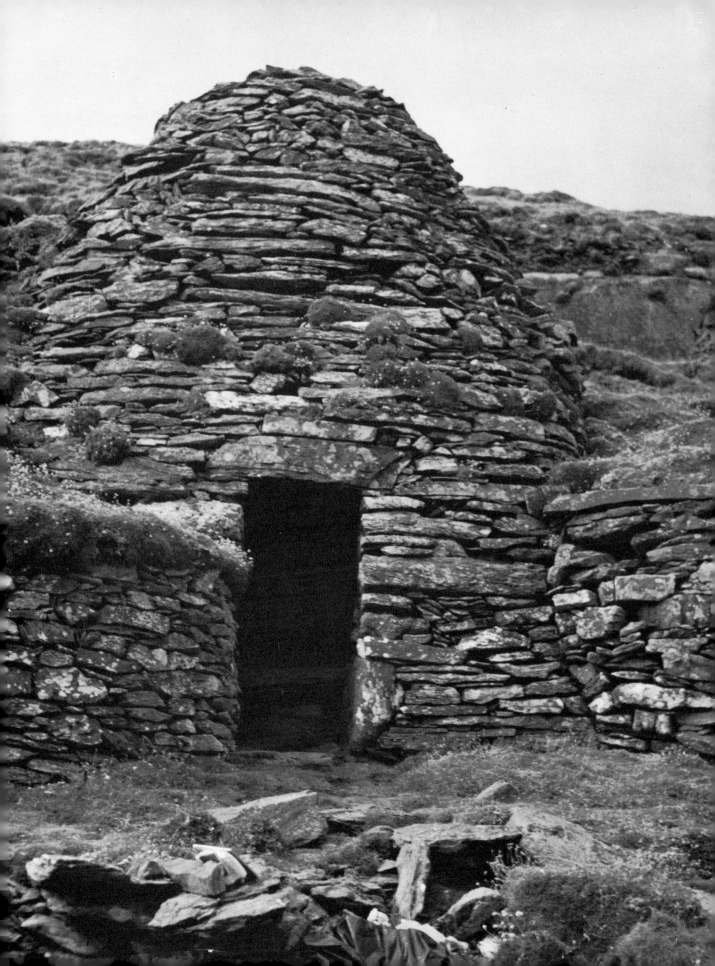

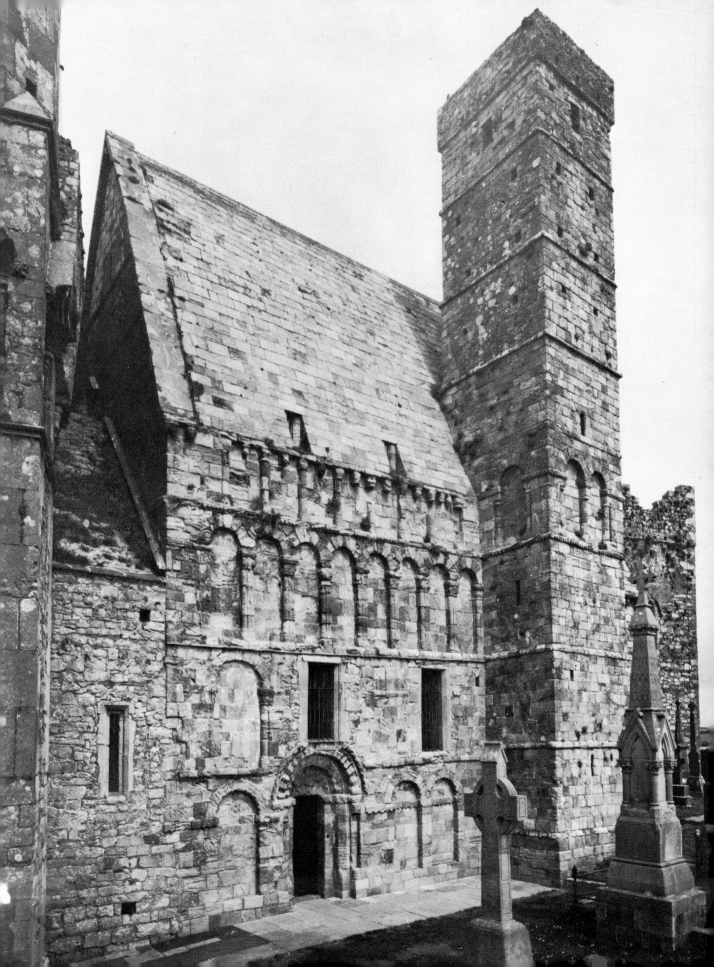

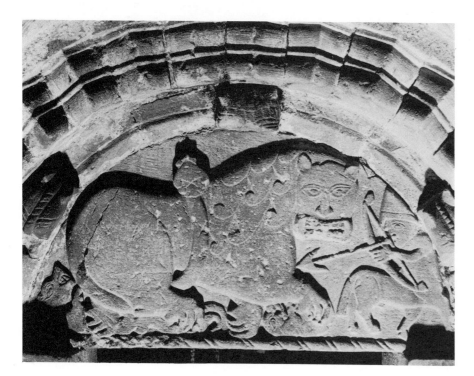

of Urnes complexion, a cross of unique shape known as St Patrick's Cross, and the ruins of a large cathedral built between 1235 and 1270.

The decorated phase of the Irish Romanesque to which Cormac's Chapel belongs lasted little more than a hundred years, from the late eleventh to the late twelfth century. The masterpiece of the style is the portal of St Brendan's Cathedral at Clonfert, Co. Galway, dating to shortly after the middle of the twelfth century (Fig. 128). Though small by continental or even by British standards, it is the largest portal in Ireland. It has broad outer pilasters and five inner orders of engaged columns supporting a perspective of seven richly carved arch rings (Fig. 129). The inserted Gothic doorcase probably replaces still another order. The whole is surmounted by an elaborate triangular pediment framed by twin cable mouldings and consisting of an arcade with human masks, above which is a diaper of fifteen triangular panels, the alternate ones filled with human heads. The surface of the columns of arcade and doorway is covered with the shallow tracery of patterns characteristic of the Irish Romanesque, the motifs including ribbon and animal interlace, foliage designs, palmettes, zig-zags and frets. The inward slope of the jambs, which is a constant feature of all early Irish stone buildings, is reproduced at Clonfert, the degree of slope of the columns of the portal being greater than in any other building in the country.

The ruins of further good examples of Romanesque churches are to be found at Killeshin, Co. Carlow, Monaincha and Roscrea, Co.

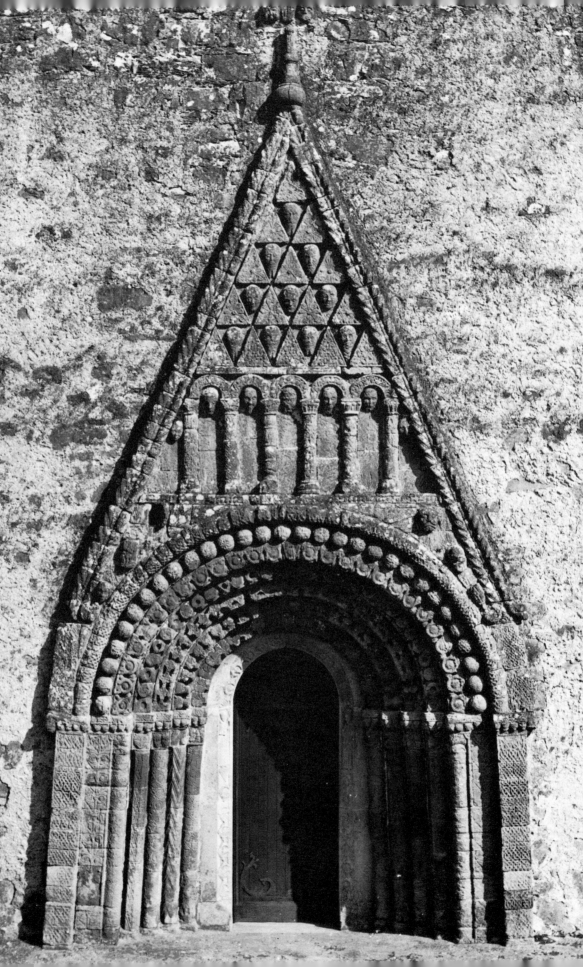

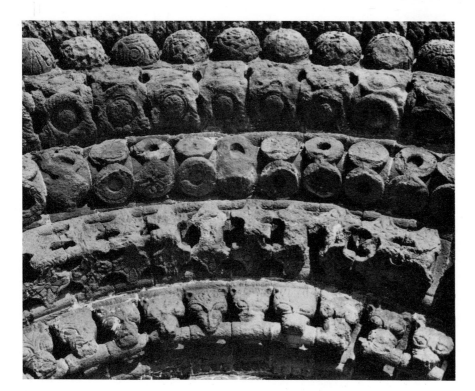

Fig. 129. This page: Clonfert Cathedral, Co. Galway: detail of doorway arch.

Tipperary, and Kilmalkedar (Fig. 130) and Ardfert, Co. Kerry. The restored doorway and chancel arch of the Nuns' Church at Clonmacnoise, dating to about 1166, are also typical (Plate 41). The doorway is of four orders, the arch of the outer forming a hood moulding ending in animal heads. The arch of the second consists of ribbon chevrons, that of the third of animal masks holding a roll in their jaws, while that of the fourth is plain. The chancel arch is in three orders and is decorated with deeply cut chevrons and rolls.

Fig. 128. Opposite: Clonfert Cathedral, Co. Galway: doorway.

Before Clonfert Cathedral or the Nuns' Church had been built the Cistercian order had arrived in Ireland. Their first house was consecrated at Mellifont, Co. Louth, in 1157 and was probably built in Romanesque style, but the order was instrumental in introducing Gothic architecture, the diffusion of which was furthered by the rapid spread of the Cistercian abbeys and by the foundations of other newly arrived orders, including Canons Regular of St Augustine, Franciscans, Dominicans and Hermits of St Augustine. Jerpoint, Co. Kilkenny, Dunbrody, Co. Wexford, Holycross, Co. Tipperary, and Boyle, Co. Roscommon, are the sites of some of the larger Cistercian houses. Boyle Abbey was founded from Mellifont in 1161 and has one of the largest and best preserved churches of the order in Ireland. It is in the Transitional style and is typical of the severe tone favoured by the order as in keeping with their strict and abstemious way of life.

One creation of the ancient architects is so characteristic that it was

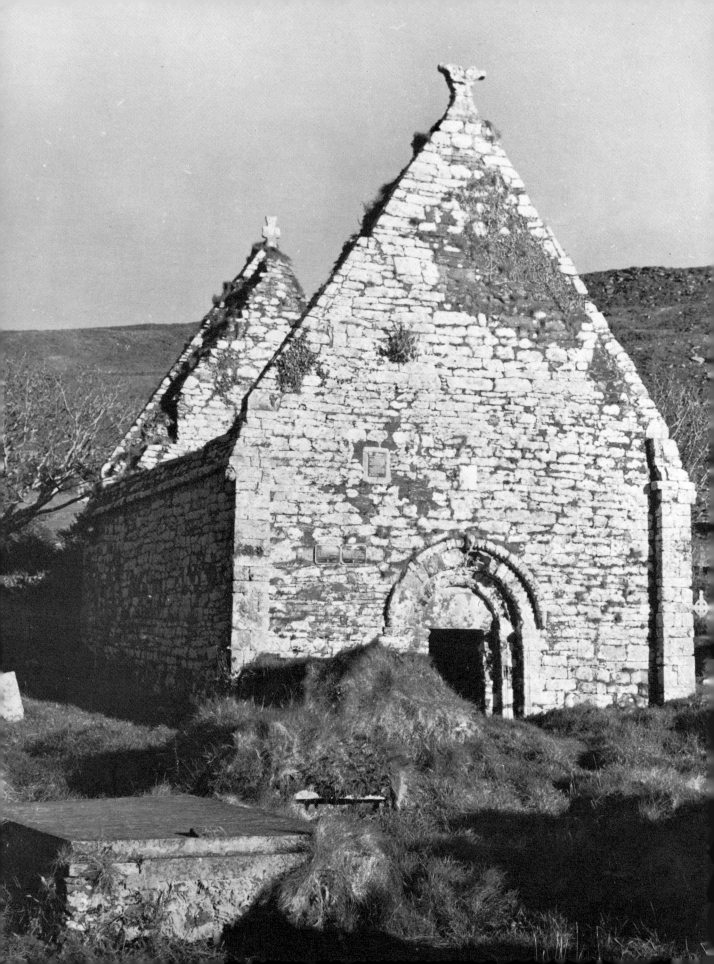

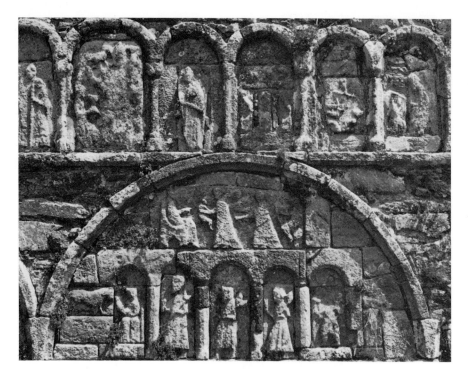

Fig. 131. This page: Detail of arcading on church gable at Ardmore, Co. Waterford. The central panel depicts the Judgement of Solomon. 12th cent. A.D.

Fig. 130. Opposite: Romanesque church, Kilmalkedar, Co. Kerry. The ornamental finial on the apex of the gable is derived from the decorated crossing ends of the gable beams of wooden buildings. 12th cent. A.D.

adopted as a symbol of the country by the romantic nationalists of the nineteenth century – the tall slender round tower with a conical roof which stands within the precincts of many of the old monasteries. Over a hundred in varying states of preservation remain, including a number which have survived virtually unscathed. Of these last, that which stands on the site of the monastery founded by St Kevin at Glendalough, Co. Wicklow, is typical of its kind (Fig. 132). An average tower is something under 30 m. high and tapers from base to top. The doorway is always at a considerable height above the ground – sometimes as much as 5 m. – and access was gained by means of a ladder which could be drawn up into the tower by persons taking refuge there. Internally, the tower was originally divided into storeys, usually four in number, by wooden floors, communication between the storeys being effected by ladders. Each storey, except the lowest, was lit by a single small window and at the top of the tower four rather larger windows faced the cardinal points. The majority of the towers appear to have been built during the ninth and tenth centuries, but a twelfth-century date is usually ascribed to a particularly graceful example at Ardmore, Co. Waterford, which is segmented at felicitous intervals by three prominent string courses (Fig. 133). The towers are the most ambitious purely native essays in architecture, and although they were, in all likelihood, inspired by continental exemplars, they conform to the overruling canon of Irish style in eschewing the vertical line and giving an inward slope to the external walls, the door-jambs and the sides of the windows.

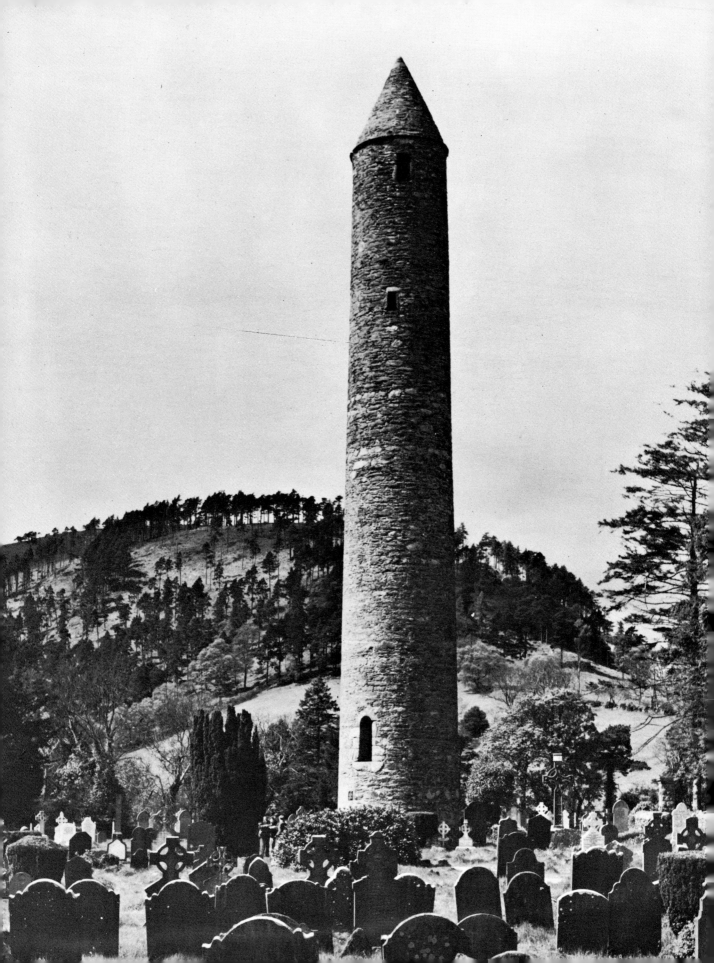

The height of the doorways and the absence of windows in the lowest storeys indicate that the towers were designed to function as strongholds should the need for a secure retreat arise. On this account, their erection has, inevitably, been correlated with the Viking incursions but, although their suitability as safe refuges for persons and as strongrooms for the storage of church valuables is undeniable, the primary reason for building them may well have hinged on the less practical considerations of architectural fashion and monastic prestige. At all events, the old Irish name for a tower of this kind, *cloigtheach* or 'bell-house', suggests that the people of the time thought of them first and foremost as belfries. Since there is no contemporary evidence for the existence of large hanging bells, we must, if this is the correct implication of the name, visualise small bells of the type of that associated with St Patrick being rung by hand from the upper windows of the towers.

Fig. 132. Opposite: Round tower, Glendalough, Co. Wicklow. 10th cent. A.D.

Fig. 133. Overleaf: Round tower and church with arcaded gable, Ardmore, Co. Waterford. 12th cent. A.D.

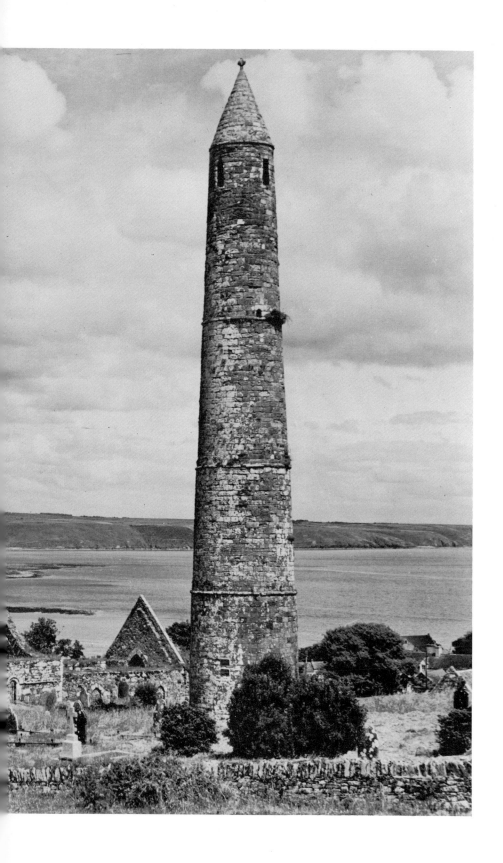

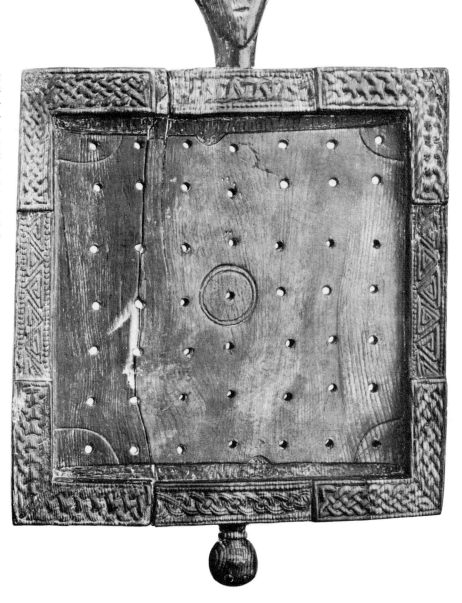

Fig. 134. Wooden gaming board, Ballinderry, Counties Offaly-Westmeath. The playing pieces were evidently provided with pins which were inserted in the holes. The margins are carved with fret and ribbon interlace but two diagonally opposite corners bear patterns of 'ring-chain' interlace which is common in Viking art but very rare in Irish contexts. L. 21 cm. Late 10th cent. A.D.

Conclusion

n this brief account of Irish art an attempt has been made to cover at least its major aspects in all the fields where it found expression. Any account, whether it be an outline or a detailed study, must, however, present at best a very incomplete picture since for prehistoric times we are almost totally dependent on material which has come to light through chance finds or archaeological excavation and, in general, only articles fashioned in the most durable substances have survived from that period. An unusually troubled history has tended to perpetuate circumstances inimical to the preservation of the national artistic heritage down to comparatively recent centuries, leading to the virtually complete disappearance of wall paintings, wood carvings, textiles and, as a general rule, of everything which required continuous shelter for its preservation. A few items which escaped this fate by having been preserved in favourable archaeological contexts, like the late tenth-century wooden gaming board from Ballinderry (Fig. 134), serve to remind us of how much material of an artistic nature executed in such perishable media has been irretrievably lost. Notwithstanding these losses, enough remains to enable us to appreciate reasonably fully the highly characteristic and subtle idiom of Irish art and its place in the history of European culture.

Select Bibliography

Nils Åberg, *The Occident and the Orient in the Art of the Seventh Century: The British Isles*, Stockholm 1943.

Ludwig Bieler, *Ireland, Harbinger of the Middle Ages*, London 1963.

Arthur Champneys, *Irish Ecclesiastical Architecture*, London 1910.

George Coffey, *New Grange and Other Incised Tumuli in Ireland*, Dublin 1912.

H. S. Crawford, 'A Descriptive List of Irish Shrines and Reliquaries', *Journal Royal Society of Antiquaries of Ireland*, 53 (1923), 74–93 and 151–76.

H. S. Crawford, *Handbook of Carved Ornament from Irish Monuments of the Christian Period*, Dublin 1926.

Máire and Liam de Paor, *Early Christian Ireland*, London 1958.

Myles Dillon and Nora K. Chadwick, *The Celtic Realms*, London 1967.

Earl of Dunraven, 'On an Ancient Chalice and Brooches lately found at Ardagh, in the County of Limerick', *Transactions Royal Irish Academy*, 24(1858–71), 433–54.

Earl of Dunraven, *Notes on Irish Architecture*, 2 vols, ed. Margaret Stokes, London 1875–77.

A. M. Friend, 'The Canon Tables of the Books of Kells', *Medieval Studies in Memory of A. Kingsley Porter*, ed. Wilhelm R. W. Koehler, Harvard 1939, Vol. II, 611–41.

L. S. Gogan, *The Ardagh Chalice*, Dublin 1932.

Dom Louis Gougaud, 'The Earliest Irish Representations of the Crucifixion', *Journal Royal Society of Antiquaries of Ireland*, 50(1920), 128–39.

G. Haseloff, 'Fragments of a Hanging-Bowl from Bekesbourne, Kent, and Some Ornamental Problems', *Medieval Archaeology*, 2(1958), 72–103.

H. O'N. Hencken, 'Ballinderry Crannog No. 1', *Proceedings Royal Irish Academy*, 43C(1936–37), 10–239.

H. O'N. Hencken, 'Lagore Crannog, an Irish Royal Residence of the 7th to 10th Centuries A.D.', *Proceedings Royal Irish Academy*, 53C(1950), 1–247.

Françoise Henry, *La sculpture irlandaise pendant les douze premiers siècles de l'ère chrétienne*, 2 vols, Paris 1933.

Françoise Henry, 'Emailleurs d'Occident', *Préhistoire*, 2(1933), 65–146.

Françoise Henry, 'Hanging Bowls', *Journal Royal Society of Antiquaries of Ireland*, 66(1936), 209–46.

Françoise Henry, 'Irish Enamels of the Dark Ages and their Relation to the Cloisonné Techniques', *Dark Age Britain: studies presented to E. T. Leeds*, ed. D. B. Harden, London 1956, 71–88.

Françoise Henry, 'The Effects of the Viking Invasions on Irish Art', *Proceedings of the International Congress of Celtic Studies, Dublin 1959*, Dublin 1962, 61–72.

Françoise Henry, *Irish High Crosses*, Dublin 1964.

Françoise Henry, *Irish Art in the Early Christian Period to A.D. 800*, revised ed., London 1965.

Françoise Henry, *Irish Art during the Viking Invasions, 800–1020 A.D.*, London 1967.

Françoise Henry, *Irish Art in the Romanesque Period, 1020–1170 A.D.*, London 1970.

Françoise Henry and G. L. Marsh-Micheli, 'A Century of Irish Illuminations (1070–1170)', *Proceedings Royal Irish Academy*, 62C(1962), 101–64.

Kathleen Hughes, *The Church in Early Irish Society*, London 1966.

Paul Jacobsthal, *Early Celtic Art*, 2 vols, Oxford 1944.

T. D. Kendrick and Elizabeth Senior, 'St Manchan's Shrine', *Archaeologia*, 86(1937), 105–18.

James F. Kenney, *The Sources for the Early History of Ireland*, Vol. I: *Ecclesiastical*, New York 1929.

H. G. Leask, *Irish Churches and Monastic Buildings*, Vol. I: *The First Phases and the Romanesque*, Dundalk 1955; Vol. II: *Gothic Architecture to A.D. 1400*, Dundalk 1958; Vol. III: *Medieval Gothic, the last phases*, Dundalk 1960.

E. T. Leeds, *Celtic Ornament in the British Isles down to A.D. 700*, Oxford 1933.

Pádraig Lionard, 'Early Irish Grave Slabs', *Proceedings Royal Irish Academy*, 61C(1961), 95–169.

A. T. Lucas, 'The Plundering and Burning of Churches in Ireland, 7th to 16th Century', *North Munster Studies*, ed. Etienne Rynne, Limerick 1967, 172–229.

A. T. Lucas, 'Irish-Norse Relations: Time for a Reappraisal', *Journal of the Cork Historical and Archaeological Society*, Vol. 71(1966), 62–75.

Proinsias Mac Cana, *Celtic Mythology*, London 1970.

Máire MacDermott, 'The Kells Crozier', *Archaeologia*, 96(1955), 59–113.

Eoin MacWhite, 'A New View on Irish Bronze Age Rock-Scribings', *Journal Royal Society of Antiquaries of Ireland*, 76(1946), 59–80.

Adolf Mahr, *Ancient Irish Handicraft*, Limerick 1939.

Adolf Mahr and J. Raftery, *Christian Art in Ancient Ireland*, 2 vols, Dublin 1932–41.

Herbert Maryon, 'The Technical Methods of the Irish Smiths in the Bronze and Early Iron Ages', *Proceedings Royal Irish Academy*, 44C(1938), 181–228.

J. V. S. Megaw, *Art of the European Iron Age*, Bath 1970.

G. L. Micheli, *L'enluminure du haut moyen-âge et les influences irlandaises*, Brussels 1939.

O. H. Moe, 'Urnes and the British Isles', *Acta Archaeologica*, 26(1955), 1–30.

Carl Nordenfalk, 'Before the Book of Durrow', *Acta Archaeologica*, 18(1947), 141–74.

E. R. Norman and J. K. St Joseph, *The Early Development of Irish Society*, Cambridge 1969.

Claire O'Kelly, *An Illustrated Guide to Newgrange*, 2nd ed., Wexford 1971.

M. J. O'Kelly, 'The Cork Horns, the Petrie Crown and the Bann Disc', *Journal Cork Historical and Archaeological Society*, 66(1961), 1–12.

Seán P. Ó Ríordáin and Glyn Daniel, *New Grange and the Bend of the Boyne*, London 1964.

Peter Paulsen, 'Koptische und Irische Kunst und ihre Austrahlungen auf alt-Germanische Kulturen', *Tribus*, 149–87, Stuttgart 1952–53.

Joseph Raftery, *Prehistoric Ireland*, London 1951.

Joseph Raftery, 'Ex Oriente . . .', *Journal Royal Society of Antiquaries of Ireland*, 95(1965), 193–204.

Helen M. Roe, 'The High Crosses of Co. Louth', *Seanchas Ardmhacha*, 1(1954), 101–14.

Helen M. Roe, 'The High Crosses of Co. Armagh', *Seanchas Ardmhacha*, 2(1955), 107–14.

Helen M. Roe, 'The High Crosses of East Tyrone', *Seanchas Ardmhacha*, 3(1956), 79–89.

Helen M. Roe, *The High Crosses of Kells*, Kells 1959.

Helen M. Roe, *The High Crosses of Western Ossory*, 2nd ed., Kilkenny 1962.

Anne Ross, *Pagan Celtic Britain: studies in iconography and tradition*, London 1967.

John Ryan, *Irish Monasticism*, Dublin 1931.

Etienne Rynne, (ed.) *North Munster Studies, essays in commemoration of Monsignor Michael Moloney*, Limerick 1967 (especially the contributions by J. S. Jackson, J. Raftery, P. ÓhÉailidhe, H. M. Roe, L. de Paor, E. Rynne and A. T. Lucas).

Etienne Rynne, 'The Art of Early Irish Illumination', *Capuchin Annual*, 36(1969), 201–22.

Etienne Rynne, 'Celtic Stone Idols in Ireland', *The Iron Age of the Irish Sea Province*, ed. Charles Thomas (C.B.A. Research Report 9), London 1972, 79–98.

R. A. Smith, 'Irish Brooches of Five Centuries', *Archaeologia*, 65(1914), 223–50.

R. Stalley, *Architecture and Sculpture in Ireland, 1150–1350*, Dublin 1971.

Charles Thomas, *Britain and Ireland in Early Christian Times, A.D. 400–800*, London 1971.

Charles Thomas, *The Early Christian Archaeology of North Britain*, Oxford 1971.

David M. Wilson and Ole Klindt-Jensen, *Viking Art*, London 1966.

H. Zimmermann, *Vorkarolingische Miniaturen*, Berlin 1916.

FACSIMILES OF MANUSCRIPTS

Book of Durrow (*Evangeliorum Quattuor Codex Durmachensis*), 2 vols, Olten, Lausanne and Freiburg 1960.

Book of Kells (*Evangeliorum Quattuor Codex Cenannensis*), Berne, Vols. 1–2, 1950; Vol. 3, 1951.

Book of Lindisfarne (*Evangeliorum Quattuor Codex Lindisfarnensis*), 2 vols, Olten and Lausanne 1956–60.

The Irish Miniatures in the Abbey Library of St Gall, Olten, Berne and Lausanne 1954.

Index of Subjects

Key: 34, 42-3 etc. = references to text pages
Pl. 4, 5, etc. = references to colour plates
23, 118, etc. = references to monochrome figures

Index of Places